THE NEW TYPOGRAPHY

WEIMAR AND NOW: GERMAN CULTURAL CRITICISM
Edward Dimendberg, Martin Jay, and Anton Kaes, General Editors

JAN TSCHICHOLD

THE NEW TYPOGRAPHY

A HANDBOOK FOR MODERN DESIGNERS

Translated by Ruari McLean

WITH AN INTRODUCTION BY ROBIN KINROSS

UNIVERSITY OF CALIFORNIA PRESS

BERKELEY LOS ANGELES LONDON

**The publisher gratefully acknowledges receipt of
a translation grant from Inter Nationes.**

First Paperback Printing 1998

Published in 1987 as *Die neue Typographie:
Ein Handbuch für Zeitgemäss Schaffende,*
by Brinkmann & Bose, Berlin
First published in German in June 1928 by the
Bildungs verband der Deutschen Buchdrucker.
University of California Press
Berkeley and Los Angeles, California
University of California Press Ltd.
London, England
Copyright © 1995 by The Regents of
the University of California
Printed in the United States of America
08 07 06 05 04 03
9 8 7 6 5 4 3

The paper used in this publication meets the minimum
requirements of ANSI/NISO Z39.48-1992 (R1997)
(*Permanence of Paper*). ∞

CONTENTS

TRANSLATOR'S FOREWORD

RUARI McLEAN

Jan Tschichold's first book, *Die neue Typographie,* was published in Berlin in 1928. Its design was not only startling, with its famous frontispiece of solid black facing the title, but also extremely elegant, in a soft black linen case blocked in silver. This was six years after D. B. Updike's *Printing Types* was published in the United States, two years before Stanley Morison's article "First Principles of Typography" appeared in *The Fleuron* 7, and three years before Eric Gill's *Essay on Typography.* It was out of print by 1931 and remained out of print for fifty-six years, until the Brinkmann & Bose facsimile reprint of 1987.

Tschichold was recognized by a few people in Britain and the USA before 1939. A small exhibition of his work was held in the London office of a forward-looking printer, Percy Lund Humphries, between 27 November and 14 December 1935 (probably at the suggestion of Edward McKnight Kauffer); an article on his work by Robert Harling appeared in *Printing* in January 1936; and in 1937 Tschichold himself read a paper "A New Approach to Typography" to the Double Crown Club in London. The design of the menu for that dinner showed how little Tschichold's ideas, and those of the modern movement generally, were understood in Britain at that time. He continued to be supported by Lund Humphries, for whom he designed the firm's letterhead, in use from 1936 to 1948, and the 1938 edition of the *Penrose Annual.*

In March 1947 Tschichold came to England to overhaul the typography of the fast-growing paperback publisher Penguin Books (founded in 1935) — where he stayed for three years. But it was not until 1967 that any book of his appeared in English translation. This was his sixth book, *Typographische Gestaltung,* originally published in Basel in 1935 and now appearing under the title of *Asymmetric Typography.* It had been translated by the present writer in 1945, but remained without a publisher until Cooper & Beatty, the Toronto typesetters, sponsored it for distribution in the USA by Reinhold and in Britain by Faber & Faber.

In the same year, 1967, Tschichold asked me to translate *Die neue Typographie.* He planned it as a second, revised edition. He gave me a copy of the text with numerous corrections, editorial revisions, and deletions of matter he considered to be no longer relevant or now out of date: for example the entire section on standardization was taken out. It should be remembered that in a speech made to the Type Directors Club of New York in 1959 (later printed in *Print* under the title "Quousque Tandem . . ."), he

said: "What I do today is not in the line of my often mentioned book Die neue Typographie, since I am the most severe critic of the young Tschichold of 1925–8. A Chinese proverb says 'In haste there is error.' So many things in that primer are erroneous, because my experience was too small."

I translated the greater part of *Die neue Typographie* incorporating all the revisions, but again no publisher could be found. When Tschichold died in 1974, I placed the draft of my translation in the St Bride Printing Library in London where it could be consulted by anyone who wished to read it.

Now the University of California Press has enabled the book to appear at last in English, but in a new translation made exactly from the original text. It is therefore treated as a text of historical importance rather than the latest publication of Tschichold's thoughts.

All the self-critical comments written by Tschichold on his revised proofs are printed below, and two of his original pages are reproduced. The original passages of text were to stand unaltered. It was not feasible to show here the cuts and other corrections, which although numerous were not of serious textual importance. In the second edition which Tschichold had planned, there would certainly have been typographical changes: paragraphs were to be indented, and book and magazine titles italicized, in accordance with modern practice. Indented paragraphs have not been introduced in the present translation, and the illustrations, some of which Tschichold intended to change or omit, are unaltered.

Tschichold's text was epoch-making when first published. Its fundamental tenets are still absolutely valid: the book is as well worth reading today as it ever was.

For helping me at various times with my translation I must express my gratitude first to the late Hans Unger, and later to Hans Dieter Reichert, Jost Hochuli, Robin Kinross, and my Californian copy editor Nicholas Goodhue. But any grievous errors must be my own.

April 1993 ISLE OF MULL

x

REVISIONS TO DIE NEUE TYPOGRAPHIE

JAN TSCHICHOLD, 1967.

P. 30: as governing design in general (Gesetze der Gestaltung überhaupt*).
*Der Autor, 1967: *Das stimmt nicht. Die Malerei kann zwar einen befruch-tenden Einfluss auf die Typographie ausüben, doch sind die Gesetze der typographie autonom.*
The author, 1967: That is not right. Painting can indeed have a fruitful influence on typography, but the laws of typography are its own.

P. 67. and therefore must be inorganic (und darum unorganisch sein muss*).
*Die Autor, 1967: *Dieses Urteil über den zentrierten Büchtitel ist reichlich ungerecht.*
The author, 1967: This pronouncement on centered book title-pages is substantially unjust.

P. 68. Every piece of typography which originates in a preconceived idea of form, of whatever kind, is wrong (Jede Typographie die von einer vorge-fassten Formidee — gleichviel welcher Art — ausgeht, ist falsch*).
*Die Autor, 1967: *Das ist ein allzu rigoroser Standpunkt. Er würde das typographische Spiel, an dem wir uns gelegentlich freuen, verurteilen.*
The author, 1967: That is altogether too narrow a view. It would contradict the freedom for typographic jokes which we sometimes enjoy.

P. 71. a fear of *pure* appearance (indem man ihn "schmückt"*).
*Der Autor, 1967: *So einfach ist das nicht. Das Bedürfnis nach Schmuck ist elementar und nicht kindlich-naiv.*
The author, 1967: It is not so simple. The desire for ornament is elemental and not childish-naive.

P. 75. also the classical typefaces (will) disappear, as completely as the contorted furniture of the eighties (etwa den Muschelmöbeln der achtziger Jahre zuteil wird**).
**Die Prognose über die Zukunft der klassischen Schriften hat sich als irrig erwiesen.*
The forecast about the future of classical typefaces has been proved wrong.

P. 76. among whom I expect there must be an engineer (unter denen sich wohl auch ein Ingenieur befinden müsste*).

*Der Autor, 1967: *Die Situation ist heute ganz anders. So ist die Univers, aus der dieses Buch gesetzt ist, eine der besten heutigen Endstrichlosen und stellt dar, was ich 1928 erträumt habe.*

The author, 1967: The situation today is quite different. Univers, in which this book is set, is one of the best sanserifs, and is what I dreamed of in 1928.

P. 77. Their use for parody, in the sense described above, of course remains legitimate (oben bezeichneten Sinne bleibt natürlich offen*).

*Der Autor, 1967: *Diese Meinung hat sich als viel zu streng erwiesen.*

The author, 1967: This opinion now seems far too strong.

P. 78. It will remain the exception (eine Ausnahme bilden*).

*Der Autor, 1967: *Das war einmal.*

The author, 1967: That was in the past.

P. 78. would hardly have brought them back again (kaum wieder ans Tageslicht gezogen**).

**Der Autor, 1967: *Die Assoziation stellen sich nur bei wenigen ein und stören auch diese nicht.*

The author, 1967: The associations have little real influence and do not harm these types.

P. 80. or an industrial catalogue (oder ein Industriekatalog*).

*Der Autor, 1967: *Hier wird das Kind mit dem Bade ausgeschüttet!*

The author, 1967: Here, the baby is thrown out with the bathwater!

P. 80. it is totally unsuitable for the 20th century (heute noch zu verwenden**).

(Der Autor) **Auch hier!*

Here too!

P. 96. the luxury-concept of the "Book Beautiful" belongs to the past (der Vergangenheit angehört).

Der Autor, 1967: *Welch ein Irrtum!*

The author, 1967: What a mistake!

lebhafte [handwritten]

Wir dies [margin handwritten] ...en heute eine Sympath.. für das Licht, also für Weiß, undart seinf... Vorherrsch... in der Neuen Typographie. Diet des Rot entspricht unserer eigenen, und wir geben darum dieser .. vor allen anderen den Vorzug. Der an sich starke Kontrastarz-Weiß kann durch Hinzutreten des Rot außerordentlich gesteigert (~~Das ist freilich keine neue Weisheit, vielleicht ab.. hab.. wir...~~ ~~...ahl..ten dieser Farbstellung schärfer zugespitzt als frühere Zeiten...~~ ~~...als Schwarz-Rot auf Weiß sehr gern verwandten, wie die Gotik und...~~ ~~Barock.)~~

....stverständlich ist die Farbstellung Schwarz-Rot nicht die einzig mögliche,vielfach irrtümlich angenommen wird. Infolge ihrer besonders starkennsität wird sie aber oft jeder anderen vorgezogen. Die Farbigkeit dercksorte muß im übrigen dem Zweck entsprechen: man wird Besuchs- ...n nicht dreifarbig setzen und sich bei Plakaten nur selten mit Schwarz- ...ß begnügen.

....reinen, nicht mit Schwarz vermischten Farben Rot, Gelb, Blau genießenen ihrer Intensität den Vorrang, sie schließen aber die übrigen gemischtenntöne nicht aus.

Schrift

zur grundgestalt [handwritten]

Alle Schriftformen, deren Wesen durch ~~zum Skelett~~ hinzutretende Orna-te (**Endstriche** bei der Antiqua, Rauten und Rüssel bei der Fraktur) ent-lt ist, entsprechen nicht unserem Streben nach Klarheit und Reinheit. allen vorhandenen Schriftarten ist die sogenannte Grotesk ~~oder~~schrift (die richtige Bezeichnung *ist Endstrecklose*) die einzige, dierer Zeit geistig gemäß ist.

....roklamierung der Grotesk als der Schrift unserer Zeit ist **keine**Modeangelegenheit. ~~H~~entspricht ~~durchaus~~ den allgemeinen Tendenzen der Architektur. Die Zeit ist nicht mehr fern, wo nicht nur dieerschriften (die dieses Los zum Teil schon heute trifft), sondern auchlassischen" Schriften allgemein dieselbe Ablehnung erfahren werden.ute etwa den Muschelmöbeln der achtziger Jahre zuteil wird **xx**~~Keine Frage, daß~~ D..e heute vorhandenen Groteskschriften den An-hen, die an eine vollkommene Schrift gestellt werden müssen, noch .. ganz ~~genügen~~. Die spezifischen Eigentümlichkeiten dieser Schrift sind kaum herausgearbeitet, die Formen insbesondere der Kleinbuch-n sind noch zu sehr von der humanistischen Minuskel abhängig. Dien und gerade die neuesten künstlerischen Groteskschriften (z.B. Erbar-l und Kabel) zeigen, zu ihrem Nachteil gegenüber den namenlosen Grotesken, individuell modifizierte Bewegungen, die sie grundsätz-n eine Linie mit den andern Künstlerschriften stellen. Als Brotschriften

H sondern [margin handwritten]

genügen [margin handwritten]

75

....~~...fassen 1930~~ [handwritten/struck]

*** Die Prognose über die Zukunft der klassischen* [handwritten]

Pages from *Die neue Typographie* showing Tschichold's hand-written revisions for a planned second edition.

sein als etwa Mörikes Gedichte oder ein Industriekatalog. Die Gotik hat den Kirchenvater Augustin aus Textur, nicht aus Unziale gesetzt!

Alles Druckwerk, gleichviel welcher Art, das in unserer Zeit geschaffen wird, muß die Kennzeichen unserer Zeit tragen und darf nicht Druckerzeugnisse früherer Zeiten imitieren. Das gilt natürlich nicht bloß von der Schrift,

darf
un?
wird

sondern von allen Aufbauteilen, auch den Abbildungen, dem Einband. Frühere Zeiten, die sich im Gegensatz zur unseren stets ihrer selbst bewußt waren, haben stets das Vergangene, oft in krasser Form, verneint. Das lehren die Ergänzungsbauten der Dome, die allgemeine Kulturentwicklung und auch die Typographie. Der Stempelschneider Unger, Schöpfer der

braucht

Unger-Fraktur (um 1800), ein bedeutender Typograph, erklärte die Schwabacher für eine häßliche Schrift und wurde dadurch zum Erfinder der Auszeichnung des Fraktursatzes durch Sperren (früher hatte man Fraktur mit Schwabacher ausgezeichnet). Er hatte damit vollständig recht. Seine Zeit,

dabei

das Rokoko, fand die Gotik und ihre Ausdrucksformen, und damit auch die Schwabacher, weil ihrem Wesen entgegengesetzt, häßlich, und Unger war nur ihr Sprachrohr auf unserem Gebiete.

Ein Kunsthistoriker mag die Qualität etwa der alten Schwabacher schätzen können; auch wir sehen in ihr eine vollkommene Schrift ihrer Zeit – aber

it.

wir müssen es ablehnen, diese Schrift des 15. Jahrhunderts heute noch zu verwenden, denn sie ist höchst unzeitgemäß. So ist es mit allen historischen Schriften.

Auch wir

Wie jede Zeit müssen auch wir nach einer Schrift suchen, die unser eigener Ausdruck ist. Unsere Zeit ist gekennzeichnet durch ein allgemeines Streben nach Klarheit, und Wahrheit, nach der reinen Erscheinung. Darum ist das Schriftproblem notwendig ein anderes als früher. Wir verlangen von der Type Deutlichkeit, Klarheit, Weglassung alles Überflüssigen. Damit kommen wir zur Forderung eines geometrischen Formaufbaus. In der Grotesk besitzen wir eine Schriftform, die dieser Forderung sehr nahe kommt, und darum ist diese Schrift die Grundlage aller Weiterarbeit an der Schrift unserer Zeit. Der Charakter einer Zeit kann sich nicht nur in reichen und ornamentierten Formen zeigen. Auch die einfachen geometrischen Formen der Grotesk drücken etwas aus: Klarheit und Beschränkung auf das Wesentliche, und damit das Wesen unserer Zeit. Auf diesen Ausdruck kommt es gewiß an. Nicht aber kommt es darauf an, Spezialschriften für die Ankündigungen von Parfümfabrikanten und Modengeschäften oder für lyrische Ergüsse zu schaffen. Nie war es Aufgabe der Stempelschneider früherer Zeiten, eine Schrift mit einem individuellen Ausdruck herzustellen. Darum sind auch die

jene,

besten Schriften die die für alles brauchbar sind, und die die schlechten, die man nur für Visitenkarten oder Gesangbücher verwenden kann.

80 * *Der Autor, 1967: Hier wird das Kind mit dem Bade ausgeschüttet!*

INTRODUCTION TO THE ENGLISH-LANGUAGE EDITION
ROBIN KINROSS

Significant literary work can only come into being in a strict alternation between action and writing; it must nurture the inconspicuous forms that better fit its influence in active communities than does the pretentious, universal gesture of the book — in leaflets, brochures, articles, and posters. Only this prompt language shows itself actively equal to the moment. Opinions are to the vast apparatus of social existence what oil is to machines: one does not go up to a turbine and pour machine oil over it; one applies a little to hidden spindles and joints that one has to know.

1928 WALTER BENJAMIN*

Die neue Typographie was published in Berlin in June 1928. The author was the then twenty-six-year-old German typographer Jan Tschichold. The publishers were the Bildungsverband der Deutschen Buchdrucker: the educational association of the German printing-trade union. The book was the most detailed and best-illustrated exposition of the New Typography. This was the manifestation in the sphere of printed communication of the modern movement in art, in design, and — at least this was its aspiration — in life as a whole, which developed in Central Europe between the two world wars. To take representative or iconic instances, one could mention the new architecture built for the city of Frankfurt (under the direction of Ernst May), the political theatre of Bertolt Brecht and Hanns Eisler, the tubular-steel furniture of Mart Stam or Marcel Breuer, the cinema of Dziga-Vertov or Joris Ivens, journals such as *i10* or *Die Form*: work in which formal innovation and social concerns were intertwined. The New Typography now falls into place in the constellation of Central European modernist culture. Tschichold's book remains unsurpassed as the best single document of and about the New Typography. But its context and concerns now need considerable explanation.

TSCHICHOLD BEFORE *DIE NEUE TYPOGRAPHIE*
Jan Tschichold (1902–1974) was the son of a Leipzig sign-writer and lettering artist.[1] His early start in — and lifelong preoccupation with — lettering and typography is thus not surprising. Leipzig was one of the centres for printing and publishing in Germany, and at the heart of the country's typographic culture. After an informal apprenticeship to his father, he

attended classes at the Akademie für Künste und Buchgewerbe [academy of art and of the book trade] in Leipzig (from 1919) and then (from 1921) at the Kunstgewerbeschule [school of arts and crafts] at Dresden. In 1921 he also started to teach an evening class in calligraphy at the Leipzig Akademie.

In the early 1920s Tschichold worked primarily as a calligrapher, writing out texts for printed reproduction. Small advertisements for the Leipzig trade fairs were a staple job. The design approach of this early work can be called traditional, although it seems to show a rather eclectic experimentation with different letterforms and styles of writing.

In Tschichold's own account, two turning-points for him came in 1923. First, he began to practice "the previously unknown profession of typographic designer" with the large Leipzig printing firm of Fischer & Wittig.[2] The characteristic, defining activity of the typographic designer was the instruction of compositors by precisely drawn and dimensioned layouts. Previously the process of setting type had not been formally directed, except perhaps by vague sketches drawn by compositors themselves (or their senior colleagues), or occasionally (since perhaps the end of the nineteenth century) by the figure that Tschichold refers to, in quotation marks, as the "book-artist."[3]

The second turning-point was Tschichold's conversion to modernism, which he dated from his visit to the exhibition of the Weimar Bauhaus in the summer of 1923. This was the first full presentation of work done at the Bauhaus, held just at the point when the school was turning from its initial handicrafts phase towards a more technically oriented program and an engagement with the conditions of industrial production. The experience of visiting this exhibition touched Tschichold at the deepest level.[4] The first clearly modern works by Tschichold that have been reproduced are dated to 1924: a poster for the Philobiblon publishing house in Warsaw, a letter-heading for Nina Khmelova in Moscow. Before this, in 1922 or 1923, he is reported to have made the acquaintance of László Moholy-Nagy, who in turn introduced him to El Lissitzky: the two artist-designers whose work most encouraged his turn.[5] And a significant indicator in this process of change was his adoption, around 1923/24, of the name "Iwan Tschichold."[6] His given name had been Johannes Tzschichhold: his father, and mother also, had Slav origins. Throughout his working life Tschichold tended to look East — he became an authority on Chinese and Japanese prints — but at that point in the mid-1920s, this perhaps ancestral inclination took on a particular ideological charge.[7] "Iwan" proclaimed his new allegiance to the social-artistic ideas of the Russian Constructivists.

xvi

Tschichold's first published statement came in October 1925, in a special issue of the journal *Typographische Mitteilungen,* entitled *elementare typographie.*[8] This was the journal of the Bildungsverband der Deutschen Buchdrucker (then published in Leipzig), and in having the same publisher and in its character as an anthology of the movement, this document prepared the way for *Die neue Typographie.*[9] Even more clearly than the later book, *elementare typographie* represented an implant of foreign ideas into the settled world of the German printing trade. Among the texts included were a manifesto of Russian Constructivism (a version of the document known as "the program of the Productivist group" of 1920), Moholy-Nagy on "typo-photo," and statements by El Lissitzky. Work by Lissitzky, Moholy-Nagy, Max Burchartz, Kurt Schwitters, and Herbert Bayer was among the illustrations. Tschichold contributed two texts: "Die neue Gestaltung," a cultural-historical introduction on the lines of the section on "The new art" in the present book; and the manifesto *elementare typographie.* The publication is rounded off by lists of useful addresses, a bibliography, and editorial commentary, all done with an attention to detail and to the provision of useful information that would become characteristic of Tschichold.

Here, as subsequently, Tschichold's distinction was to mediate complex ideas, and to express them in clear, detailed formulations. If Lissitzky and Moholy-Nagy (to take the two main proponents) were artistic visionaries, Tschichold was the lucid practitioner, able to formulate and develop these visions in the ordinary world. Where they lacked the ability to specify exactly configurations of type and image, and were thus at the mercy of often insensitive printers, Tschichold knew what he wanted and could get it. (The free graphic work of these and similar artists is another matter.)

In the issues of *Typographische Mitteilungen* that followed *elementare typographie,* and elsewhere in the trade press, a good deal of argument about these ideas was published.[10] From around this time, the themes of the New Typography, and work done in its spirit, began to be a factor of some significance in German printing. For a few years in Germany, and in Central Europe more generally, there was some economic and material prosperity that could provide a base for this work: say, between the influx of US finance into Germany under the Dawes Plan (1924) and the crisis triggered by the world economic crash of 1929. If the immediate postwar years had been a time of material desolation and of utopian dreams of a new world, there was now the chance of developing and realizing the project of the modern movement.

Tschichold's own work and life developed, in tune with this larger pattern, in these years. In 1926 he married Edith Kramer and moved to Berlin, work-

ing as a freelance designer. In the summer of that year he moved again, to Munich, to take up a post as teacher at the Meisterschule für Deutschlands Buchdrucker [advanced-level college for German printers]. This institution was then in the process of being established, under the direction of Paul Renner, to provide a more advanced education for printers (there was already a college for the profession — the Graphische Berufsschule [vocational college for the graphic industries] — in Munich). This position would seem to have been an ideal one for Tschichold. It gave him a secure financial basis (evidently it was not possible for him to live on freelance work, especially now that he was married and, from 1929, the father of a son). It enabled him to develop his particular talent of explaining design principles to printers. And it put him in touch with other gifted colleagues, among them: Renner, who was then working on his Futura typeface; Georg Trump, the graphic designer, calligrapher, and typeface designer; and the graphic artist Hermann Virl.[11]

DIE NEUE TYPOGRAPHIE

Tschichold was working on the ideas and material published in *Die neue Typographie* certainly from late in 1926. In January 1927, *Typographische Mitteilungen* published a report of a lecture that he gave to the Munich group of the Bildungsverband der Deutschen Buchdrucker.[12] In May 1927 Tschichold gave a lecture on "Die neue Typographie," also under the auspices of the Bildungsverband, at the Graphische Berufsschule at Munich. A small notice advertising the lecture — which is reproduced here, as a good sample of Tschichold's typography at this stage — is revealing in the precision of its description: "the lecture will be accompanied by over a hundred slides, for the most part in more than one colour, and there will be no discussion afterwards." The last clause seems to say something about the firmness of Tschichold's views.[13]

In August 1927, Tschichold wrote to Piet Zwart that "a book by me about 'the new typography' will appear soon."[14] But it was not until summer of the following year that the book was printed and officially published. The imprint of the book gives the date as "June 1928" (and the number of copies printed as 5,000). As the publicity leaflet — reproduced here — indicates, the price was 6.50 Marks, or 5.00 Marks if ordered from the publishers before 1 June. This price would seem to have been quite modest for a heavily illustrated, cloth-cased book.[15]

The reception of *Die neue Typographie* appears to have been quiet. *Typographische Mitteilungen* carried almost no discussion of it, and published very little advertising for the book, in contrast to the debate that fol-

Advertisement for a lecture by Tschichold in 1927.

lowed the publication of *elementare typographie*. Some reviews can be found in other journals, and these include some perceptive observations that will be taken up again when the themes of the book are discussed.[16] As to the sales of the book, there is some record of this in the lists of previous publications by the author, which Tschichold provided, with typical exactness, in subsequent books. In 1930, *Die neue Typographie* was described as "almost out of print"; and in 1931, as "out of print" without qualification.[17] In these terms, the book was clearly a success. And already early in 1929, Tschichold reported to Piet Zwart that he was working on a new edition.[18] Eighteen months later, this was announced as "coming out soon," and Tschichold requested material from Zwart — as presumably from other colleagues — for illustration.[19] The book was going to be "quite changed"; for example it would have a larger (A4) format. Later, in 1932, Tschichold told Zwart that although the text for the second edition was ready for setting, the publishers did not want to undertake the risk of proceeding with this, in view of unfavourable conditions.[20] He added that the Russian edition might come out before this second German edition.

xix

Another letter of September 1932 – from Lissitzky to Tschichold – asked, "What are the prospects for the new edition of the big book about new typography?"[21]

Economically and politically, prospects for radical modernism in Germany were then very bad. Almost 30 per cent of the working population was unemployed (the figure had been 6 per cent in 1928). Everyday life was increasingly politicized, and German politics became increasingly violent and extreme. In the elections of July 1932, the National Socialists more than doubled their representation in parliament, taking 37 per cent of the vote. In further elections in November of that year, the Nazi vote dropped: a factor that only increased their determination to take power by any means. The parties that might together have defeated right-wing reaction – the SPD [social-democratic party] and the KPD [communist party] – were irrevocably opposed to each other. In January 1933, Adolf Hitler was appointed Chancellor of Germany, and the National Socialist party seized power. The elections of March, held under less than free conditions, confirmed National Socialist power, and gave a semblance of legitimacy to the rapid dismantling of the fragile democratic structure of the Weimar Republic. Freedom of expression had been lost. It goes without saying that a second edition of *Die neue Typographie* was out of the question.[22]

THEMES OF THE BOOK

As its contents page indicates, *Die neue Typographie* is made up of two parts: a historical and theoretical discussion of the "growth and nature" of the movement; and detailed consideration of the "principal typographic categories," with reference to particular examples. These different parts have in common a pedagogic character: this is a "handbook," and Tschichold is bringing knowledge to printers (in the first place) and to anyone who might take a special interest in typographic communication.

The opening pages of the book put forward the social and philosophical grounds for the new typography. The ideas and the language that Tschichold uses here are those that inform modernist texts of the period: the manifestos and proclamations of the various groups and movements, many of which are listed in the book's impressively detailed bibliography (pp. 229–235).[23] Life has changed, it is mechanized, urban, faster; emphasis is now on the social, the collective, rather than the individual; on the impersonal and factual, rather than the romantically indefinite; human liberation can come through the standardization of material artefacts, through

Im VERLAG DES BILDUNGSVERBANDES der Deutschen Buchdrucker,
Berlin SW 61, Dreibundstr. 5, erscheint demnächst:

JAN TSCHICHOLD

Lehrer an der Meisterschule für Deutschlands Buchdrucker in München

DIE NEUE TYPOGRAPHIE

**Handbuch für die gesamte Fachwelt
und die drucksachenverbrauchenden Kreise**

Das Problem der neuen gestaltenden Typographie hat eine lebhafte Diskussion bei allen Beteiligten hervorgerufen. Wir glauben dem Bedürfnis, die aufgeworfenen Fragen ausführlich behandelt zu sehen, zu entsprechen, wenn wir jetzt ein Handbuch der **NEUEN TYPOGRAPHIE** herausbringen.

Es kam dem Verfasser, einem ihrer bekanntesten Vertreter, in diesem Buche zunächst darauf an, den engen Zusammenhang der neuen Typographie mit dem **Gesamtkomplex heutigen Lebens** aufzuzeigen und zu beweisen, daß die neue Typographie ein ebenso notwendiger Ausdruck einer neuen Gesinnung ist wie die neue Baukunst und alles Neue, das mit unserer Zeit anbricht. Diese geschichtliche Notwendigkeit der neuen Typographie belegt weiterhin eine kritische Darstellung der **alten Typographie**. Die Entwicklung der **neuen Malerei**, die für alles Neue unserer Zeit geistig bahnbrechend gewesen ist, wird in einem reich illustrierten Aufsatz des Buches leicht faßlich dargestellt. Ein kurzer Abschnitt „**Zur Geschichte der neuen Typographie**" leitet zu dem wichtigsten Teile des Buches, den **Grundbegriffen der neuen Typographie** über. Diese werden klar herausgeschält, richtige und falsche Beispiele einander gegenübergestellt. Zwei weitere Artikel behandeln „**Photographie und Typographie**" und „**Neue Typographie und Normung**"

Der Hauptwert des Buches für den Praktiker besteht in dem zweiten Teil „**Typographische Hauptformen**" (siehe das nebenstehende Inhaltsverzeichnis). Es fehlte bisher an einem Werke, das wie dieses Buch die schon bei den einfachen Satzaufgaben auftauchenden gestalterischen Fragen in gebührender Ausführlichkeit behandelte. Jeder Teilabschnitt enthält neben **allgemeinen typographischen Regeln** vor allem die Abbildungen aller in Betracht kommenden **Normblätter** des Deutschen Normenausschusses, alle andern (z.B. postalischen) **Vorschriften** und zahlreiche Beispiele, Gegenbeispiele und Schemen.

Für jeden Buchdrucker, insbesondere jeden Akzidenzsetzer, wird „Die neue Typographie" ein **unentbehrliches Handbuch** sein. Von nicht geringerer Bedeutung ist es für Reklamefachleute, Gebrauchsgraphiker, Kaufleute, Photographen, Architekten, Ingenieure und Schriftsteller, also für alle, die mit dem Buchdruck in Berührung kommen.

typ. tschichold

Das Buch enthält über **125 Abbildungen**, von denen etwa ein Viertel **zweifarbig** gedruckt ist, und umfaßt gegen **200 Seiten** auf gutem Kunstdruckpapier. Es erscheint im Format DIN A 5 (148× 210 mm) und ist biegsam in Ganzleinen gebunden.

Preis bei Vorbestellung bis 1. Juni 1928: **5.00** RM
durch den Buchhandel nur zum Preise von **6.50** RM

Bestellschein umstehend ■▶

Publicity leaflet for *Die neue Typographie.*

equality of provision; no longer the artist and the privileged sensibility, but the engineer and the ordinary citizen.

If Tschichold's prose in these opening pages seems excited — especially in the context of a handbook for printers — it is of its time. One could argue that it is actually a few years behind the leading formulations. For example, Tschichold's play with the figure of "the engineer" — which he sets in bold type, at a crucial rhetorical moment (p. 11) — is clearly in the same spirit as Le Corbusier's rhapsodic argument in *Vers une architecture*, first published in book form in 1923:

> Not in pursuit of an architectural idea, but simply guided by the results of calculation (derived from the principles which govern our universe) and the conception of a living organism, the engineers of to-day make use of the primary elements and, by co-ordinating them in accordance with the rules, provoke in us architectural emotions and thus make the work of man ring in unison with universal order.[24]

And this is also the spirit of Tschichold's references to automobiles, telephones, electric light-bulbs, boxers, and other icons of the modern age.

Tschichold's argument here gains particular force and authenticity, because in his publisher (the Bildungsverband) and its readership of printers, he was directly in touch with real "engineers." And for internal evidence of this contact, one could cite the beautiful detail on page 122, where he advises that numbers indicating fold-marks on a letter-heading should be made from brass (rather than the normal predominantly lead alloy), because, standing isolated in the margin of the sheet, they are subject to greater pressure and wear. As already noted, Tschichold treats the artist-designer with considerable disdain. In his account of "the old typography (1450–1914)," the artistic and decorative approach is only excused as perhaps valid in its day. Those who still try to practice such an approach in the modern world — the "book artists," for example — are condemned as out of touch with the new age and are thus mere formalists:

> But the difference between these modern works and their classical models is that the models really are an expression of their time, whereas the imitations are the expression of a highly sensitive eclecticism, which is an attitude foreign to the present day, looking for its ideal in another time and world. (P. 25)

Tschichold's arguments may employ the terms of use, need, and function, but they are deeply and explicitly infused with the idea that form must be created and that it must be the form of the new age. In this he was

absolutely typical as a theorist of modernism. The paradox in the argument lies in the wish for self-effacing, abstract form. A characteristic statement of position might be quoted from a few pages further on:

> Individualistic work, the "line" of the artist, are the exact opposite of what we are trying to achieve. Only anonymity in the elements we use and the application of laws transcending self combined with the giving up of personal vanity (up till now falsely called "personality") in favour of pure design assures the emergence of a general, collective culture which will encompass all expressions of life — including typography. (Pp. 28–29)

The political dimension of this view becomes more evident in the section that deals with "the new art" (pp. 30–51). Borrowing quite frequently from the language of Marxism, as then popularly disseminated, Tschichold discusses the history of art in terms of social class and technical development. (The atmosphere of a workers' education lecture is further recalled by his conscientious footnote translations of foreign terms.) Historical development, as he outlines it, points ineluctably to abstract art (perhaps dissolved into the forms of everyday life, as architecture and industrial design) and to photography and film.

In these passages, the intimate association between modernism in design and socialist politics is clear — or, at least, the connection was clear at that time and in that place. Both strands combined into a single outlook that might typically be termed "progressive." Tschichold was here writing for a trade-union-associated publisher, and his design work at this time included work for socialist — or socially oriented — publishers and other clients.[25]

Tschichold's Marxist rhetoric was made fun of in a review of the book published in *bauhaus,* the journal of the school, which was then (under Hannes Meyer) at its most committed to the socialist-materialist position.[26] After quoting Tschichold's suggestion that borders around the printing area of a large advertisement are "a characteristic expression of the earlier individualistic epoch" (p. 199), the anonymous reviewer remarked that in order to combat individualism one needs to address not just the appearance of advertisements but the very existence of such advertising. In this reviewer's account, Tschichold's book discussed and illustrated only formal matters, and ended up by proposing no more than a new formalism, which its author mistook for a new conception of the world. Whether or not that judgment of Tschichold as a "formalist" was just, there was certainly some point in the objection to his appropriation of the language of political change in the discussion of typographic detail.

THE NEW TYPOGRAPHY

The New Typography — as a term, as a movement — is given some explana-
tion by Tschichold in the first half of this book. As he makes clear, it was a
collective endeavour, which was finding definition step by step. László
Moholy-Nagy's article entitled "Die neue Typographie" — appearing in the
publication that accompanied the Bauhaus exhibition of 1923 — would have
helped to establish the term, as well as formulating its leading ideas at a
relatively early moment. Tschichold cites this text in his outline of the his-
tory of the New Typography (p. 58), but, as his discussion suggests, it was
only one of a series of articles and publications of a movement that was
just then (in 1928) gathering momentum.

One might see Tschichold's book as standing at the point when the New
Typography movement had just taken off, after quite a lengthy journey
along the runways. There was enough work for him to reproduce as illus-
tration in the book, but it was of variable quality, and — we can say now —
there would be work to come that would make many of the things illus-
trated here look "early."

A good indication of the state of this movement is the history of the semi-
formal association of artists and designers working in the spirit of the New
Typography: this was the Ring "neue werbegestalter."[27] Evidently following
the example of the "Ring" of modern architects in Germany (established in
Berlin around 1925), this was a loose group of like-minded practitioners,
instigated and coordinated by Kurt Schwitters. The Ring "neue wer-
begestalter" came into existence towards the end of 1927, and became
publicly evident early in 1928, with nine founding members: Willi
Baumeister, Max Burchartz, Walter Dexel, Cesar Domela, Robert Michel,
Kurt Schwitters, Georg Trump, Jan Tschichold, Friedrich Vordemberge-
Gildewart. (Other members, joining later, included Piet Zwart, Hans
Leistikow, Paul Schuitema.) The Ring can be characterized as a pressure
group for New Typography: it came together in exhibitions of work by mem-
bers and invited guests, discussed and agitated for these and other outlets
for work (for example, an international magazine). In the years of its activ-
ity (1928 to 1931) over twenty exhibitions were held primarily in German
museums, but also in institutions in other countries, including Switzerland
and the Netherlands. If one wants to locate the movement of New
Typography, the Ring was the most convincing real embodiment of it: a
slightly shaky, intermittent affair, largely held together and fuelled by the
enthusiasm of Kurt Schwitters.[28]

The activities of the Ring "neue werbegestalter" were just starting when
Tschichold would have been completing *Die neue Typographie*. In this con-

nection, one could make some observations that may help an understanding of Tschichold and the present book. First, that in this book he had done as much as any writer could to imagine such a movement into existence. One of the best indications of this is the list of addresses on the last page, which seems to say: here are the protagonists, you have seen their work reproduced in these pages, now write to them! And second, the history of the Ring shows that Tschichold played a moderately active part in it, but not a leading one. He was a colleague, on a level with the others. Tschichold's distinction — and *Die neue Typographie* is prime evidence of this — lay in explaining and documenting what the others were doing.

It is worth noting also that the Bauhaus, the institution that has so dominated the history of the modern movement (to the extent of sometimes being taken as synonymous with it), is seen in *Die neue Typographie,* as in all the literature of the period, as just one of the contributing components: one star in a diverse and spreading constellation of institutions and individuals. The Ring "neue werbegestalter" was another star, if a small and erratic one, and it is interesting to observe the rather wary relationship between the Ring and the Bauhaus: as if the former was felt by its members to be in danger of being gobbled up by the latter.[29] In the event, none of the Bauhaus teachers became members of the Ring, and they participated in its exhibitions only as guests. On the question of Tschichold's relations with the Bauhaus: there is no record of any substantial contact. This apparent distance may point to Tschichold's capacity as a professional typographer, teaching at a school for printers, and the lack of typographic and printing-trade expertise at the Bauhaus, even at Dessau in the time of its greatest ideological commitment to designing for industrial production.[30]

DESIGN PRINCIPLES

Although Tschichold himself is clear enough about the principles that inform the New Typography in its approach to designing (see especially "The Principles of the New Typography," pp. 64–86), it may be worth pointing out certain aspects that are assumed or latent within his discussion. First, and as already indicated, it is clear that the New Typography could not, for Tschichold, be a simple matter of aesthetics: this category was always dissolved into a larger and more complex consideration of use and purpose. This is not to say that the New Typography was without an aesthetic or formal dimension: and least of all in the work of Tschichold, which by this time was beginning to display a sure control of subtly chosen and often self-effacing means. In the original edition of *Die neue Typographie,* good evidence for this lies in the material substance of the book itself. The

just-flexible boards of the case-binding were covered in fine-grain black cloth. The corners of the case were rounded. These features might have seemed to encourage its use as a "handbook": it might sit happily in the pocket of a printer's workshop jacket. Or one could consider the "frontispiece" to the book: the page facing the title-page. This is simply a black page. Should one regard this in functional terms — as a device to concentrate the reader's attention on the title-page? Or is it a defiant assertion of abstraction, against the figurative or decorative illustration employed in the old typography? Or could one take it more metaphysically — as a statement of the possibility of maximum ink, an extreme of the book's subject of printing?

A fundamental theme of the book, which tends inevitably to be lost in English translation of German texts of this period, is the charge that the word "Gestalt" and its derivations carried. It means "design," but design in a full and complex sense: the process of giving or finding form. (The full sense of the term is clear in Tschichold's one-sentence summary of his approach, quoted on p. xxxvi below.) The matter is further confused by the fact that the word "design" has since become so widely used, even to the extent, in several languages, of displacing native words for the activity. But here, "design" has nothing to do with decoration and the mere making of patterns. The examples that Tschichold reproduces (pp. 83–85) to illustrate a false understanding of modern design make the point with splendid clarity and finality.

Against such false decoration, Tschichold proposes a way of designing that develops "its visible form out of the function of the text" (pp. 66–67). From this assumption come the principles that distinguish the New Typography, and all branches of modern design: asymmetry, the positive deployment of empty space, the meaningful use of colour, the meaningful exploitation of contrast and a corresponding lack of interest in visual balance. Tschichold's discussion (for example, p. 68) recalls a characteristic modernist theme: asymmetry is a principle of freedom, of adaptability, just as the "free plan" of the modern house is a response to new social habits and desires. These ideas were translated into, or used as support for, the characteristic visual vocabulary of the New Typography. As examples one could cite: the use of axes from which to range text and other elements, and the renunciation of axial symmetry; the use of bold type, perhaps (as in this book) in marked contrast to text set in a light weight of type; acceptance of constraints, perhaps in the form of an underlying grid-structure, as a means of bringing order to the material and also of giving freedom to the producers (the diagrams on pp. 210–211 are a classic demonstration of

xxvi

this point). Finally, one can notice that nowhere in this book or elsewhere in his theory or practice did Tschichold give any sustained attention to the issue of setting continuous text unjustified or ragged (and with equal word-spaces). It was left to others to explore this seemingly logical extension of the principle of asymmetry.[31]

STANDARDIZATION

Norms and standards play a fundamental part in the argument of *Die neue Typographie,* and this may also be the element in the book that now needs most explanation. In the modern movement as a whole, the promise held out by standardization can be briefly summarized: this was a means for bringing order to industrialized societies, for settling some of the fundamental elements of life. Producers, users, and intermediaries would be able to act more freely once these basic factors had been determined. In design, as Tschichold's discussion here recognizes, there were some awkwardnesses and paradoxes. Would not standardization (of paper sizes, or of the layout of business stationery) limit invention and variety? Could standardization embody good design principles?

The standards described in this book are those of the Deutscher Normenausschuss, a body whose history reached back into the nineteenth century.[32] Initially (since 1850) there had been the Verein Deutscher Ingenieure, which formed a committee on standardization (Normalienausschuss der VDI). During the First World War, the need to mobilize industry for maximally efficient production gave a strong impulse to the standards effort. And the conditions of impoverishment and disorganization in Germany, following defeat in that war, only provided further stimulus. In 1917, the VDI's committee had become the Normenausschuss der Deutschen Industrie, which in 1926 had become the Deutscher Normenausschuss. This genealogy suggests one ground for the attraction that standardization held for modernist designers. This really did seem to be the voice of the engineer, issuing in very exact recommendations for the design of artefacts. Standards seemed to embody a collective wisdom, as against the willful arbitrariness of individual expression.

The standards for printed matter that Tschichold mainly refers to were generated from within a particular sector of interest: the rationalization movement in industry and in office-work. Here one can observe a familiar paradox in the modern movement: a system of beliefs that often encompassed revolutionary socialism and (capitalist) theories of business-efficiency.[33] The most vivid precedent here was Lenin's espousal for the Soviet Union of a Taylorist approach to industrial organization. The prime mover behind the

DIN (Deutsche Industrie-Normen) standards for office-work and printing would seem to have been Walter Porstmann, from whose writings Tschichold would have drawn most of his knowledge of the matter. Porstmann had written a doctoral dissertation on measurement systems, and had also worked as an assistant to the scientist Wilhelm Ostwald, among whose varied activities was the proposal for paper-size standardization that Tschichold describes in his outline history of the subject (pp. 96–97).[34] From at least 1917 and through the 1920s, Porstmann was an active participant in the development of the DIN standards that were of importance to printing and typography.

Of the "principal categories" discussed in the second half of the book, the business letter-heading was the most ubiquitous and most fundamental item, and the one most thoroughly affected by standardization. One could also see it as the ground on which business efficiency and design-aesthetics most clearly come together, or confront each other. First, the DIN standard fixed the size of the letter-heading as its A4 format (297 × 210 mm): the size that has become standard throughout the metric world (that is, everywhere except North America). And then, within the sheet, fields were established for the disposition of categories of information, as well as a minimum left-hand margin and positions for fold-marks and punch-holes.

As Tschichold makes clear, he did not think that a DIN standard was any guarantee of design quality. His view of the design of publications issued by the Deutscher Normenausschuss, and the examples that it had designed to illustrate its standards, was that they were "of astonishingly low quality" (p. 112, footnote). Tschichold developed, here and elsewhere in his writings of this time, a set of terms that he deployed to brilliant pedagogic effect.[35] The possibilities form a spectrum from "unstandardized and undesigned" (the example on p. 121), "standardized but undesigned" (p. 123), "unstandardized but designed" (p. 113), through to the most desired state of "standardized and designed" (p. 120). In particular, the contrast between the examples facing each other on pages 120 and 121 shows the order and clarity that Tschichold — more than the other New Typographers — was by then able to achieve.

LETTERFORMS

"Among all the types that are available, the so-called 'Grotesque' (sanserif) . . . is the only one in spiritual accordance with our time" (p. 73). Here, as throughout the book, Tschichold gives his argument the largest world-historical resonance. But, by comparison with his arguments con-

cerning all the other aspects of typography, it does seem that his attitudes to letterforms, and to typefaces in particular, were especially informed by the rationale of the *Zeitgeist* and by larger, not strictly typographic, considerations. In the German-speaking world, more than in other cultures, the style of letterform could be a highly charged issue. A glance at the diagram on page 75 confirms this. In Germany, to set text in some variety of blackletter script was still normal in the 1920s; though, since the reforming movement of the previous few years, it was also on the wane. Tschichold's discussion of the typefaces of current German newspapers (p. 212) is interesting evidence of this state of affairs; so too is his addendum note (p. 233) reporting that the *Berliner Tageblatt* was the first large German newspaper to go over entirely to roman (*Antiqua*) typefaces. One need only consider the subsequent history of letterforms in Germany, during the 1930s and 1940s, to realize that Tschichold's highly charged arguments were of a piece with the raised emotions of his times.[36]

On the question of letterforms, the demands made by German New Typography, as expressed in this book, might be seen in this way: roman as a minimum demand; sanserif (as a special category of "roman") as the preferred choice; and then a reformed orthography and alphabet as the maximum demand (discussed in the next section). Having asserted the appropriateness — the necessity — of sanserif as the letterform of the modern world, Tschichold then makes the realistic qualifications that were always a feature of his writing, even at its most utopian. Thus: currently available sanserifs were not really satisfactory, and the recently designed ones, such as Erbar and Kabel, show the idiosyncrasies of the "artist's typefaces"; Futura, designed by Paul Renner, is better in this respect; but the satisfactory sanserif will probably come only through a process of collective and anonymous design (p. 74). It is interesting to note Tschichold's recommendation of certain anonymously designed (seriffed) roman typefaces. Thus, he mentions Sorbonne, Nordische Antiqua, and Französische Antiqua — all now forgotten and out of use — as to be preferred over other available sanserifs and romans, for setting continuous text. "They are easily legible; they are also above all in a technical sense useful and free from personal idiosyncrasies — in the best sense of the word, uninteresting" (p. 76). This pleasure in the unassuming and the modestly efficient, coupled with a hefty dislike of the self-indulgently "artistic," was a persistent motive throughout Tschichold's career.

As Tschichold explains (p. 75), in choosing a typeface for this book, he was constrained by what the printer had available. One may guess that the

printer (the "Buchdruckwerkstätte GmbH") was simply the printing office of the Bildungsverband.[37] The typeface used was an "Akzidenz Grotesk": a "jobbing sanserif," designed anonymously, probably in the 1900s. For the reasons already outlined, he would have preferred this over any of the recently designed sanserifs, which (in the case of Futura) would hardly have been available for purchase at the time the book was being set. On the evidence of a contemporary catalogue, there could be several possibilities for a more exact identification of the typeface used.[38] But, for the purpose of characterizing Tschichold's preferences, "Akzidenz Grotesk" in a light (as against medium or regular) weight is sufficient description. He remarks (p. 75) that he wanted to show that such a typeface could be easily read in continuous text — against the common assumption that sanserif is less legible or readable here than are seriffed letters. At least one reader complained about this aspect: "This thin typeface — and then printed on shiny art-paper — makes the reading of the book hardly the pleasant exercise that Tschichold assumes it will be."[39] Tschichold was at least aware that readability was a prime issue, if one that was complicated by the other issues with which he was then concerned.

In a later reference to the setting of his own book (p. 227), Tschichold mentions the constraint of having a sufficient quantity of type with which to set a long text: something that could militate against setting a book in sanserif. It is clear that he was then still working in conditions where hand-setting of books was common or even usual: in book printing, at least, if not throughout the industry.[40] In this light, it may not be so surprising that the mechanization of text-setting is not discussed or even mentioned in this book. Here, as elsewhere in architecture and design, modernist theory — which would have preferred machine-setting, as more in tune with the spirit of the age — could only run ahead of the real conditions of production.[41]

ORTHOGRAPHY

For Tschichold, as for some of his visionary artist-designer colleagues, the question of letterforms could not be separated from orthography and a reform of the systems of written and printed language. And, as with letterforms and the debate over black letter, there was a specifically German-language dimension to the matter. He argues for a revised orthography that would be phonetically exact and consistent, and for a single set of letters. The argument is shot through with the rhetoric of modernism: for economy

xxx

of means, consistency, speed of action, greater comprehensibility, and (perhaps implicitly) abolition of hierarchy. It is part of the reform of life, and nothing to do with mere fashion, Tschichold insists (the advertisement from *Vogue* set in lower case, reproduced on page 80, sums up the empty fashionable manner).

In comparison with other language communities, orthographic reform was more of a live issue in the German-language context, in which capital letters were (and still are) conventionally used for the first letter of every noun. So the proposal to abolish capitals would have had greater shock effect in German. As Tschichold points out with some evident pleasure (p. 81), the best source for these radical ideas was a book written, not by a philologist or artist, but by an engineer. This was Walter Porstmann, already introduced here as a principal proponent of paper-size standardization, whose *Sprache und Schrift* was published by the Verein Deutscher Ingenieure in 1920. Porstmann's book is a quite extensive (108 pages, A4 format) compendium of argument and evidence on these themes, put into the narrowly utilitarian typographic dress that was habitual in publications from standardization bodies. As with paper-size standardization, this reform was proposed by Porstmann and the Deutscher Normenausschuss merely on grounds of efficiency and commercial expediency; the argument was then translated into a new sphere of visual and also social-political consciousness by the artist-designers who took it up.

Tschichold's advocacy of lower-case typography (*Kleinschreibung*) and a reformed orthography was first made in his *elementare typographie* manifesto of 1925: "An extraordinary economy would be achieved through the exclusive use of small letters — the elimination of *all* capital letters; a form of writing and setting that is recommended as a new script by all innovators in the field."[42] He then refers to Porstmann's *Sprache und Schrift,* and hints at the need to consider phonetics. The book was in the air at that time. Thus, in a letter to Tschichold in response to *elementare typographie,* El Lissitzky asked: "What sort of book is this *Sprache und Schrift* (Porstmann)? If it is good, can you get it for me, I will send money at once."[43]

Several of the artist-designer New Typographers took up the cause of orthographic reform: El Lissitzky and László Moholy-Nagy had already published generalized proclamations, but now these demands began to be worked into visual form. In 1925, the Bauhaus went "lower case" in its publications and internal communications, as part of a general shift towards a more industrially oriented modernism (summed up in the move from Weimar to Dessau).[44] The three-part statement at the foot of the school's letter-

heading (reproduced here on p. 124) would have given any correspondent the theoretical justification, complete with reference to Porstmann's book. Moholy-Nagy argued for "opto-phonetic" research towards a new script; Herbert Bayer published his essay towards a new alphabet; Joost Schmidt and Josef Albers used the notion of a simplified alphabet in teaching projects. In 1927, Kurt Schwitters — who as a visually conscious "sound-poet" had an obvious interest in the matter — published his "Systemschrift."[45] And in 1930, Tschichold too published an essay towards a reformed script, thus going some way towards fulfilling his own postulation (pp. 83–84) of a truly consistent and "economic" system.[46]

The debate over orthography was not confined to the artist-designers, as can be seen in the pages of *Typographische Mitteilungen,* particularly from around 1928. The issue of August 1929 contained a number of articles on the theme and an editorial affirming support for lower-case typography. One culmination came in 1931. A special issue in May included an editorial, which is unusual in its emphasis on the political aura of lower-case typography (as bringing equality of status to letters). The printers were asked to read the articles carefully, and then to vote on whether they preferred (1) capitals at the start of sentences and for proper names only, (2) complete abolition of capital letters, (3) retention of present German orthography. The August issue reported the result: 53.5 per cent of the 26,876 votes were for the first option, 23.5 per cent for the second, and 23.0 per cent for the third. Around this time the debate over letterforms (black letter or roman) was coming to the fore again, and orthographic reform was pushed aside. Despite the result of this poll, *Typographische Mitteilungen* never adopted the moderate reform of the first option.

PHOTOGRAPHY

"As a consequence of the purity of its appearance and of the mechanical production process, photography is becoming the obvious means of visual representation in our time" (p. 88). Photography was an essential, constituent part of the New Typography, as Tschichold's consideration of it in this book shows. His discussions here makes some defense of photography against the accusation that it cannot be "art" (but, given the modern movement's attack on conventional notions of art, such a defense would be rather beside the point). An issue of more immediate moment was the disapproval of photography within printing, particularly "fine printing" and traditionalist book typography, which were then still devoted to hand-produced means of generating images. Here, Tschichold is unapologetic:

xxxii

"We today have recognized photography as an essential typographic tool of the present. We find its addition to the means of typographic expression an enrichment, and see in photography exactly the factor that distinguishes our typography from everything that went before" (p. 92).

One should point out that there is a distinction to be made between photography used as a means of reproduction in the processes of printing and the printed reproduction of photographic prints. Tschichold's discussion, like many others, blurs the two phenomena. He is essentially concerned with the second — the evident presence of photography in printing — and not with the first phenomenon, which includes fundamental but hardly visible innovations like photolithographic printing and (then still hardly developed) photocomposition of text.

The argument for the photographic image paralleled that for sanserif (equally disliked by traditionalists); and the two elements could then be joined in "typo-photo."[47] This — the conjunction or juxtaposition of text and image — was really the defining method of New Typography in using images, and can be regarded as one of its lasting legacies, now so generally employed as to be unnoticed or called simply "graphic design." But, at this point, the issues surrounding photography were still contested. Through the common ground of typo-photo, New Typography spilled over easily into the parallel "new photography" movement. Thus Tschichold was one of a three-person executive committee for the Deutscher Werkbund's seminal "Film und Foto" exhibition, held in Stuttgart in 1929, and for which he also designed stationery. He was also the designer and joint author, with his friend Franz Roh, of the book that arose from this exhibition, *foto-auge*.[48]

THE NEW BOOK

The last of the "principal categories of typography" to be considered is the book: apparently the stronghold of traditionalists, but also the subject of some recent visionary speculation. Tschichold describes and reproduces examples of work that breaks with conventional procedures of book design. Behind such work lay the hypothesis that the form of the book should adapt to new needs and new patterns of life (more active, more visual, a quicker tempo). Postulations of this kind were in the air then, and have resurfaced in various guises since. Certainly books were then becoming more visual. The integration of pictures with text was becoming technically easier, with developments in lithographic and gravure printing. The "integrated book," with pictures placed beside the text relating to them, would

also have been encouraged by the change of attitudes that New Typography brought about. This meant a disruption of "classical" ideas of separation and balance, towards a view of the book as a usable carrier of information.

Tschichold touches on the social and material context of book production, showing again his deep dislike of bibliophile attitudes (pp. 224, 227). One can add something to his remarks here, and also suggest that "new books" were then being produced in Germany, as well as being postulated in visionary theory. From the mid-1920s a number of book clubs began to publish books that aimed to provide their members with affordable, well-produced, intelligent books, which were broadly progressive or socialist in content.[49] The Bildungsverband's own Büchergilde Gutenberg and the Bücherkreis, which had affiliations with the SPD (the German social-democratic party), were both launched in 1925, and may be mentioned here especially for the typographic quality of their books. Tschichold designed one book for the Büchergilde Gutenberg, the *Fahrten- und Abenteuerbuch* by Colin Ross (reproduced on p. 223, with his annoyed remark about a change in its design), which can be taken as typical of early exercises in New Typography in this medium: headings in bold sanserif type, ranged to the left; photographs as illustration, printed on the same paper as the text (though not on the same pages); page numbers set in bold sanserif, larger in size than the text typeface (an unostentatious ser-iffed type). Later, from around 1930, Tschichold worked (as a freelance) for the Bücherkreis: he was responsible for the design of most of their books, as well as for their leaflets, stationery, and graphic symbol. These books show New Typography developing a subtler approach — headings are now in smaller sizes, there is some integration of pictures with text — and at least one of these books was entirely set in Futura.

Tschichold's realism, in this his most extreme book, is evident on the closing page of its text. His remarks about typefaces for books take into account availability, readability, and content. Finally, qualifying any absolute commitment to the DIN sizes, he suggests that books to be read while held in the hand will have to be put into formats other than these. In a moment of seemingly absurd but delightful precision, he suggests that at least the height of such books could be standardized at 176 mm: in fact the height of the B5 format (see the diagram on the facing page).[50] The tension between the wish to stick to agreed norms and the urge to design for human ease is resolved in this aside: "e.g. 176 mm depth for novels."

AFTER *DIE NEUE TYPOGRAPHIE*

The publication of the book came at a moment when the New Typography movement was consolidating, after a time of discovery and invention; and the book itself would have played some part in the process of growing self-awareness and self-confidence among those involved. Tschichold continued to teach at the Meisterschule at Munich, although evidently restless in this position.[51] He and other New Typographers continued to write and publish, though the difficulty of doing so — in a time of recession, growing unemployment, and political violence — can be seen and felt in the thinning issues of the journals of those years. *Typographische Mitteilungen* is a case in point: its editorial comment increasingly takes on political concerns, so that the "struggle" for the New Typography is indivisible from the political struggle.

Tschichold became, from 1928 and up to the end of his life, a remarkably prolific author of articles about typography in the specialist press: a bibliography lists around 175 such pieces, over almost fifty years.[52] Three further books, or independent titles, on typography by him were published in Germany, before his emigration in 1933. *Eine Stunde Druckgestaltung* appeared in 1930: one might explicate the title as "one hour for most of what you need to know about the subject of designing for print." Tschichold used the occasion to publish perhaps his most compact and compelling statement of the principles of New Typography, as a preface to an anthology of examples, which follows the themes and methods of the second half of the present book.[53] *Schriftschreiben für Setzer* (1931) is a brief (32 pages, landscape A5 format) introduction to letterforms and to the practice of formal writing for printing-compositors. *Typografische Entwurfstechnik* (1932) is another short (24 pages, A4 format) manual, also directed at compositors and typographers. It explains techniques of drawing printing-typefaces on layouts — a topic largely passed over in the literature of practical typography — as well as providing design instruction and useful information on the DIN formats. These works assume and demonstrate the integration of New Typography into the everyday practice of printing: as if the revolutionaries had captured the key centres of control, and it now remained for their ideas to be spread calmly into the lifeblood of the whole system.

Some of the other literature of New Typography from these years should be mentioned, as a reminder that the ideas of the movement emanated from more than one source. Paul Renner's *Mechanisierte Grafik* (1931) makes an

interesting contrast with *Die neue Typographie*. A work of theory, rather than a practical manual, its discussion is consistently general, as if from a level above that of the pointed specificity of Tschichold's writing (even at its most theoretical).[54] While of approximately the same size and number of pages, the design of the two books is markedly different. Although set in a sanserif (his own Futura), Renner's book still feels conservative: text set in quite a large type-size and well leaded, printed on an uncoated cartridge paper, while the pictures are printed on an art-paper section at the end. By comparison, in content and in its own form, *Die neue Typographie* is more severe and more committed to a new vision.

Closer in spirit to Tschichold's book was *Gefesselter Blick* (which might be translated as "captured glance"), a sequence of "25 short monographs" edited by Heinz and Bodo Rasch.[55] This book contains short introductory considerations of "the image" and "letters," followed by its main content of the monographs: a short biography of the designer, a statement (signed with a facsimile signature), and examples of work. Among the twenty-five participants, the Ring "neue werbegestalter" designers were all repre- sented, and the book and an accompanying exhibition in Stuttgart were arranged with the collaboration of the Ring. Tschichold's statement of posi- tion was very brief: "In my graphic design, I attempt to achieve maximum purposefulness [*Zweckmäßigkeit*] and to unite the individual component parts harmonically: to design [*zu gestalten*]." By comparison with *Die neue Typographie,* in which Tschichold is the sole mediator and reporter, *Gefesselter Blick,* in its anthology or group character, is an even clearer indication of New Typography as a movement.

The Bildungsverband der Deutschen Buchdrucker published another hand- book in 1929: *Grundsätzliches zur neuen Typographie* by Philipp Albinus. This short work (52 pages, just smaller than A5 format) points up, by con- trast, the qualities of *Die neue Typographie.* The book includes some ideo- logical references, as well as instruction about design, but Albinus (a printer) was without the formal sensitivity and verbal eloquence that marked Tschichold. The same can be said of the book *Modern Typography and Layout* (1929) by the American printer Douglas McMurtrie: an early, stray treatment of the subject from the English-language world.

TSCHICHOLD'S EMIGRATION

Early in March 1933, Tschichold was taken into "protective custody" by the recently installed National Socialist authorities in Germany.[56] He was included in the crack-down, soon after Hitler's seizure of power, against those termed "cultural bolsheviks" and other opponents of the regime.

There would, for example, have been enough evidence of this "cultural bolshevism" within the pages of *Die neue Typographie,* if the new authorities had chosen to look through its pages. And in his case, as already indicated, perhaps unremarkable socially progressive modernist views had been coloured by a specific affiliation to Slavic culture. Tschichold was held for about six weeks, during which time he was dismissed from his post at the Meisterschule. The conditions of detention were lenient enough for him to design a book-binding for the Insel-Verlag, before being released under a general amnesty of such prisoners. Jan and Edith Tschichold, with their young son, then immediately made plans to emigrate to Switzerland. Tschichold secured a part-time job with the printer and publisher Benno Schwabe at Basel, and some teaching work at the Gewerbeschule there, and moved with his wife and child in July 1933.

Since the late 1920s, Tschichold's typography had begun to show a greater subtlety and sophistication: a development that was continued and accentuated in his first years in Switzerland. The prime document from this period was his book *Typographische Gestaltung,* published in Basel by Schwabe (1935), and in foreign-language editions: Danish, Swedish (both 1937), and Dutch (1938).[57] The book follows the structure of *Die neue Typographie*: a historical review, a statement of the aims of New Typography, and then detailed consideration of the elements of typography, ending with a section on "the new book." But the language is more considered, with much less invocation of the "spirit of the time" and with more emphasis on the details of typographic design. This commitment to details — always present in his work — would have been helped in its development through his experience with the printer-publisher Schwabe, where the work would have encompassed editorial, printing-technical, and design considerations.[58] The shift away from ideological argument can be seen as a response to "the times," which were indeed very bad. The political storms and ruptures had, as one small side effect, destroyed the confidence with which Tschichold could publish lists of like-minded designers in Europe: their addresses had now changed or were uncertain and contact with them had ceased. The New Typography as a "movement" had come to an end.

Tschichold was unusual among emigrés from Germany in the way in which he was (after some years of insecurity) able to settle and integrate into Swiss society: in 1942, he was granted citizen's rights in Basel; and it was remarked that he learned to speak flawless Swiss-German dialect.[59] The trauma of 1933, the slide of world politics towards war, the new context of a politically neutral and culturally more stable society, his growing and eventually almost exclusive concentration on book design: these are among

the factors that can be mentioned in Tschichold's turn to a traditional approach to typography. Another factor that has been mentioned is his contact with the "new traditionalist" typographers in England (Stanley Morison and Oliver Simon, most notably), whom he would have met personally on a visit to London in 1937, when he addressed the Double Crown Club in an after-dinner speech.[60] The change may be dated (on Tschichold's own account) to around 1938: from which time he worked almost exclusively in the symmetrical mode, with typefaces deriving from pre-industrial models (though in versions made for machine composition); and from being a tireless promoter of modernism in typography, he became one of its most acute and sometimes acid critics.[61]

AGAINST THE NEW TYPOGRAPHY

The first published statement of position came in 1946, in a reply to Max Bill, who had made a barely veiled attack on his change of position.[62] Tschichold's argument was notable for its moral and political dimension, especially for its contemplation of the seemingly inevitable loss of human values in industrialized labour. A key passage (set in italics) read:

> Its [the New Typography's] intolerant attitude certainly corresponds in particular to the German inclination to the absolute; its military will-to-order and its claim to sole power correspond to those fearful components of German-ness which unleashed Hitler's rule and the Second World War.[63]

This was uttered in the heat of a polemical exchange, and in the immediate aftermath of the war.

Tschichold maintained this political-philosophical charge against the New Typography for the rest of his life, though later he put it in less intense language. He also came to emphasize a set of more purely typographic objections to modernism in this field. Thus in an exchange with the modernist "Swiss typographers" (as they are now termed) who came to prominence in the late 1950s, he made a number of powerful criticisms of the New Typography (or, more exactly, the typography that it had by then led to in Switzerland).[64] Among these objections were: that it was essentially limited to publicity work and to the subject matter of the modern world, and could not deal with the complexities of book design; that in relying on sanserif, it used an unbeautiful letterform that could not be read easily as continuous text; that the DIN paper-sizes were inappropriate for many purposes, books above all; that it tended to adopt a rigid formalism that failed to articulate the meaning of the text; that it lacked grace.

DIE NEUE TYPOGRAPHIE IN ITS CONTEXT

Tschichold was by this time speaking from vast experience, particularly as a book designer, and in a context — the German-speaking world in the years of the Federal Republic's "economic miracle" — very different from the fresh and uncertain years of Weimar Germany, in which the New Typography had come into existence. The gap between the two moments contains a world war, extraordinary devastation and reconstruction, and, although only thirty years in extent, it covers a profound change in the quality of culture and society. It was perhaps inevitable and understandable that the later Tschichold should have wanted to modify and sometimes forbid the republication of the documents of his New Typography.

In an obvious and fundamental sense, he was still the same author: although his views had changed, he had the same traits of a polemical manner and a passion for detail, the same wish to point out faults, which he did for anyone whom he saw making errors, including his younger self. Although the change of approach surprised contemporaries, the continuities of Tschichold's career may now be seen to outweigh the breaks. Even at the time of its publication, his old teacher at Dresden, Heinrich Wieynck, observed that *Die neue Typographie* was a marker in a development that was not over yet; he wondered if this development could "perhaps in the future restore Johannes to a place of honour."[65] This was a remarkable perception, although false in the sense that the "Johannes" who returned was not the Johannes of Leipzig or Dresden in 1921, but the "Jan" of Basel in the late 1930s (and subsequently). In other words: a typographer who had incorporated the experiences of his times and contexts, and whose work evolved into something fresh. The context of the present edition of *Die neue Typographie* is different from any that its author knew. Equally, the present edition will have an afterlife in contexts that we cannot imagine. But we do know something of the first context of this book, five thousand copies of which were printed and published in Berlin in the summer of 1928.

ACKNOWLEDGMENT

For help with research and in the writing of this introduction, I am grateful for help and advice given by the following people: András Furész, Richard Hollis, James Mosley, and the Resource Collections staff at the Getty Center for the History of Art and the Humanities. An important collection of Tschichold papers is now in the collection of the Getty Center, but became available too late for me to consult for this work. Except where noted, translations from German texts other than the present book are by myself.

A fairly complete edition of Tschichold's writings has been published as *Schriften 1925–1974* (2 vols.; Berlin: Brinkmann & Bose, 1991–92); references to texts reprinted there are given as *"Schriften."*

* Walter Benjamin, *Einbahnstraße* (Berlin: Rowohlt, 1928), p. 7. The translation quoted here is very slightly modified from Edmund Jephcott's in: Walter Benjamin, *One-Way Street and Other Writings* (London: NLB, 1979), p. 45.

1. Except where noted, biographical information on Tschichold is taken from the account written by the subject himself: "Jan Tschichold: Praeceptor Typographiae." This text was first published under the pseudonym "Reminiscor" in *Typographische Monatsblätter*, vol. 91, no. 4 (April 1972), on the occasion of Tschichold's seventieth birthday. It was reprinted as the principal text in the monograph whose content and design he determined, though it appeared after his death: *Leben und Werk des Typographen Jan Tschichold* (Dresden: VEB Verlag der Kunst, 1977; [reset and slightly altered edition] Munich: Saur, 1988; also *Schriften* 2:416–433).

2. *Leben und Werk des Typographen Jan Tschichold*, p. 16 (*Schriften* 2:422). The large claim — perhaps a true one — that Tschichold was the first typographic designer is quite typical of the tone of this anonymous autobiographical Festschrift essay.

3. The book-artist (Emil Rudolf Weiss was a characteristic example) is slightingly referred to also in *Die neue Typographie*. Throughout his career, against figures of that kind, Tschichold worked as the capable professional who knew his job in all its details.

4. "*Er . . . kam aufgewühlt zurück*": he came back all churned up (*Leben und Werk des Typographen Jan Tschichold*, p. 17; *Schriften* 2:423).

5. See Edith Tschichold's contribution to Philipp Luidl, ed., *J.T.* (Munich: Typographische Gesellschaft, 1976), pp. 29–33. Tschichold's first letter to Lissitzky, 19 January 1925 (reproduced in facsimile as a loose insert in this book), explained: "Herr Moholy-Nagy knows me very well and has given me your address. I am the only typographic Constructivist in Leipzig."

6. Edith Tschichold explained the changes in the names of her (then) late husband in her contribution to Luidl, *J.T.* When later "Iwan" proved to be an irritant to the conservative sensibilities of his colleagues and employers at Munich, Tschichold chose "Jan," as the Slav form of "Johannes." In his contribution to the same book, Werner Doede quoted a letter to him from Tschichold: ". . . now 'Jan' instead of 'Ivan,' since Munich! 'Ivan' is impossible here!" (5 June 1926). These changes and their significance were noted at the time by Tschichold's teacher at Dresden, Heinrich Wieynck, in his perceptive review of *Die neue Typographie* in *Gebrauchsgraphik* (see note 16).

7. See, for example, the discussion of the Japanese newspaper in this book (p. 206), with its side-blow against "North American pseudo-culture." Unlike some of the Weimar modernists, Tschichold showed no romantic longings for America.

8. This has been reprinted twice, most accessibly by the printers and publishers H. Schmidt (Munich, 1986). *elementare typographie* was quite long in preparation: at Easter 1925, Tschichold wrote to Imre Kner that publication had been delayed until July (letter dated "Pfingsten 1925" in the Békés County Archive, Gyula, Hungary).

9. Tschichold himself suggested this in a letter to Piet Zwart, 31 August 1927 (Getty Center Archives, Santa Monica: file 850831).

10. See the account by Friedrich Friedl in his introductory text to the 1986 reprint.

11. References in correspondence from this time suggest that relations between Renner and Tschichold were quite distant and difficult. For example, Tschichold advised Piet Zwart to send examples of work to him rather than to Renner, adding "Renner still doesn't know who you are. And he is someone who has changed sides [*ein Überläufer*]" (14 December 1927, Getty Center Archives, Santa Monica: file 850831). Edith Tschichold described Jan Tschichold's years in Munich, including the situation at the Meisterschule, in an interview published in: Deutscher Werkbund, *Die zwanziger Jahre des Deutschen Werkbunds* (Gießen: Anabas, 1982), pp. 183–192.

12. "Jan Tschichold über die neue Typographie" [signed "Neumeyer (München)"], *Typographische Mitteilungen* 24, no. 1 (January 1927): 22. This short précis of Tschichold's lecture suggests that most of the ideas of the book were already formulated by this time.

13. I owe this perception to Hans Schmoller, Tschichold's successor at Penguin Books, who wrote: "Whether he was the perfect teacher may be open to doubt. He rarely wanted to use the Socratic method . . ." (Hans Schmoller, *Two Titans: Mardersteig and Tschichold* [New York: The Typophiles, 1990], p. 26).

14. Letter of 15 August 1927 (Getty Center Archives, Santa Monica: file 850831).

15. The sum is in line, for example, with prices for books published by the Bildungsverband's Büchergilde Gutenberg, which were kept to a minimum level. In these years, there was some public debate over book prices in Germany, reflected in Tschichold's discussion here (pp. 230, 231); see note 48 below.

16. A thorough search has not been attempted, but two interesting reviews are: Heinrich Wieynck, "Die Wandlungen des Johannes," *Gebrauchsgraphik* 5, no. 12 (December 1928): 77–79; an untitled and anonymous review in *bauhaus* 3, no. 2 (1929): 28.

17. See, respectively, the lists in Tschichold's *Eine Stunde Druckgestaltung* (Stuttgart: Wedekind, 1930) and *Schriftschreiben für Setzer* (Frankfurt a.M.: Klimsch, 1931).

18. Letter of 3 February 1929 (Getty Center Archives, Santa Monica: file 850831).

19. Postcard of 28 September 1930 (Getty Center Archives, Santa Monica: file 850831).

20. Letter of 16 February 1932 (Getty Center Archives, Santa Monica: file 850831). In the book's statement of copyright, it is stated that "all rights are reserved by the author, in particular those of translation into other languages, including Russian."

21. Letter of 29 September 1932, in: El Lissitzky, *Proun und Wolkenbügel* (Dresden: VEB Verlag der Kunst, 1977), p. 138.

22. A second edition, described as such on its title page, was published in 1987 by Brinkmann & Bose in Berlin. Apart from its title and imprint pages, it is a facsimile reprint.

23. Several of these texts are available in English translation in: Ulrich Conrads, ed., *Programmes and Manifestoes on 20th-Century Architecture* (London: Lund Humphries, 1970).

24. Quoted from the English translation by Frederick Etchells: Le Corbusier, *Towards a New Architecture* (London: Rodker, 1927), p. 33.

25. Notably as designer for the Bücherkreis book club (from around 1930 to 1933), which was affiliated to the German social-democratic party (SPD). Tschichold's *Leben und Werk* reproduces (illustration section, p. 41) a cover for the magazine *Sportpolitische Rundschau* (1928) that might stand for "left-wing graphic design" of this period; just as would the strikingly similar cover of a KAPD magazine *Proletarier* (1927), which Tschichold reproduces on p. 217 of the present book. (The KAPD was a "left-radical" grouping, which broke away from the main German communist party in 1920.) Tschichold was not the sort of person who joins political parties, but such associations were inevitable for someone of his inclinations — and in 1933 it was equally inevitable that he should have been detained as a "cultural bolshevist."

26. *bauhaus* 3, no. 2 (1929): 28.

27. The most complete documentation of the Ring is provided by a set of four exhibition catalogues published under the title *Typographie kann unter Umständen Kunst sein*. See, in particular: *Ring "neue werbegestalter" 1928–1933: Ein Überblick* (Hannover: Sprengel Museum, 1990); *Ring "neue werbegestalter"; Die Amsterdamer Ausstellung 1931* (Wiesbaden: Landesmuseum Wiesbaden, 1990). The other two catalogues, both published by the Landesmuseum Wiesbaden, document the typographic work of Kurt Schwitters and Friedrich Vordemberge-Gildewart.

28. The flavour of the Ring's activities is conveyed in the typewritten communications that Schwitters circulated. Those received by Piet Zwart are now in the Getty Center Archives, Santa Monica (file 850831), and are transcribed and published in *Ring "neue werbegestalter"; Die Amsterdamer Ausstellung 1931*, pp. 112–116.

29. See the references in Schwitters' circulars, particularly the members' comments quoted in his "Mitteilung 19" (1928): *Ring "neue werbegestalter": Die Amsterdamer Ausstellung 1931*, pp. 115–116.

30. Herbert Bayer was the only "master" at the Bauhaus with a long-term commitment to typography: but — by comparison with Renner, Tschichold, or Trump, at Munich — his work showed little of the calligraphically trained and historically informed typographer's sensitivity to letterforms or to the handling of text.

31. This was one of the issues raised implicitly by Max Bill, whose "über typografie" (see note 62 below) was set unjustified and without word-breaks; in his reply, Tschichold pointed to Eric Gill's earlier use of it and to the fact that machine-composition could handle either mode with the same facility. Another notable explorer of unjustified setting was the Dutch designer Willem Sandberg, from the 1940s onwards.

32. Some account of the German standards bodies is available in an anniversary history: Bruno Holm, ed., *Fünfzig Jahre Deutscher Normenausschuß* (Berlin: Beuth-Vertrieb, 1967).

33. On the history of Taylorism and "Scientific Management," see: Judith A. Merkle, *Management and Ideology* (Berkeley, Los Angeles, London: University of California Press, 1980). Of particular relevance here is Merkle's chapter on "Scientific Management and German rationalization," which outlines the "central role" of the Verein Deutscher Ingenieure in introducing Taylorism into Germany.

34. Walter Portstmann (1886–1959) is at present an obscure figure, but he is referred to in Holm, *Fünfzig Jahre Deutscher Normenausschuß*, and something can be inferred also from the entries under his name in the National Union Catalog published by the Library of Congress, Washington, D.C. Ute Bruning has chased him in notes to two articles: "Zur Typografie Herbert Bayer," in *Herbert Bayer: Das künstlerische Werk 1918–1938* (Berlin: Bauhaus-Archiv, 1982), pp. 118–137: "Die neue plastische Systemschrift," in *"Typographie kann unter Umständen Kunst sein": Kurt Schwitters, Typographie und Werbegestaltung* (Wiesbaden: Landesmuseum Wiesbaden, 1990), pp. 98–107. Ostwald published his views — and his resentment — concerning the development of the German paper-size standard in an autobiography, *Lebenslinien* (Berlin: Klasing, 1926–1927), 3:300–308.

35. See especially his *Eine Stunde Druckgestaltung*, pp. 14–25.

36. While during the 1930s the National Socialists predominantly preferred black letter as the most "German" letterform, the argument was finally settled by Hitler's decree of 1941, which outlawed black letter as "Jewish." Just as the National Socialists eventually opted for neoclassical architecture, so too in typography, roman became the form that fitted the dreams of a world empire. For some detailed discussion, see: Hans Peter Willberg, "Schrift und Typografie im Dritten Reich," in *Hundert Jahre Typographie: Hundert Jahre Typographische Gesellschaft München* (Munich: Typographische Gesellschaft München, 1990), pp. 87–103.

37. They shared the same postal district of Berlin, SW61, and the Buchdruckwerkstätte was also the printer of books published by the Büchergilde Gutenberg (the Bildungsverband's book club), and seems to have moved with the Bildungsverband from Leipzig to Berlin.

38. See the *Handbuch der Schriftarten*, compiled and published by Albrecht Seeman (Leipzig, 1926). Among the samples shown on p. 193, the "Grotesk P, Breite magere" from Berthold closely resembles the typeface of the book — but so do nine others.

39. Wieynck, "Die Wandlungen des Johannes," p. 77.

40. *Typographische Mitteilungen* published regular reports of the number of typesetting machines installed in Germany, taken from the "Jahresbericht der Zentralkommission der Maschinensetzer Deutschlands": these show a steady growth in these years, but the relation to hand-setting remains to be determined.

41. For one instance of modernist consciousness of machine composition, see note 55 below. Seven years later, in his second major book, Tschichold did devote some paragraphs to machine composition (*Typographische Gestaltung* [Basel: Schwabe, 1935], pp. 32–33).

42. *elementare typographie* (= *Typographische Mitteilungen*, vol. 22, no. 10 [October 1925]), p. 198.

43. Letter of 22 October 1925, in Lissitzky, *Proun und Wolkenbügel*, p. 137.

44. Much the best source here is: Gerd Fleischmann, ed., *Bauhaus Typografie* (Düsseldorf: Edition Marzona, 1984). All the Bauhaus material referred to in this paragraph can be found in this compendium.

45. First published in his article "Anregung zur Erlangung einer Systemschrift," *i10* 1, no. 8/9 (August-September 1927): 312–316. See also the article by Ute Bruning (note 34 above).

46. In an article entitled — as if he were conscious of the by then growing list of such experiments — "noch eine neue schrift," published as an insert to *Typographische Mitteilungen,* vol. 27, no. 3 (March 1930).

47. This idea can be seen reflected in contemporary advertising for Futura, as the typeface "for photomontage" (for example, in *Typographische Mitteilungen,* April 1929).

48. Among the literature of the new photography, see: Ute Eskildsen and Jan-Christopher Horak, *Film und Foto der zwanziger Jahre* (Stuttgart: Württembergischer Kunstverein, 1979); David Mellor, ed., *Germany: The New Photography 1927–33* (London: Arts Council of Great Britain, 1978). Roh and Tschichold's *foto-auge* (Stuttgart: Wedekind, 1929) was published in facsimile reprint (London: Thames & Hudson, 1974). Another result of the Roh-Tschichold collaboration was the "Fototek" series, edited by the former, designed by the latter, and published by Klinkhardt & Biermann in Berlin. Only volumes on Moholy-Nagy and Aenne Biermann appeared (in 1930).

49. See: Michael Bühnemann and Thomas Friedrich, "Zur Geschichte der Buchgemeinschaften der Arbeiterbewegung in der Weimarer Republik," in *Wem gehört die Welt* (Berlin: Neue Gesellschaft für Bildende Kunst, 1977), pp. 364–397; Horst Bunke and Hans Stern, *Buchgestaltung für die Literatur der Arbeiterklasse 1918–1933* (Leipzig: Deutsche Bücherei, 1982). The Malik-Verlag has been voluminously celebrated, though it is not of special interest typographically. But see: Jo Hauberg et al., eds., *Der Malik-Verlag 1916–1947: Chronik eines Verlages* (Kiel: Neuer Malik-Verlag, 1986), whose thorough documentation includes (pp. 114–119) articles first published in *Die Weltbühne* in 1928 on the theme of the price of German books ("Ist das Deutsche Buch zu Teuer?").

50. Gerd Fleischmann in a perceptive essay ("'Können Sie sich einen Flieger mit Vollbart vorstellen?'" in *Beiheft: Die neue Typographie* [Berlin: Brinkmann & Bose, 1987], pp. 33–46) also remarks on this "surprising and fascinating" detail (p. 33), but does not notice the derivation from the B5 format.

51. As is clear from his private correspondence of this time (for example in letters to Piet Zwart). There were also premature public announcements that he had taken jobs in Vienna, presumably at the Gesellschafts- und Wirtschaftsmuseum, which he visited briefly then (*Typographische Mitteilungen* 26, no. 9 [September 1929]: 225), and at the Höhere Graphische Fachschule in Berlin (*Typographische Mitteilungen* 30, no. 3 [March 1933]: 92).

52. *Schriften* 2:444–454.

53. "Was ist und was will die Neue Typografie," in *Eine Stunde Druckgestaltung,* pp. 6–8 (*Schriften* 1:86–94); this text was published in translation in French and English magazines, in 1930. Adolf Behne's *Eine Stunde Architektur* (1928) had also been published by Wedekind: suggesting an "Eine Stunde" series.

54. Renner did write a more practical counterpart to this book: *Die Kunst der Typographie* (Berlin: Frenzel & Engelbrecher, 1939; rev. ed., Berlin: Druckhaus Tempelhof, 1948), but by then his already tempered modernism had tempered further.

55. Heinz and Bodo Rasch, *Gefesselter Blick: 25 kurze Monografien und Beiträge über neuer Werbegestaltung* (Stuttgart: Zaugg, 1930). The Rasch brothers worked across the whole range of design disciplines and came to typography with a certain untroubled freshness. Thus in a note on the text of their book (p. 2): ". . . machine composition was used as a matter of principle (nothing but lines of equal length). The lines contain 65–70 characters, in all of the three type sizes that are employed. This is the longest line that, with this typeface, is still comfortably readable."

56. Edith Tschichold described this, in the considerable detail with which traumatic events are remembered, in the interview published in: Deutscher Werkbund, *Die zwanziger Jahre des Deutschen Werkbunds,* especially pp. 188–191.

57. An English-language edition appeared much later (London: Faber & Faber, 1967). It shows the awkwardness that Tschichold found in dealing with his younger self: the book's design (by Tschichold) hesitates between symmetry and asymmetry; warning footnotes are inserted by the older author; the discussion of standard paper-sizes is omitted (although these were then being introduced in Britain); and the title of *Asymmetric Typography* represented a revision of his earlier assumption, implied in the 1935 title, that New Typography was not a special category, but that it provided the obvious central ground for all "typographic design."

58. See the composition rules that he drew up for Benno Schwabe (*Leben und Werk des Typographen Jan Tschichold,* pp. 22–23; *Schriften* 1:202–204). This experience, as well as his

work for the publisher Birkhäuser (from 1941), led on to his celebrated reform at Penguin Books (1947–1949). For an account of the latter, including reproduction of the Penguin composition rules, see Ruari McLean, *Jan Tschichold: Typographer* (London: Lund Humphries, 1975), pp. 86–104.

59. Legislation that deterred the settlement of refugees from the occupied countries was enacted in Switzerland, which tended to be a transit zone for them. See: Helmut F. Pfanner, "The Role of Switzerland for the Refugees," in: Jarrell C. Jackman and Carla M. Borden, eds., *The Muses Flee Hitler* (Washington, D.C.: Smithsonian Institution Press, 1983), pp. 235–248. Max Frisch's reminiscences ("Jan Tschichold als Nachbar") in Luidl, *J.T.,* pp. 81–85, give an impression of the older, Swiss Tschichold.

60. This is one of the suggestions made by G. Willem Ovink in his thorough and perceptive article "Jan Tschichold 1902–74: Versuch zu einer Bilanz seines Schaffens," *Quaerendo* 8, no. 3 (Summer 1978): 187–220.

61. It was around 1937 that Tschichold began to give away or sell his collection of modernist typography, which would have come to him partly through work on books such as *Die neue Typographie.* (Bruno Monguzzi observes this in the course of his meticulous investigation, "Piet Zwart: L'opera tipografica 1923–1933," *Rassegna,* no. 30 [June 1987]: 4–88; see p. 9, note 35.) But if there were emotional reasons for Tschichold to shed this material then, there may have been financial pressures too. Among institutions to acquire such work from him then were the Museum of Modern Art (New York) and the Victoria and Albert Museum (London).

61. Max Bill, "über typografie," *Schweizer Graphische Mitteilungen* 65, no 4 (April 1946): 193–200; Jan Tschichold, "Glaube und Wirklichkeit," *Schweizer Graphische Mitteilungen* 65, no. 6 (June 1946): 233–242; an English translation of Tschichold's text is given, as "Belief and Reality," in McLean, *Jan Tschichold: Typographer,* pp. 131–139. Bill's statement is a manifesto for his own typography, as well as an attack on Tschichold (whom he does not name).

63. Tschichold, "Glaube und Wirklichkeit," p. 234.

64. "Zur Typographie der Gegenwart," *Börsenblatt für den deutschen Buchhandel* 13 (1957): 1487–1490. Tschichold's article appears to have stimulated a special issue of *Typographische Monatsblätter* (vol. 78, no. 6/7 [June/July 1959]), with contributions from most of the leading Swiss typographers of that time, including a point-by-point response by Emil Ruder, which used the title of Tschichold's original article (pp. 363–371).

65. Wieynck, "Die Wandlungen des Johannes," p. 79.

JAN TSCHICHOLD

THE NEW TYPOGRAPHY

A HANDBOOK FOR MODERN DESIGNERS

BERLIN **1928**

PUBLISHER FOR THE EDUCATIONAL ALLIANCE OF GERMAN PRINTERS

CONTENTS

PIET MONDRIAN:
For the man of today there exists only the equilibrium between nature and spirit. At every moment of the past all variations of the old were "new" — but they were not "THE" new. We must never forget that we are now at a turning-point of civilization, at the end of everything old. This parting of the ways is absolute and final.

INTRODUCTION

The appearance of my Special Number of *Typographische Mitteilungen* entitled *elementare typographie* started a lively discussion of the questions raised therein throughout the printing associations and printing-trade journals of Germany. The New Typography, after being violently attacked and often decisively condemned, has now established itself in central Europe. Its manifestations confront modern man at every step. Even its most ardent opponents have eventually had to resign themselves to accepting it.

But much remains to be done. Many still regard the New Typography as essentially a kind of technical-symbolical formalism, which is the exact opposite of what it really is. This attitude is historically understandable: the old typography was formal in concept: it has nothing at all to do with recent attempts to turn the book printer into a commercial graphic artist, which would be foreign to the true nature of his profession.

An explanation of the spiritual principles of the New Typography is therefore an absolute necessity for all who wish to be successful in the field of printing. Merely to copy its external shapes would be to create a new formalism as bad as the old. We must free ourselves completely from the rigid patterns of the past, and training in calligraphy or graphics alone will never achieve this. It will come only from a complete reorientation of the role of typography and a realization of its spiritual relationship with other activities. The laconic brevity of the proclamation of the New has created the need for a fuller account, which it is the purpose of the present volume to provide. The author also felt it important to set down guidelines for the design of the commonest jobbing printing and above all to acquaint printers with the standards of book printing which are every day gaining wider acceptance. No book providing these general guidelines has ever before existed, no doubt owing to the chaotic appearance still presented by typography today. Despite its many illustrations this is not a copybook. It is intended to stimulate the printer and make him aware of himself and the true nature of his work. As with my Special Number *elementare typographie,* a brief leafing-through of its pages will lead only to misunderstandings and new errors. The "form" of the New Typography is also a spiritual expression of our world-view. It is necessary therefore first of all to learn how to understand its principles, if one wishes to judge them correctly or oneself design within their spirit.

The illustrations in this book, with few exceptions examples of practical work, prove that the concepts of the New Typography, in use, allow us for the first time to meet the demands of our age for purity, clarity, fitness for purpose, and totality.

Modern man, whose vision of the world is collective-total, no longer individual-specialist, needs no special reminder of the rightness of being closely aware of such related activities as modern painting and photography. I therefore thought it desirable to say something more about this new way of viewing our world, in which our spiritual conception of the new forms are linked with the whole range of human activity.

Thanks are due to the publishing house of the Educational Association of the German Printing Trade Union, which has already performed a service to the dissemination of contemporary typography by publishing the booklet *elementare typographie* and which far-sightedly and generously has also made possible the publication of this book.

Munich, June 1928. JAN TSCHICHOLD

GROWTH AND NATURE OF THE NEW TYPOGRAPHY

THE NEW WORLD-VIEW

The revolutionary technical discoveries of the late 19th and early 20th centuries have been only slowly followed by man's ability to make use of his new opportunities and develop them into a new pattern of life. "Civilization" and the too-rapid penetration of all classes by these new technical discoveries have led to complete cultural chaos, caused by the failure of the affected generation to draw the right conclusions for a new way of life from the new facts.

The new generation facing this state of affairs is free of the prejudices against the New that obsessed the previous generation. The technical advances in every tool and service used by man have been enthusiastically accepted by the younger generation and have brought about a completely new attitude to their surroundings.

The objects in use by the new generation suffer from the fatal compromise between a supposedly "artistic" intention and the dictates of technical manufacture; from a feeble turning back to historical parallels; from the conflict between essence and appearance. Instead of recognizing and designing for the laws of machine production, the previous generation contented itself with trying anxiously to follow a tradition that was in any case only imaginary. Before them stand the works of today, untainted by the past, primary shapes which identify the aspect of our time: Car Aeroplane Telephone Wireless Factory Neon-advertising New York! These objects, designed without reference to the aesthetics of the past, have been created by a new kind of man: **the engineer!**

The engineer shapes our age. Distinguishing marks of his work: economy, precision, use of pure constructional forms that correspond to the functions of the object. Nothing could be more characteristic of our age than these witnesses to the inventive genius of the engineer, whether one-off items such as: airfield, department store, underground railway; or mass-produced objects like: typewriter, electric light-bulb, motor cycle. They have created a new — our own — attitude to our surroundings. An immense enrichment of our lives comes from the new inventions which confront us at every step. The collective whole already largely determines the material existence of every individual. The individual's identical fundamental needs are met by standardized products: electric light-bulbs, gramophone records, Van Heusen collars, Zeiss bookcases, tinned milk, telephones, office furniture, typewriters, Gillette razors. The standardization and electro-mechanization of the things we use daily will be further increased. Economies in production and use of materials will lead to constant improvements. But electro-mechanization as an end in itself is nonsense: its

true purpose, by satisfying basic needs through mass-produced objects of highest quality, is to make possible for the first time a true and unlimited awakening of all the creative powers of man.

In some fields, standardization, rationalization, and mechanization have made great progress, but in most others almost everything remains to be done. Where no tradition existed, and where therefore there was the least amount of restraint on design, record progress was made, e.g. in Rumpler-Tropfen cars, in giant aircraft, in typewriters. Further rationalization in the manufacture of the parts of these engineering products will allow even more energy to be harnessed that today is going to waste. But in most spheres of human activity, progress towards the shapes expressive of our time is slow indeed. Thus in the field of housing, the projects of Gropius and Le Corbusier have only very recently been recognized, achieving in an unpromising-looking area a high degree of standardization and series-production. The design and construction of homes for people who live the same sort of lives can be planned so as to meet the economic demands of our time for rationalization and standardization.

Modern engineering and standardized machine manufacture have of necessity led to the use of precise geometric forms. The final and purest shape of a product is always built up from geometric forms. The new age has created an entirely new visual world, and has guided us to the primary elements of human expression: geometric shape and pure exact form. Our sympathy for the shapes derived from geometry and science is part of our inborn striving for order, both in things and in events, which is redoubled when we are confronted by chaos. We, who require the utmost purity and truth in our surroundings, arrive everywhere at forms which do not, as previously, deny the necessary elements of their construction, but openly reveal and affirm them. Such shapes must by necessity transcend individualism and nationalism in their appearance. The value of an object is not measured by its origin, but by its approach to perfection of form, the highest and purest design. The creator disappears completely behind his work. People of today regard the arrogant thrusting forward of the man before his work as aesthetically embarrassing. Just as every human being is part of a greater whole, and is conscious of his connection with it, so his work should also be an expression of this general feeling of wholeness. An analogy in the field of sport is the excitement shared by millions in a victory by Tunney over Dempsey. Every new record means, to the individual, a higher achievement in which all have participated; it shows how successfully the dashing new generation is replacing middle-aged stuffiness by movement and action. Contemplative introversion has given way to new realities, the

thrills of active modern life. The theatre, an illusion of life, has lost its draw-
ing power, for life itself has become a play: city street, neon signs, stadium!
A few clear heads, the avant-garde of all nations, are leading the way here.
Their achievements in painting and architecture have led to a new vision
and a new activity in all other fields of human creativity. Their exemplars
were the works of the engineers, expressing purity and clarity in their con-
struction and appearance. "Beauty" is no longer, to us, an end in itself, an
autocratic entity, but a result, an attribute of rightness and fitness in con-
struction. Construction is the basis of all organic and organized form: the
structure and form of a rose are no less logical than the construction of a
racing car — both appeal to us for their ultimate economy and precision.

Thus the striving for purity of form is the common denominator of all endeav-
our that has set itself the aim of rebuilding our life and forms of expression.
In every individual activity we recognize the single way, the goal:

Unity of Life!

So the arbitrary isolation of a part is no longer possible for us — every part
belongs to and harmonizes with the whole. Where slackness is still the rule,
we must make it our work to fight against laziness, envy, and narrow-
mindedness.

Typography too must now make itself part of all the other fields of creativ-
ity. The purpose of this book is to show these connections and explain their
consequences, to state clearly the principles of typography, and to demand
the creation of a contemporary style. The connection between typography
and all other fields of creativity, especially architecture, has been accepted
in all progressive periods. Today we are witnessing the birth of a new and
splendid architecture, which will set its stamp on our period. Anyone who
has recognized the deep underlying similarity between typography and
architecture and has understood the true nature of the new architecture
can no longer doubt that the future will belong to the new typography and
not the old.

And it is impossible for both the old and the new typography to continue to
exist together, as some think they can. The great period of design that is
coming would not be one if the Renaissance style continued to exist beside
the modern, in whatever field, whether of printing or architecture. The
romanticism of the previous generation, however understandable, never
hindered the birth of a new style. Just as it is absurd today to build villas
like Rococo palaces or Gothic castles, so people tomorrow will smile at
those who continue to practise the old typography.

In the battle between the old and the new, it is not a question of creating
a new style for its own sake. But new needs and new contents create new

forms which look utterly unlike the old. And it is just as impossible to argue away these new needs as it is to deny the need for a truly contemporary style of typography.

That is why printers today have a duty to concern themselves with these questions. Some have forged ahead with energy and creative success: for the rest, however, it seems that there is still almost **EVERYTHING**
to do ●

THE OLD TYPOGRAPHY (1440–1914)

The history of typography shows a steady progress from its invention down to about the middle of the last century, but after that it is disturbed by disorganized movements and turned upside down by new technical inventions which decisively affected its course.

The typography of the first period (1440–1850) is limited almost entirely to the book. The few broadsheets and newspapers that were produced were in book formats. The distinctive feature, especially since the beginning of the 16th century, was the typeface. The other parts of the book seem of secondary importance; they are decorative, inessential additions. The basic form of the book varied from time to time but did not change decisively. Gutenberg, who was concerned only to imitate the book of his day — which was handwritten — developed his types out of the contemporary book hand, the gothic minuscule. That type, reserved today for religious and other ceremonial matter, was at that time used for the writing or printing of all, even profane, texts. The inventor also used "textura," the gothic minuscule, for texts of more than day-to-day importance. Beside the gothic minuscule, there was also the gothic cursive (known in France as "Bâtarde") for day-to-day writing, notes, and records, which Schoeffer later took as a basis for the "Schwabacher" type which he was the first to use. Between the invention and the beginning of the 16th century these were the only two letterforms in use. For the purposes of this historical survey we may disregard the variations of gothic and Schwabacher, whose contours were similar to the types of Gutenberg and Schoeffer, as well as the forms of roman type before 1500.

The form of the book as a whole corresponded almost entirely, at this time, with the design of the late gothic handwritten codex. Its wealth of painted, gold-heightened large initials and coloured smaller initials, rubrications, and margin decorations on opening pages was taken over by the printed book. Originally filled in by hand, these decorative additions were soon being cut on wood and printed with the text, and in expensive works afterwards hand-coloured. Text was generally in two columns. Title-pages were asymmetric but not arranged very logically. Centred layouts were hardly ever used and were confined to Italy. Harmony of text, initials, and titling was achieved by strong contrasts of colour, shape, and weight. In this respect gothic books can be compared with the typographical expression of our own day.

Around 1500, the humanistic Renaissance, through the work of Aldus Manutius, its chief exponent, established a completely different visual ideal, the even silver-grey page, whether text, title-page, illustrations, or

15

Page from the facsimile edition of the Gutenberg Bible (Insel-Verlag)

ornaments (*Hypnerotomachia Poliphili*). The type that now came into use was "Antiqua" (roman). (The earlier use of a gothicized roman in Rome, by Sweynheim and Pannartz, was part of the change of style which began earlier in Italy.) The new style originated in Italy about 1450, but did not spread to other countries until considerably later.

A page of the
Hypnerotomachia
Poliphili.
Aldus Manutius,
Venice 1499.

Aldus Manutius was the first to recognize that printed books had a character of their own and were different from manuscripts. Aldus can therefore be seen as the beginner of the new typographic age in book design; Gutenberg by comparison was more the imitator of medieval manuscripts.

In the Renaissance and the Baroque and Rococo periods deriving from it, the types corresponding to the two gothic faces (textura and Schwabacher) were the so-called Medieval-Antiqua (roman) and the cursive (italic) developed by Aldus from a cursive version of the roman.

In Germany at the beginning of the 16th century, Vinzenz Rockner, the emperor Maximilian's private secretary, developed from the textura face a German Renaissance type: fraktur. It is a partially successful attempt, in the context of the Renaissance, to give the clumsy gothic letters some of the fluency and elegance of the new form-world. Just as the latest German Gothic, by-passing the true Renaissance, led to Baroque, indeed almost

German title-page, 1741.
Black and red.

already is Baroque (Tilman Riemenschneider), so the types of the German Renaissance are really baroque. This can be seen in the curly ornamented movements of the main stems, the snouts of the capital letters, indeed in the handwriting of the time (which is still today the official German hand!) with its over-decoration of large initial letters.

In the Baroque and Rococo periods following the Renaissance, fraktur changed very little; not until the end of the 18th century were attempts made to reform it. Fraktur was used almost only in Germany: other countries either never used it, or gave it up after a short time.

Books of the Renaissance, the Baroque, and the Rococo, set in fraktur, all look pretty much alike, and are differentiated from the books set in roman only by their type. The domination of centred setting sometimes gives German books a stronger, more "colourful" appearance because of the nature of fraktur type. Proportions and general style were the same in German and Latin-style books. Title-pages of books set in fraktur often looked garish and clumsy because of the use of too many type sizes and too many lines in red — but this also happened in books set in roman. Not until the end of the 18th century did a lighter look come into both kinds of book, with more leading, less complicated headings, smaller sizes of type, etc.

Towards the end of the 18th century the punch-cutters Didot, Bodoni, Walbaum, and others completed the transformation of the Medieval-Antiqua into the so-called Französische Antiqua. The success of Antiqua (roman) types on the Continent at this time was due not only to their clarity but to the influence of the French Rococo in the so-called culture-countries. Under its influence Peter the Great in Russia at the beginning of the 18th century caused the cyrillic types to be brought closer to the Latin forms. Leading German typecutters already saw the fraktur types as old-fashioned, medieval. The efforts of Unger (Unger-fraktur) and Breitkopf (the so-called Jean-Paul-fraktur) show how concerned the feeling then was to bring the external appearance of fraktur closer to roman. The characteristic quality of the Französische Antiqua types showed itself in their increasing departures from pen forms. If the older romans and their italics show clearly, in their details, their imitation of pen and occasionally chisel strokes, the types of Didot are the archetype of the engraved letter — no corresponding written or chiselled forms exist. The complicated individual movements of the Medieval-Antiqua are replaced by the simpler, more "regular" line of the Didot-Antiqua. The letters convey a much clearer effect, closer to their essential characters. The new "Empire" style, which brought in the Didot types with it, led to a certain typographical revival, a

Not a design by a "book-artist" of the 20th century—but the work of a simple compositor in the 18th century. Also, not an invitation to a garden party but a funeral!

new flowering of typography usually known today in the history of typography as the "classical" period.

Bodoni and Didot, like Aldus, developed their style of book design from their types and typographical material; but the greater clarity and typographic quality of their types enabled them to reach still greater perfection in book typography than that achieved by Manutius.

This last flowering of the typography of the Middle Ages was followed by a period of increasing decline which eventually, in the eighties and nineties of the last century, became quite unbearable. A certain organic development of classicistic typography can, it is true, be traced up to about 1850, at a diminishing rate; from that time on, one untypographic conception follows another. It is often overlooked that one further typeface resulted from the development of the Französische Antiqua — the sanserif. Its origins can be found in the type specimens of the first half of the 19th century. Sanserif is a logical development from Didot. The letters are free of all extra accessories: their essential shapes appear for the first time pure and unadulterated.

20

The invention of lithography influenced the construction of typography: lithographers' strongly decorated lettering and ornaments were copied by the punch-cutters; printers vied with each other in trying to copy the styles of lithography — a totally different process — by typographic means. The artificial linear mannerisms of the seventies, the boxes and borders of the eighties, and the horrible "artistic" printing of the nineties were the last stages of the decline. Hand in hand with this decline in the general appearance of printed matter went the decline in typefaces. The Französische Antiqua and Medieval-Antiqua (popular in the seventies during a vogue for the Renaissance) became insipid, colourless, and formless. Our ordinary roman types in use today originated at this time.

There were several reasons for this general decline. The fact that its origin coincides with the beginnings of the machine age points to its deeper causes. The inventions of lithography and photography, of photolithography

Example of "freie Richtung" ("artistic printing")
From the folder of the "International Graphic Design-Exchange of the German Printing Association" (1889)

and high-speed presses, all accelerated the decline. The tremendous power of these inventions gave contemporaries new opportunities whose possibilities were not grasped as quickly as they occurred, or perhaps were

Example of "freie Richtung" ("artistic printing")
From the folder of the "International Graphic Design-Exchange of the German Printing Association" (1889)

not recognized at all. At the same time, new kinds of publications made possible by the new inventions, such as magazines and newspapers, emphasized the confusion in typographic design. When finally the process line-block was invented, and reproductive wood engraving, then at the highest point of its development, had to give way to it, confusion was complete. This state of affairs in printing was however only parallel with a general cultural collapse.

Germany especially, emerging victorious from the Franco-Prussian war, was flooded with machine-made substitutes for craftsmanship, that suited its megalomania which the victorious end of a war brought with it, and were

enthusiastically taken up — indeed, people were actually proud of this tin-niness. Like the profiteers of our own postwar period, people of that time had lost all sense of what was genuine; like us, they were blinded by the phoney glitter of those horrors.

The whole era is characterized on the one hand by a slavishly and entirely superficial copying of every conceivable old style, and on the other by a ca-priciousness in design without precedent. A town hall, for example, might be built to look like a pseudo-Gothic palace (Munich) or a "Romanesque" villa.

Similar conditions flourished in other countries, though not nearly to the same extent. Sickened by them towards the end of the eighties in England, William Morris took the wrong perspective of fighting against machines and machine-production. Morris visualized the ideal as replacing machine-work by a rebirth of handicraft and a return to earlier times. By his action he interrupted natural development, and became the father of the "Arts and Crafts" movement. He was also the first producer of an artist-designed type, Morris-gothic, well known even in Germany. In it he followed closely a gothic model. With his type he printed books in which everything was made by hand. With this he gave impetus to a movement whose last off-shoots, the German private presses, were for the most part killed only by inflation. As creator of the first artist-designed typeface Morris is the pro-totype of the "book-artist," who first appeared in the history of book pro-duction at about the beginning of the present century, chiefly in Germany.

There is no question that book design in the last decades of the 19th cen-tury had become feeble and insipid. The thoughtless copying of a style, for example the German Renaissance in Munich, did not provide an answer. For this reason, Morris's views were undoubtedly stimulating. It is chiefly thanks to him that "Jugendstil" (Art Nouveau) came into being.

Jugendstil was the first movement to deliberately try to free itself from imi-tation of historic styles. The Arts and Crafts school style of the seventies and eighties had to be defeated; form must emerge purely from purpose, construction, material. The products of such logical creation were to fit harmoniously into the forms of modern life. The search for new forms finally extended from objects of everyday use to the interior as a whole, to archi-tecture, even to a world-view of life. The leaders of this movement were painters, e.g. van de Velde, Eckmann, Behrens, Obrist, and others in Ger-many, Hoffmann in Vienna, and others all over the rest of Europe. The movement as we know collapsed shortly after the turn of the century. A characteristic of the movement was that it tried to give the new feeling for life, as it was then believed to be, a sovereign expression. The heroic

efforts of these pioneers failed — although in many respects their ideas were right — because the true needs of the time could not yet be exactly grasped, and because of the mistaken borrowing of art forms from nature. The main aim was seen too simply as new forms, a new line (van de Velde: La ligne, c'est une force — a line is power), in other words, an aesthetic renewal, a change in outward shape, instead of the construction of objects in obedience to their purpose, their materials, and their methods of manufacture. The ideas of these artists were too much in the future, were by and large imprecise, and because of lack of opportunities at that time could not be realized. After a few years the movement lost itself in a Jugendstil-influenced new Biedermeier, in other words another repetition of an earlier style.

The school of Morris and Jugendstil had a beneficial effect on the quality of this latest imitation-style. Eckmann, an exceptionally able exponent of Jugendstil, who sadly died young, gave the printing trade his Eckmann-type, a kind of combination of fraktur and roman, whose line seems to have been influenced by brush lettering and plant forms. Soon after that, Behrens produced his gothic type for Klingspor. The early Wieynck types — his bold poster-cursive, and Trianon — were typographic expressions of the new Biedermeier. The designing of a book as a whole followed the path of general development from the revolutionary shapes of Jugendstil to the modernized Biedermeier style, and from these step by step by way of the work of such men as Rudolph Koch and Ehmcke to the complete acceptance of the classical style by such personalities as Tiemann and Weiss. The tight, squared-up style of typographic arrangement adopted by Jugendstil was replaced shortly before the war by a fashion for the so-called "free" style of setting, in tune with the general change towards a renewed preference for the classical style. Its most important representative was Carl Ernst Poeschel of Leipzig. Squared-up setting ("Kastensatz") as such was really a new idea, without historical precedent. But it was based too closely on preconceived ideas of form, which nearly always does violence to the contents. The "free" style of setting resulted from a new and extremely thorough study of the last classical period, the early 19th century. The classical types were rediscovered by Carl Ernst Poeschel.• The publisher Insel, with Otto Julius

• Long before the war, Mendelsohn was wrong to say that Jacob Hegner was the father of this rediscovery. No one used older types so exclusively as Hegner, but he did not begin printing until after the war. The return to the classical faces such as Unger-fraktur, Walbaum-Antiqua, Breitkopf-fraktur, dates to around 1911.

Bierbaum, made an important contribution here. Instead of the poor and backward-looking types of the late 19th century, true historical forms were used. The type designers really studied these forms: after the "Sturm und Drang" (wild and violent) shapes of Jugendstil, types gradually became more and more moderate, until they finally reached their high point and culmination in the nearly totally classical forms of Tiemann-Antiqua, Ratio-Latein, Tiemann-gothic, Weiss-Antiqua. Squared-up setting continued in the specimens of the type-foundries, although in a less pronounced form, until the last years before the war. The increasing use of classical types forced the use of a classical form of setting, the so-called "free" style. Highly developed examples in this style can naturally only be distinguished from their models by unimportant details. It must be admitted that a high quality was achieved; a very cultivated taste indeed was needed to produce results which so closely rivalled their models. But the difference between these modern works and their classical models is that the models really are an expression of their time, whereas the imitations are the expression of a highly sensitive eclecticism, which is an attitude foreign to the present day, looking for its ideal in another time and world. In contrast to the imitators of Jugendstil, who though they may not have achieved any final success nevertheless tried to bring all expressions of life in their time into harmony, the Arts and Crafts book-artists, restricting themselves to the book, and possibly book-like journals, became rigid with eclecticism and thus lost all connection with the shapes and appearances of their own time. While the "Empire book" in all respects fitted its period, the "Arts and Crafts" book sought to make itself a pretentious exception. Scarcely any really contemporary solutions of contemporary problems are known. A very well known dictionary, which appeared recently, looks like an encyclopedia of the Rococo. It must be freely admitted that the contents of most books regarded as of high quality at that time almost all consisted of literature from the past, providing themes which must have been inhibiting to contemporary book-designers (the pattern-book of Hans v. Weber, the Tempel classics). Nevertheless it is thanks to the work of the artist–book-designers that the taste for pure typography in books was reawakened, and that today most publishers avoid decoration inside their books. That however is not such an important achievement, since basic form (reine Sachform) is only a mid-point between decorated and designed form — a zero between minus and plus. This more or less decoration-free kind of book, in its outward appearance, owing to its use of historical or would-be historical types, harking back to the past, has since shortly before the war become the norm.

25

But as I pointed out above, books are no longer the only kind of printing. More and ever more important matter appears today in the form of magazines, newspapers, advertising, and so on. Here the above-mentioned artist-designers, because of their one-sided outlook, could not perform. A few of them did, indeed, try to introduce "reforms" in this field without success; and there are still a few artists of that generation who are seriously talking about the reintroduction of the woodblock into newspapers! (That this is a positively atavistic fallacy I need hardly say here. The book-artists of the pre-war period used to proclaim, and still do, that the halftone block [from photographs] does not harmonize with the clear black-and-white of type. Woodcuts, or at least line blocks, must take the place of halftones. In practice this is impossible, because neither woodcuts nor line blocks offer

**Title-page of an 18th-century type specimen.
Brown type on printed tint.**

CARL ERNST POESCHEL:
Title-page of a type specimen.
Black and orange.

anything like the reproductive accuracy needed today and possessed by the halftone, nor can the medieval rate of production of the woodcut remotely compete with modern process block manufacture.)

Apart from negligible exceptions, restricted to literary periodicals, the book-artists were unable to put their theories into practice in the important field of newspapers and magazines. In the great area of advertising they were shut out from the start.

A whole book on its own would be needed to describe all the different characters and theories of the artists of the advertising world before and after the war. Their common fault was that they always made their own per-sonalities or their "handwriting" an effective factor in their work. A factual,

27

impersonal way of thinking was foreign to them. Exceptions, such as Lucian Bernhard's posters, only prove the rule.

These artists too, for example Lucian Bernhard, were not without influence on book design. Some of them have also designed new typefaces, based on recent American designs, which try to imitate random brush strokes (Bernhard-, Lo-, Glass- and similar types).

These various and varied influences make up the picture of today's typography. Type production has gone mad, with its senseless outpouring of new "types"; worse and worse variations of historical or idiosyncratic themes are constantly being drawn, cut, and cast. The two main directions of typography before the war, in "books" and "posters," have now been joined by a third, the "Arts and Crafts" kind, which playfully covers printed matter with all kinds of pretty shapes in the belief that by doing so it achieves a "charming" effect. The closer one looks at these three main tendencies of typography, the more one is aware of hundreds of other lesser and lesser tendencies, all leading in different — and always wrong — directions.

It is essential to realize today that the "forms" we need to express our modern world can never be found in the work of a single personality and its "private" language. Such solutions are impossible because they are based on a false, purely superficial grasp of the nature of form. The domination of a culture by the private design-concepts of a few "prominent" individuals, in other words an artistic dictatorship, cannot be accepted.

We can only acquire a true general culture (for a culture of the few, as has existed up till now, is no culture but a kind of barbarism) if we remember the natural law of general relationship, the indissoluble oneness of all men and peoples, and of all fields of human creativity. Only in degenerate times can "Personality" (opposed to the nameless masses) become the aim of human development.

Printers in the recent past — a period of decadence caused by the final collapse of a culture — had to submit themselves in their work to the whims of a "book-artist's" private style, if they wished to make any sense in the use of his types. As a result of this spiritual restraint, they could not achieve free creativity. To these men today we offer logical, "non-personal" work, using impersonal materials, which alone will make possible a free, impersonal creativity, a logical outcome of truly personal ability and a unified form of life, a "style." Individualistic work, the "line" of the artist, is the exact opposite of what we are trying to achieve. Only anonymity in the elements we use and the application of laws transcending self combined with the giving up of personal vanity (up till now falsely called "personality") in

favour of pure design assures the emergence of a general, collective cul-
ture which will encompass all expressions of life — including typography.
Today the old and decadent, the young and vital, confront one another. The
living man, if he does not side with the old and musty, can support only the
new!

THE NEW ART

In order to fully understand the new typography, it will help to study the most recent developments in painting and photography. For the laws governing typographic design are the same as those discovered by modern painters as governing design in general. The following pages therefore attempt to give in broad outline an account of the recent developments in painting.

In the Gothic period a change took place from frescoes or wall-paintings to movable easel-paintings. Painting at that time still had a social function, it was a form of worship and an expression of the religious philosophy of the times. The decline of religion during the Renaissance brought with it a change in the content of painting. The easel- or altar-painting of the Gothic period had remained basically the same in content as the frescoes: despite certain wealthy burgher-class tendencies it had remained essentially religious. The feudal life of the Renaissance brought with it a freeing of art content from the dictates of the Church. Even though religious subjects were used, they became an expression of a new attitude to life, a mirror for the life of the ruling classes, the feudal lords. The "artist," once a retainer of the Church, was elevated to a higher social sphere. During the Renaissance and the times which followed, he led the life of the great lords, and their ideology was reflected in his paintings.

This was the situation of all painting and "art" until the French Revolution. The period which followed it, in which we are still living, was formed by the new class which rose to power, the middle class, and its ideology. At first,

MANET: In the greenhouse
(Verlag der Photographischen Gesellschaft, Berlin-Charlottenburg 9)

PAUL CÉZANNE: Landscape
(Verlag der Photograph.
Gesellschaft,
Berlin-Charlottenburg 9)

middle-class art copied the art of the feudal classes (Classicism: Ingres). Only around 1830 did it attain a form of expression of its own (the Romantics: Runge, C. D. Friedrich). But whereas until then the subject of painting had been of purely ideological significance, now painting for its own sake became important, and the subject lost more and more of its importance.

The invention of photography in about 1830 had much to do with this development. Its existence made possible the posing of a new problem. Previously, two main factors had influenced painting: the purely painterly one of arranging colours; and the subject, the motive, to which representation was subsidiary. The representative, ideological, and narrative functions of painting were in the 19th century taken over by other areas of activity. The path now to be taken by painting meant a gradual liberation from subject, a progress towards the pure use of colour. This way lay clear after photography had found the means to provide an exact mechanical representation of the material world. For the first time the purely painterly problems could be recognized.

A comparison between a picture by Otto Philipp Runge and a daguerreotype shows that photography could take over from the point which painting

31

SEURAT: Girls posing
(Verlag der Photograph.
Gesellschaft,
Berlin-Charlottenburg 9)

PAUL SIGNAC:
La Rochelle harbour
(Verlag der Photograph.
Gesellschaft,
Berlin-Charlottenburg 9)

had then reached. The individual motives for the new attitudes of the pro-
gressive painters had begun a new stage of development.

The romantic painting of Runge and Caspar David Friedrich was replaced
by the naturalism of Corot and Monet. A close study of nature followed the
earlier generation's romantic transfiguration of subject.

The next phase of development, "Plein-air-ism"• (Manet, Degas), tried to

• plein air (French) = pure light, natural light

32

achieve new effects by the bright light illuminating its subjects. The dark, impure colours of the Middle Ages were replaced by pure, glowing colours. The object painted appeared "in a new light," changed and transformed.

The partly new intentions of painters at this time should not deceive us into thinking that the contents of painting had by then been radically altered, for such was not the case: nor did it happen with the Impressionists* (Cézanne), who gave to light an entirely new strength and power. Their chief preoccupation was with the changes in colour of an object in light and the open air. The object lost its literary significance almost entirely, it became an excuse for painterly creation. Colour became more and more important.

Pointillism** (Seurat, Signac) went further: it broke up the object into single dots of colour, and captured the flickering effect of sunlight. The photographic representation of an object, which more or less clearly distinguishes the romantic painter and the painter of naturalism, is abandoned in favour of a purer colour effect.

Perspective too — the apparent space behind the surface of a painting — disappears more and more. This could be noticed in the paintings of the Impressionists and the Pointillists, but became complete for the first time in the work of the Cubists. Here "background" and picture surface are

* Impression (French) = impression
** point (French) = point

PABLO PICASSO:
Still life
with red wallpaper
(Verlag der Photograph.
Gesellschaft,
Berlin-Charlottenburg 9)

GINO SEVERINI: Restless dancer
(Verlag der Photographischen
Gesellschaft,
Berlin-Charlottenburg 9)

identical: the "subject" even seems to stand out in front of the picture's surface. At the same time the subject was so recklessly deformed and geometrized that the layman could hardly recognize it any more. The transformation applied equally to shape and colour. Cubism* (Gleizes, Léger, Picasso, Feininger) tried for the first time to create a truly visual harmony quite independent of the subject. What was also new in Cubism was the occasional introduction of tin, paper, wood, and other materials as components of painting, which were used just like paint as constructional elements in the design.

As well as Cubism, which was predominantly French, Futurism** in Italy and Expressionism in Germany appeared concurrently before the war. Futurism, in order to achieve a new content, tried to capture movement in painting. Different methods were employed: in some, the object was partially repeated several times (Balla), or by being broken up into individual parts, so that perspective was abolished and the illusion of several simultaneous

* Cubus (Latin) = cube
** futur (French) = future

34

views was given (Severini). Expressionism* also tried to find a new content for art. It is difficult to reduce its various tendencies to a common generalization. In contrast to the greater preoccupation with shape and form of French Cubism or Italian Futurism, Expressionism was more spiritually inclined. It attained a metaphysical transformation of the object, which incidentally was rarely taken from the world of fact. The outstanding exponents of Expressionism were the Germans Paul Klee and Franz Marc.

The decision to break entirely with the subject was not taken by either the

* expression = expression

FRANZ MARC: Two cats. Coloured drawing.

35

Expressionists or the Cubists, or the Futurists, but by the generation which followed on after the war.

Though the war was an interruption to development, it liberated, at the same time, the forces of renewal. The general disillusion at first gave birth to Dadaism.[*] In Germany this took on a political and radical aspect (Grosz, Huelsenbeck, Heartfield); in Switzerland and in France it was more lyrical (Arp, Tzara). It was the prelude to the creation of abstract art.

By its total denial of the past, Dadaism cleared the way for what was to come. This was achieved by fooling the greedy Philistines and their world, and destroying them morally; and the Philistines actually took the cynical fun of the Dadaists for art (which it was never intended to be) and were violently outraged. Dada's uncompromising shapes had a far-reaching influence in almost all fields, particularly in advertising.

The disillusionment which followed the war and whose expression Dadaism was, at least brought with it a clear awareness of the chaos then existing in all creative fields. The extravagant individualism of the pre-war years ended in total negation. In isolated fields came the realization that in all this confusion the only thing that really belonged to the present was the work of the engineers and the technicians, industrial architecture and machines.

So a group of individual painters then attempted to take over from these things the true and mathematical logic of their construction, and make art subject to laws from elementary principles.

Cubism had freed painting from literature and destroyed the subject. The movements which followed denied the subject completely and built a new

[*] The name is arbitrarily derived from dada (French) = little wooden horse.

FRANZ MARC:
Horses
(Verlag der Photograph.
Gesellschaft,
Berlin-Charlottenburg 9)

**W. KANDINSKY: In the balance (Schweres Schweben). Water-colour.
1924** (Neues Museum zu Wiesbaden)

unity in art out of pure forms and colours and conditions governed by laws. The first to follow this path, starting before the war, were the Russians Kandinsky and Malevich. Kandinsky created abstract harmonies out of colours and forms — not the distortions of the Cubists, but with synthetic unities whose effect could be compared to that of music. By discarding physical objects he conquers para-physical space, like Malevich, who set his geometrical planes in space and created an ascetic crystal world (Suprematism).[*] The consistent work of this artist led the picture as a flat representation towards the zero-point, to endless white space. "In his longing for the material, man envelops himself in the flames of abstract idealism and destroys everything that is material in himself, in order to become pure for the reception of the new object. It was here that man closed with composition and went over to construction" (Ulen). In 1919 Malevich turned from painting to architecture.

The Russian El Lissitzky gathered the broken pieces of Suprematism together and extended their resources into stereometric structures. His vision, inspired by the beauty and the extraordinary possibilities of modern science, created a new art structure. He called it, as the existing names "painting" and "sculpture" could no longer be applied, by the new word "Proun" (pronounced pro-un).

[*] supremum (Latin) = the highest, the utmost

K. MALEVICH

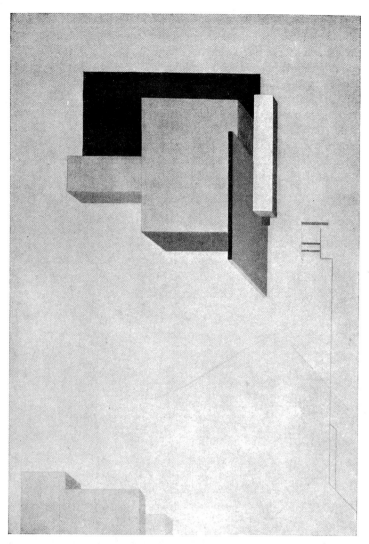

EL LISSITZKY: Proun. 1919.
(Hannover, Provinzial-Museum)

The western counterpart of this art form is the Dutch "Neo-plasticism,"•
represented by Theo van Doesburg and Mondrian. In contrast to the spa-
tially dynamic creations of Suprematism, Mondrian avoids all illusion of
space and restricts himself to the absolute plane. The tensions of his red,
blue, and yellow areas of colour, always at right angles and always
horizontal-vertical, express a solemn and spiritual monumentality. In his
endeavour to avoid every illusion of space and in order to contain the nat-
ural dynamic of the colours, Mondrian encloses them inside black lines. By
this means the impossible becomes possible: red, blue, and yellow really do

• Neoplastizismus = Neue Gestaltung

PIET MONDRIAN:
Rhombic picture
(1926).

appear to be in the same plane. In Russia the first step was taken away from these still purely painterly conceptions towards Constructivism. This movement set itself to give form to the real world (it is wrong to call any kind of movement in painting Constructivism). The construction of a picture out of basic structural forms and relationships depending on laws soon led to the use, instead of the previous illusions created by colour and space, of real materials such as tin, wire, wool, wood, glass, etc. What the Cubists, especially Picasso and Braque, had been trying to do since 1913, to introduce into pictures materials previously considered foreign to them, was now carried to extremes. The start of this movement was characterized by the "Konterrelief" of Tatlin. It was still an artistic experiment, since reality was not yet created by the mere (unnecessary) use of real materials. But these experiments were at least the prelude to a practical exposition of reality. The love of our new material world of machines and apparatus, our technical era, soon led the Constructivists along the right path: Tatlin built a model of his Tower of the Third International, a colossal spiral of glass and iron. The tower was in fact never built, and it was correctly said that its author was still in some ways working from a too freely artistic point of view, and function had been kept too much in the background. That did not however lessen the basic significance of this achievement. It stands at the beginning of a movement that is today having its first public successes. At almost the same time as in Russia, similar experiments were being made in Germany: above all at the Bauhaus in Weimar, founded by Walter Gropius in 1919, which became the focus of all consciously contemporary design work. A Bauhaus was also started in Russia at this time (1918), the "Wchutemas" Institute (the abbreviation for the Russian expression for Higher State Workshops for Art) with the same aims, the coordination of all creative activities in building, where for the first time it would make sense. In both schools the real problems of our time were tackled. By approaching every problem creatively from the start, and developing its form honestly out of function, modern materials, and modern manufacturing methods, models were created for industrial production.

From here on, the development of painting in the last hundred years has contained sense and content, it becomes coherent, no longer a loose chain of apparently conflicting "isms" but a decisive influence on the visual characteristics of our times. Important as is "absolute painting" (by which term we can summarize recent tendencies in abstract art) as a point of departure for both design and architecture, that is by no means the end of its importance.

W. TATLIN: Konterrelief

After the painters themselves had declared war to the death on the "picture on the wall" and sternly rejected it, we have today got a new attitude to this problem: we see it no longer as decoration but as a necessary and functional part of life. We don't hang it on any available wall, but deliberately integrate it with the architecture of our living-rooms. We can no longer be satisfied with mere accurate representation, however perfect: for mankind must always search for something more, for a symbol of his spiritual view of life.

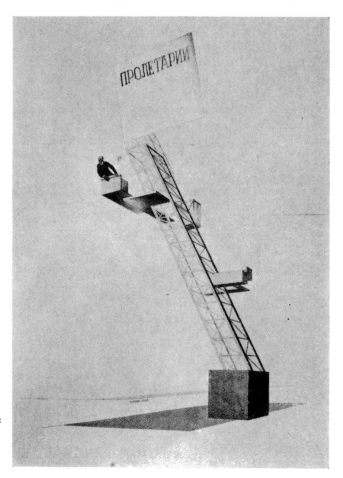

**EL LISSITZKY:
Design for a
speaker's
tribune
(1920)**

That the most powerful contradictions exist between the worlds of today and yesterday is shown most clearly in the relationship between our art and that of the past. Our ways of expression are in complete contradiction to those of the previous generations: how could we see anything in common between our art and that of the epochs of individualism? Art has always been a subtle form of expression of new intellectual focuses. The art of our own time also, however strange it may seem to some, is an expression of ourselves, for it could only have happened in our own time.

The value of the art of the past is not diminished by the art of today: it would be childish to assume a "qualitative" development of art, or to believe that only we had discovered "the" art. But every period that is different from another — and which one is not? — creates a new form of expression peculiar to itself and only to itself. Art is the sum of all these individual utterances. It follows that one must adopt a different attitude towards the art of our time than towards that of earlier epochs. One does not, after all, look at Renaissance art from the same standpoint as Romanesque. The basic premiss of all modern art is that it can no longer be representational. Previously art without a subject (real or imaginary) was unthinkable. Today painting has cast off these chains: it strives to create a

RODCHENKO: Composition with black circle
(Verlag der Photographischen Gesellschaft, Berlin-Charlottenburg 9)

44

LAJOS KASSAK: Relief in wood, paper, and tin

new and elementary harmony from surface, colour, and form and their rela-
tionships which are subject to certain laws. The domination of subject,
which was the distinguishing mark of naturalism, has been replaced in
modern painting by the domination of form and intellect (Hildebrandt). In
the art of today, therefore, one will not see a (possibly distorted) version of
nature but a genuinely new creation, not dependent on nature but an addi-
tion to it, being another kind of nature with its own laws. More than all pre-
vious art, the art of today demands creative will and strength. Its aim is
utmost clarity and purity. It makes use of exact geometric forms and so
achieves an aesthetic paraphrase of our technical-industrial times. Just as
exact geometric forms hardly ever appear in nature, so the colours of the
new painting are not derived from nature either, as they largely were in
earlier painting. The new painting has been developed from its own

45

WALTER
DEXEL:
Glass
picture
(Glasbild)
1925–IV

autonomous laws, which are independent of nature. Is it then surprising that its representations at first baffle the unsophisticated viewer, who is used to something completely different, or even actually repel him? Lazy and hostile people are still trying to make it appear contemptible in the eyes of others, and describe it as nonsense. These are the same people from whose physical attacks Manet's "Olympia" had to be protected by the police, a picture that is today one of the most precious treasures of the Louvre. Their prattling is too empty and unimportant to be taken seriously. We have recognized today that art does not consist in superficially copying nature, but in the creation of form that takes its laws not from the external appearance of nature but from its internal structure. Nature, the engineer, builds her structures with the same economy, technical care, and sureness of deduction as we of today do in our paintings. In our new art we have ended the conflict between "being" and "seeming," for both are identical. The new painting shows clearly what it is: an unrepresentational, pure, painterly harmony.

It appeals above all to the eyes, and rejects the feeble substitutes of emotional appeal through tragedy or joy. These are reserved for the private life of the individual: they are a barrier between him and the picture as a cult form. Here modern painting shows that it has developed out of the collective spirit of the time.

It follows from the total preoccupation of the painters of today with their own times that in the creation of their pictures they prefer to make use of new techniques, such as spraying and enamelling. They are often concerned with making a model picture, i.e. a picture that, according to its technique and form, can be mass-produced. This is another proof of the collective attitude to life, which in this case prefers to do away with the limitation of the single, unique picture. Colour and surface are often no longer enough: various new materials are needed to create form, such as wood, metal, paper, and so on.

It was the American Man Ray who gave us the photogram, in technique and form an entirely new art.

He tried, in the field of photography, the technique that is truly of "today," to create an original art-form that would be independent of nature and governed by its own laws. His photograms, made without camera, and appearing as if by magic on paper that is merely sensitive to light, are as remote from nature as they are in their own way true and exist in their own right. They are the perfect poetry in form of modern man.

That photography offers still other possibilities for art and design is shown by the construction of Co-op, illustrated on this page. And free (i.e. not

applied to purpose) photomontage, photodrawing, and photo-sculpture also belong to the techniques of modern design.

The work begun by Man Ray was brought to completion in pure film, in which the principles of the new art were applied to film-making. Viking Eggeling, Hans Richter, Graf Beaumont, Fernand Léger, Picabia, and Man Ray himself were the pioneers in this field.

MAN RAY: Photogram. From the folder "Champs délicieux."

MAN RAY: Photogram. From the folder "Champs délicieux."

A new kind of art has appeared recently called "Verismus," claiming to be the art of our times. It combines objective representation with the attempt to make a tectonic construction. The phrase "Neue Sachlichkeit" by which it is generally described is unfortunately a rather unhappy choice. Clearly "Reality" has been confused with "Objectivity" or "Realism"; "Sachlichkeit"

49

in painting is the pure creation of colour and form in "absolute" painting, not merely the painting of "Sachen" (real objects). Moreover the paintings of the "New Reality" are often so petty and insignificant that we can hardly recognize them as the expression of modern man.

Not to be compared to this "New Reality," which is all too often basically only the old in new guise, is a new kind of representation of the human

CO-OP: Photo-construction 1926/1

WILLI BAUMEISTER: Drawing
From the book *Willi Baumeister,* Akademischer Verlag, Dr. Fritz Wedekind & Co., Stuttgart.

form, and also of inanimate objects, being attempted by Willi Baumeister and Fernand Léger, showing the way to a new development of the "pure" picture without a loss of its essential character.

The reproductions in this book can unfortunately give only a faint idea of the beauty of modern pictures, which depend so much on colour. Even reproductions in colour are far inferior to the originals.

We can only express the hope here that people will familiarize themselves with modern art by visiting art exhibitions and really experiencing the phenomenon of the New Art.

THE HISTORY OF THE NEW TYPOGRAPHY

After the jumble of styles of the eighties, which affected typography as devastatingly as everything else, and after the reaction of the "Freien Richtung" movement which followed it, the Jugendstil movement at the end of the 19th century was an attempt to give expression to a new philosophy of life. It tried to discard historicism by going back to the forms of nature and creating a contemporary style out of function, construction, material, and methods of manufacture.

In the field of books the most notable work in search of a new style was that of Peter Behrens. Despite their basically correct theories, however, the artists of the Jugendstil did not succeed in creating a truly meaningful style. They placed too great an emphasis on form as a concept in its own right, and failed to recognize its dependence on the factors which really control design, such as demand, purpose, raw materials, and manufacturing methods. Jugendstil did succeed in finding a truly new and original style of decoration to replace historical styles; but a really new attitude towards form, despite countless good starts, was not discovered. Nevertheless, Jugendstil made a great contribution in decisively preparing the way for the new, which after years of reaction would again be recognized.

It must now be observed that in some of the books designed by Peter Behrens he used sanserif as a text face. The Jugendstil movement in Holland, which leads in an unbroken line to Oud, Mondrian, and Doesburg of today, also used sanserif right from the start as their only typeface — at first, sometimes in a very distorted form. In both cases these designers came to sanserif because they were looking for the simplest form of typeface — the "prototype." It was preferred by the Constructivist members of the Jugendstil, while Otto Eckmann, the leading painter in the movement, made a strange but very interesting attempt to combine the forms of fraktur and Antiqua (roman), drawing the shapes of the letters with a brush. Eckmann very greatly influenced book design at that period, but we cannot regard him, as we can Behrens, as the true forerunner of the modern movement in typography. As Jugendstil petered out, since it was unable to realize its vague aims owing to a lack of appropriate tasks, there followed a time in book design of revival of historical styles (initiated by Wieynck's Trianon), although perhaps on a higher plane than before. Its greatest, but final, triumphs were at the Bugra Exhibition of 1914 and the Leipzig International Book Exhibition of 1927.

A solitary gleam of hope came at this time from the Vienna Workshop (founded in the Jugendstil period), which never gave up a search for a contemporary style. I have in my possession a very interesting little booklet

52

from this Workshop, dated 1905, which I set beside the books of Behrens and the Jugendstil typography of Holland as forerunners of our modern typography. It is a small publicity booklet of black card, in the format of a cigarette packet, with a white shield bearing the firm's well-known symbol. Inside, we find, as type, the capitals of the "constructive" so-called Elzevir; a simple border; a double row of quite small black squares; reversed initials on solid, undecorated black squares. In addition there are photographic halftones the width of the type area, made from splendid photographs. Although, as we can see, typography is here still being used in an ornamental way, we can give this booklet great credit for its deliberate avoidance of "period" typography, and its use of simple geometric shapes, photography, and strong contrasts of black and white.

For the same reason I would like to mention the much later type designs and typography of C. O. Czeschka, who also came from the Vienna Workshop. The type named after him, which appeared in about 1912, is the only attempt, among all the artist-designed decorative typefaces of the pre-and postwar periods, to produce a design not from a historical prototype but from the imagination. It is a sanserif, whose rounded terminals appear to form small spirals. The accompanying ornaments, like the types themselves, in their geometric accuracy anticipate our own ways of thinking. Czeschka made no use of photography.

It is to a "non-technician," the Italian poet F. T. Marinetti, the founder of Futurism, that the credit must be given for providing the curtain-raiser for the change-over from ornamental to functional typography.

In his book of poems *Les mots en liberté futuristes*, Milan 1919, he published the following manifesto:

TYPOGRAPHIC REVOLUTION
AND FREE-EXPRESSION ORTHOGRAPHY
Typographic Revolution

I am starting a typographic revolution, directed above all against the idiotic, sick-making conception of the old-fashioned• Poetry Book, with its hand-made paper, its sixteenth-century style, decorated with galleons, Minervas, Apollos, great initials, flourishes, and mythological vegetables, with clasps, mottoes, and Roman numerals. The book must be the futuristic expression of our futuristic thought. Better: my revolution is against among other things the so-called typographic harmony of the page, which is in complete opposition to the flow of

• = earlier (opposite of futuristic)

style which the page allows. We will, if need be, use 3 or 4 different colours and 20 different typefaces on the same page. For example: *Italic* for a series of similar and swift sensations, **Bold** for the imitation of heavy tones, and so on. A new conception of the typographic/painterly page.

Free-Expression Orthography (Orthographe libre expressive)

The historical necessity of Free-Expression Orthography shows itself in the continuous revolutions which have gradually freed the human race from their chains and restrictions.

1. In actual fact the poets used to pour forth their drunken lyricism in a series of rhythmic gasps, with tones and echoes, chimes and rhymes, at pre-planned intervals (traditional prosody). Then they changed with some freedom the breathing-spaces that the lungs of their predecessors had established.

2. The poets later persuaded themselves that the varied moments of their drunken lyricism had to express these peculiar rhythms, of unexpected and completely various lengths, with an absolute freedom of accentuation. So they quite naturally invented free verse (vers libre), but they still kept syntactical• order, so that their lyrical intoxication could pour over their hearers by the logical channels of that conventional period.

3. Today we do not want the lyrical enchantment of words to coincide with syntactical order, before it has been created by our own discoveries. So we have Words in Freedom (Mots en liberté). In addition, our lyrical power must be free to re-form words by abbreviation or lengthening, to strengthen their middle or endings, while the number of their vowels or consonants can be increased or reduced. That is how we will keep the new orthography, which I call Free-Expression Orthography (Orthographe expressive libre). This instinctive remodelling of words expresses our natural love of onomatopoeia. It matters little if the transformed word is ambiguous. It coalesces better with onomatopoeic•• comparisons or sounds, and allows us to reach quickly onomatopoeic-psychic accord, the deep but abstract expression of a discovery or a pure idea.

The illustration on p. 55 shows a poem from the above-mentioned book. The types have not been chosen for formal-aesthetic, decorative reasons;

• Syntax = laws of sentence-making
•• Onomatopoeia = painting in sound, imitating sound

Lettre d'une jolie femme à un monsieur passéiste

F. T. MARINETTI: Poem from *Les mots en liberté futuristes* (Milan 1919)

55

their carefully thought-out optical impact expresses the content of the poem. The types generate a hitherto unknown visual strength. For the first time typography here becomes a functional expression of its content. For the first time also an attempt was made in this book to create "visible-poetry," instead of the old "audible-poetry," to which in any case nobody had listened for a long time. It contained all the audacity of Futurism, which at that time had had an effect like a bomb; but even this effort, the first signal of the new art that was to come, long remained the only one.

The war caused these movements of aggression, the revolution proclaimed by Futurism in its manifestos, to have a far stronger effect, in fact stronger than Futurism itself really wanted. It also brought to an end the old scheme of things and helped to free us a little from the "canker of Professors, Archaeologists, Know-alls, and Antiquarians" on whom the Futurists had declared war.

The young generation to whom the war had given importance, and who were disgusted with the rotten individualistic culture of the pre-war period, threw themselves into the Dada movement as being expressive of their own ideas. The tendency of this movement, deriving from a few anti-war intellectuals who had fled to Switzerland, was negative. Its leaders in Germany published in June 1917 a prospectus *Neue Jugend* (New Youth), which is one of the earliest and most significant documents of the New Typography. We find in it already its most typical characteristics: freedom from traditional styles of composition, strong contrasts in type sizes, design, and colour, type set at all sorts of angles, all kinds of type, and the use of photography. Overheated impotence against the capitalistic war found literary expression in political articles: "Men must be made of india rubber," "Pray with head to the wall," "Work work work work: Triumph of Christian Science," and so on. The external form of the paper reflects the chaos of the period. In France, where some of the Swiss Dadaists were hiding, Dada took on a more lyrical character. It made propaganda for "L'Art abstrait," Abstract Art; it had no political aims. In typography it broke completely with tradition and made uninhibited use of every kind of typographical material which, like the example shown on p. 57, sometimes made a "charade of dynamic values" (Kurtz). This interesting work can only be appreciated in a purely painterly sense: most genuine printers, unaware of its strong painterly qualities, which of course are utterly untypographic, can only view it with incomprehension.

In the period after the war the creators of abstract painting and constructivism worked out the rules for a contemporary style of typography in practical work. The same aim that had led to "absolute" painting — design com-

56

TRISTAN TZARA: Invitation to a Dadaist evening

ing from basic form and proportion — when applied to our field produced the new typography. In Germany it was principally Willi Baumeister, Walter Dexel, Johannes Molzahn, Kurt Schwitters, and a few others who by 1922 had made the New Typography a reality.

Among the important publications of this time I must mention the Dada-publications of George Grosz, Heartfield, Huelsenbeck, and the periodical *Merz*, published by Kurt Schwitters in Hannover, which in its 11th number contained "Theses on Typography." The book *Staatliches Bauhaus 1919 bis 1923* (The Bauhaus 1919 to 1923) contained an article on "The New Typography" by L. Moholy-Nagy, who had in the meantime joined the Bauhaus and who in the following years contributed a great deal to the clarification of typographic questions.

The *A. Z., Anzeigen-Zeitschrift zur pflege wirkungsvoller Insertionsreklame, Reutlingen* in its issue no. 2/3, November-December 1925, published an article on the new typography by Willi Baumeister.•

Walter Dexel expressed his views in detail in the *Frankfurter Zeitung* on 5 February 1927, in an article "What is the new Typography?"

In Holland, Theo van Doesburg's periodical *De Stijl* had already by 1916 published articles on typography and was itself designed in a style completely free of ornament. The postcard illustrated on p. 59 shows clearly the aims of its designer: to produce a pure typographic style using only type, space, and colour. The periodical *Mecano*, published by Doesburg in 1921, was also an example of the New Typography.

Among Russian artists the first name to mention is El Lissitzky, whose work in our field was pre-eminent. With the poet Erenburg in 1922 in Berlin, he published the three-language periodical *Gegenstand*, whose influence was very strong in Russia. Our illustration shows two characteristic pages from it. Another important work of his was Mayakowsky's book of poems *Dlja Gólossa* (For reading aloud), also published in 1923 in Berlin. It was meant to be a book for reading aloud, if the spirit moved one. The little book had a finger-index on its fore-edge, like an index file, showing the titles of the poems. If one wanted to read a poem, one put a finger at the right place in the index and immediately found the poem without having to consult a list of contents (which of course was not included, since it was contained in the index). Each poem is preceded by a title-page containing a typographic

• Mention must also be made of an experiment by the painter Johannes Itten, who in a magazine *Utopia* (Weimar, 1922) produced "Symbolist" typography. He attempted by means of choice of type and arrangement to make the type illustrate the text and give visual expression to its feeling. Admittedly this has nothing to do with the aims of the new typography, but it remains, because of its contemporary significance, a valuable document of the birth of our times.

THEO VAN DOESBURG: Postcard. Black and red on white.

paraphrase of the poem's content. Printers also are inclined, without justification, to reject this sort of thing out of hand. But it should not be forgotten that we are dealing here with a book of poems, whose nature makes this kind of treatment completely suitable. It must be understood that only its general imaginative direction, not its detailed physical form, should be considered a prototype.

In an issue of the magazine *Merz*, El Lissitzky published some remarks on typography which can be quoted here:

TOPOGRAPHY OF TYPOGRAPHY

1. On the printed page words are seen, not heard.
2. Ideas are communicated through conventional words, the concept is designed by means of letters.
3. Economy of expression — visual not phonetic.
4. The spatial arrangement of the book, by means of the type matter and according to the mechanical rules of printing, must express the strains and stresses of the contents.
5. The spatial arrangement of the book by means of process blocks, which embody our new visual concepts. The supernaturalistic reality of the perfected eye.
6. The continuity of page-sequence — the bioscopic book.
7. The new book demands the new writer. Ink-pots and goose-quills are dead.
8. The printed page transcends space and time. The printed page, the infinity of the book, must be transcended. THE ELECTRO-LIBRARY.

Parallel developments occurred in some other European countries, especially in Czechoslovakia, Hungary, Russia, Poland, and most recently in France. Today, artists in all these countries are producing new work in our field:

In BELGIUM: P. L. Flouquet, J. Peeters;

In DENMARK: Torben Hansen, Harald Landt Momberg, and others;

In GERMANY: Willi Baumeister, Herbert Bayer, Max Burchartz, Gert Caden, Walter Dexel, Cesare Domela, Werner Gräff, John Heartfield, Leistikow, Hannes Meyer, Robert Michel, L. Moholy-Nagy, Johannes Molzahn, Peter Röhl, Oskar Schlemmer, Joost Schmidt, Kurt Schwitters, Franz W. Seiwert, Jan Tschichold, Vordemberge-Gildewart, and others;

In FRANCE: Le Corbusier-Saugnier, M. Seuphor, and others;

In HOLLAND: S. v. Ravesteyn, Schuitema, H. N. Werkman, Piet Zwart, and others;

In POLAND: M. Szczuka and others;

EL LISSITZKY: Two pages from the periodical *Gegenstand*. Berlin, 1922.

In RUMANIA: M. Jancu and others;

In RUSSIA: Alexey Gan, Klutzis, El Lissitzky, Rodchenko, Syenykin, G. Stenberg, and others;

In SERBIA: Ljubomir Micić;

In CZECHOSLOVAKIA: Markalous, Zdenek Rossmann, Karel Teige, and others;

In HUNGARY: Kassák, Molnár-Farkas, and others.

Finally the magazine *elementare typographie* (special number of *Typographische Mitteilungen*), produced by the author of the present work in October 1925, did much to spread knowledge of the New Typography in printing-trade circles. After it had been originally criticized in most disparaging terms, and keenly attacked, the success of the New Typography is now assured, and even its most outspoken opponents among the leading trade papers have now to accept its validity — with the exception of the *Schweizer Graphische Mitteilungen*, which still clings blindly to the old worn-out concepts. They try to cover up this change of mind by phrases such as that they are taking the "moderate" point of view (which doesn't exist) and so on. After a series of purely malicious attacks, when they found that they could not make any serious criticisms of the New Typography, they had willy-nilly to accept it. In the worst cases they

EL LISSITZKY (1922–1923):
Two pages (poem titles) from Mayakovsky, Dlya golossa (for reading aloud)

EL LISSITZKY (1922–1923):
Two pages (poem titles) from Mayakovsky, Dlya golossa (for reading aloud)

retreated into a silence that meant acceptance, because they had nothing to say. The outcome of the struggle reveals once more how little weight is carried by opinions of a few dissenting bigots.

It would be naive and short-sighted to think that the New Typography, the result of the collective efforts of a whole generation of artists, is only a temporary fashion. The break with the old typography, made complete by the new movement, means nothing less than the total discarding of decorative concepts and the turn to functional design. This is the fundamental mark of the modern movement; and the New Typography, no less than the new technology, the new architecture, and the new music, is not a mere fashion but the expression of a newly opening epoch of European culture. Its aim, to design every job as completely and consistently as possible with contemporary means, introduces a fresh attitude towards all work; since techniques and requirements are in a state of constant change, fossilized rigidity is unthinkable. This is the starting-point for new developments: these are based not so much on artistic experiments as on the new methods of reproduction which together with social needs created the new requirements.

THE PRINCIPLES OF THE NEW TYPOGRAPHY

Modern man has to absorb every day a mass of printed matter which, whether he has asked for it or not, is delivered through his letter-box or confronts him everywhere out of doors. At first, today's printing differed from that of previous times less in form than in quantity. But as the quantity increased, the "form" also began to change: the speed with which the modern consumer of printing has to absorb it means that the form of printing also must adapt itself to the conditions of modern life. As a rule we no longer read quietly line by line, but glance quickly over the whole, and only if our interest is awakened do we study it in detail.

The old typography both in feeling and in form was adapted to the needs of its readers, who had plenty of time to read line by line in a leisurely manner. For them, function could not yet play any significant role. For this reason the old typography concerned itself less with function than with what was called "beauty" or "art." Problems of formal aesthetics (choice of type, mixture of typefaces and ornament) dominated considerations of form. It is for this reason that the history of typography since Manutius is not so much a development towards clarity of appearance (the only exception being the period of Didot, Bodoni, Baskerville, and Walbaum) as an embodiment of the development of historical typefaces and ornaments.

It was left to our age to achieve a lively focus on the problem of "form" or design. While up to now form was considered as something external, a product of the "artistic imagination" (Haeckel even imputed such "artistic intentions" to nature in his *Art Forms in Nature*), today we have moved considerably closer to the recognition of its essence through the renewed study of nature and more especially to technology (which is only a kind of second nature). Both nature and technology teach us that "form" is not independent, but grows out of function (purpose), out of the materials used (organic or technical), and out of how they are used. This was how the marvellous forms of nature and the equally marvellous forms of technology originated. We can describe the forms of technology as just as "organic" (in an intellectual sense) as those of nature. But as a rule most people see only the superficial forms of technology, they admire their "beauty" — of aeroplanes, cars, or ships — instead of recognizing that their perfection of appearance is due to the precise and economic expression of their function. In the process of giving form, both technology and nature use the same laws of economy, precision, minimum friction, and so on. Technology by its very nature can never be an end in itself, only a means to an end, and can therefore be a part of man's spiritual life only indirectly, while the remaining fields of human creativity rise above the purely functional of technical forms. But they too, following the laws of nature, are drawn towards greater clarity and purity of appearance. Thus architecture discards the ornamental facade and "decorated" furniture and develops its forms from the function of the building — no longer from the outside inwards, as determined by the facade-orientation of pre-wartime days, but from the inside outwards, the natural way. So too typography is liberated from its present superficial and formalistic shapes, and from its so-called "traditional" designs which are long since fossilized. To us, the succession of historic styles, reactions against Jugendstil, are nothing but proof of creative incompetence. It cannot and must not be our wish today to ape the typography of previous centuries, itself conditioned by its own time. Our age, with its very different aims, its often different ways and means and highly developed techniques, must dictate new and different visual forms. Though its significance remains undeniable, to think today that the Gutenberg Bible represents an achievement that can never again be reached is both naive and romantic rubbish. If we want to "prove ourselves worthy" of the clearly significant achievements of the past, we must set our own achievements beside them born out of our own time. They can only become "classic" if they are unhistoric.

The essence of the New Typography is clarity. This puts it into deliberate opposition to the old typography whose aim was "beauty" and whose clarity did not attain the high level we require today. This utmost clarity is necessary today because of the manifold claims for our attention made by the extraordinary amount of print, which demands the greatest economy of expression. The gentle swing of the pendulum between ornamental type, the (superficially understood) "beautiful" appearance, and "adornment" by extraneous additions (ornaments) can never produce the pure form we demand today. Especially the feeble clinging to the bugbear of arranging type on a central axis results in the extreme inflexibility of contemporary typography.

In the old typography, the arrangement of individual units is subordinated to the principle of arranging everything on a central axis. In my historical introduction I have shown that this principle started in the Renaissance and has not yet been abandoned. Its superficiality becomes obvious when we look at Renaissance or Baroque title-pages (see pp. 17, 18). Main units are arbitrarily cut up: for example, logical order, which should be expressed by the use of different type-sizes, is ruthlessly sacrificed to external form. Thus the principal line contains only three-quarters of the title, and the rest of the title, set several sizes smaller, appears in the next line. Such things admittedly do not often happen today, but the rigidity of central-axis setting hardly allows work to be carried out with the degree of logic we now demand. The central axis runs through the whole like an artificial, invisible backbone: its raison d'être is today as pretentious as the tall white collars of Victorian gentlemen. Even in good central-axis composition the contents are subordinated to "beautiful line arrangement." The whole is a "form" which is predetermined and therefore must be inorganic.

We believe it is wrong to arrange a text as if there were some focal point in the centre of a line which would justify such an arrangement. Such points of course do not exist, because we read by starting at one side (Europeans for example read from left to right, the Chinese from top to bottom and right to left). Axial arrangements are illogical because the distance of the stressed, central parts from the beginning and end of the word sequences is not usually equal but constantly varies from line to line.

But not only the preconceived idea of axial arrangement but also all other preconceived ideas — like those of the pseudo-constructivists — are diametrically opposed to the essence of the New Typography. Every piece of typography which originates in a preconceived idea of form, of whatever kind, is wrong. The New Typography is distinguished from the old by the fact that its first objective is to develop its visible form

BAU-AUSSTELLUNG
STUTTGART 1924 E.V.

EINLADUNG
ZUR TEILNAHME AN DER ERÖFFNUNGSFEIER DER
BAUAUSSTELLUNG
STUTTGART 1924
AM SONNTAG, DEN 15. JUNI 1924, MITTAGS 12 UHR
IN DER HALLE DES HAUPTRESTAURANTS DER
AUSSTELLUNG (EINGANG SCHLOSS-STRASSE)

v. JEHLE
PRÄSIDENT DES WÜRTT.
LANDESGEWERBEAMTS

ES WIRD HÖFL. GEBETEN,
DIESE KARTE AM EINGANG
VORZUZEIGEN

WILLI BAUMEISTER: Invitation card. Example of reading-order.

out of the functions of the text. It is essential to give pure and direct
expression to the contents of whatever is printed; just as in the works of
technology and nature, "form" must be created out of function. Only then
can we achieve a typography which expresses the spirit of modern man.
The function of printed text is communication, emphasis (word value), and
the logical sequence of the contents.

Every part of a text relates to every other part by a definite, logical rela-
tionship of emphasis and value, predetermined by content. It is up to the
typographer to express this relationship clearly and visibly, through type
sizes and weight, arrangement of lines, use of colour, photography, etc.

The typographer must take the greatest care to study how his work is read
and ought to be read. It is true that we usually read from top left to bottom
right — but this is not a law. It is shown at its clearest in Willi Baumeister's
invitation card. There is no doubt that we read most printed matter in suc-
cessive steps: first the heading (which need not be the opening word) and
then, if we continue to read the printed matter at all, we read the rest bit
by bit according to its importance. It is therefore quite feasible to start
reading a text at a different point from the top left. The exact place
depends entirely on the kind of printed matter and the text itself. But we
must admit that there are dangers in departing from the main rule of read-

ing from the top to the bottom. One must therefore, in general, not set a following body of text higher than the preceding one — assuming that the arrangement of the text has a logical sequence and order.

Working through a text according to these principles will usually result in a rhythm different from that of former symmetrical typography. Asymmetry is the rhythmic expression of functional design. In addition to being more logical, asymmetry has the advantage that its complete appearance is far more optically effective than symmetry.

Hence the predominance of asymmetry in the New Typography. Not least, the liveliness of asymmetry is also an expression of our own movement and that of modern life; it is a symbol of the changing forms of life in general when asymmetrical movement in typography takes the place of symmetrical repose. This movement must not however degenerate into unrest or chaos. A striving for order can, and must, also be expressed in asymmetrical form. It is the only way to make a better, more natural order possible, as opposed to symmetrical form which does not draw its laws from within itself but from outside.

Furthermore, the principle of asymmetry gives unlimited scope for variation in the New Typography. It also expresses the diversity of modern life, unlike central-axis typography which, apart from variations of typeface (the only exception), does not allow such variety.

While the New Typography allows much greater flexibility in design, it also encourages "standardization" in the construction of units, as in building.

BUCHVERTRIEB
G M B H

»DAS POLITISCHE BUCH«

BERLIN-SCHMARGENDORF

13.12.1926.
B.H./Sch.

Centred layout using lightweight sanserif has no visual effectiveness and reaches a "typographic low" for today (letterhead for a bookshop).

The old typography did the opposite: it recognized only one basic form, the central-axis arrangement, but allowed all possible and impossible construction elements (typefaces, ornaments, etc.).

The need for clarity in communication raises the question of how to achieve clear and unambiguous form.

Above all, a fresh and original intellectual approach is needed, avoiding all standard solutions. If we think clearly and approach each task with a fresh and determined mind, a good solution will usually result.

The most important requirement is to be objective. This however does not mean a way of design in which everything is omitted that used to be tacked on, as in the letterhead "Das politische Buch" shown here. The type is certainly legible and there are no ornaments whatever. But this is not the kind of objectivity we are talking about. A better name for it would be meagerness. Incidentally this letterhead also shows the hollowness of the old principles: without "ornamental" typefaces they do not work.

And yet, it is absolutely necessary to omit everything that is not needed. The old ideas of design must be discarded and new ideas developed. It is obvious that functional design means the abolition of the "ornamentation" that has reigned for centuries.

The use of ornament, in whatever style or quality, comes from an attitude of childish naïvety. It shows a reluctance to use "pure design," a giving-in to a primitive instinct to decorate — which reveals, in the last resort, a fear of *pure* appearance. It is so easy to employ ornament to cover up bad design! The important architect Adolf Loos, one of the first champions of pure form, wrote already in 1898: "The more primitive a people, the more extravagantly they use ornament and decoration. The Indian overloads everything, every boat, every rudder, every arrow, with ornament. To insist on decoration is to put yourself on the same level as an Indian. The Indian in us all must be overcome. The Indian says: This woman is beautiful because she wears golden rings in her nose and her ears. Men of a higher culture say: This woman is beautiful because she does not wear rings in her nose or her ears. To seek beauty in form itself rather than make it dependent on ornament should be the aim of all mankind."

Today we see in a desire for ornament an ignorant tendency which our century must repress. When in earlier periods ornament was used, often in an extravagant degree, it only showed how little the essence of typography, which is communication, was understood.

It must be understood that "ornament" is not only decorated rules and printers' flowers but also includes all combinations of rules. Even the

69

thick/thin rule is an ornament, and must be avoided. (It was used to disguise contrasts, to reduce them to one level. The New Typography, on the other hand, emphasizes contrasts and uses them to create a new unity.)

"Abstract decorations" which some foundries have produced under different names are also ornaments in this sense. Unfortunately many people have thought the essence of the New Typography consists merely in the use of bold rules, circles, and triangles. If these are merely substituted for the old ornaments, nothing is improved. This error is forgivable since, after all, all former typography was oriented towards the ornamental. But that is exactly why the utmost care must be taken to avoid replacing the old floral or other ornamentation with abstract ornaments. Equally the New Typography has absolutely nothing to do with "pictorial" typesetting (Bildsatz) which has become fashionable recently. In almost all its examples it is the opposite of what we are aiming for.

But it is not enough to dispense with ornament in order to create a meaningful form. We have already seen that even the old form that dispenses with ornament is ineffective because it is still based on the effect of ornamental types. The form of the old typography could be taken in at a glance, even though this does not correspond with the reading process. Even if I succeed in recognizing the outline of the type matter I have not really read anything. Reading presupposes eye movement. The New Typography so designs text matter that the eye is led from one word and one group of words to the next. So a logical organization of the text is needed, through the use of different type-sizes, weights, placing in relation to space, colour, etc.

The real meaning of form is made clearer by its opposite. We would not recognize day as day if night did not exist. The ways to achieve contrast are endless: the simplest are large/small, light/dark, horizontal/vertical, square/round, smooth/rough, closed/open, coloured/plain; all offer many possibilities of effective design.

Large differences in weight are better than small. The closer in size different types are to each other, the weaker will be the result. A limit to the number of type sizes used — normally three to not more than five — is always to be recommended. This has the additional advantage of being easier both in designing and in setting. Variations in size should be emphatic: it is always better for the headline to be very large and the remaining text noticeably smaller.

It is vital that all contrasts, for example in type sizes, should be logical. For example, a forename should not have a much larger initial letter if the

70

JAN TSCHICHOLD: Poster 1926, Normformat A

beginning of the principal name is not specially indicated. All form must correspond with meaning and not contradict it.

In asymmetric design, the white background plays an active part in the design. The typical main display of the old typography, the title-page, showed its black type on a white background that played no part in the design (see the reproductions on pp. 20–27). In asymmetric typography, on the other hand, the paper background contributes to a greater or lesser degree to the effect of the whole. The strength of its effect depends on whether it is deliberately emphasized or not; but in asymmetric design it is always a component. The New Typography uses the effectiveness of the former "background" quite deliberately, and considers the blank white spaces on the paper as formal elements just as much as the areas of black type. In this way the New Typography has enriched the art of printing by giving it a new medium of expression. The powerful effect in many examples of the New Typography depends directly on the use of large areas of white: white is always stronger than grey or black. Strong contrasts between white and black, in the form of type or rules, emphasize the white areas and greatly assist the total effect.

A common misunderstanding of what we are about can be seen when the area of white has been decided beforehand and the text compressed into it. It is equally wrong to suppose that areas of white are ever more important than the words of the text.

When the design of a piece of typography is looked at — and all typography has a design, of varying nature and quality — modern typography is distinguished by its formal use of the white and black areas. Of course, logically only the type is important.

The pursuit of greater effectiveness and clarity in the relationship between black and white areas often leads to a noticeable reduction of margins (always prominent in the old typography). In the New Typography margins often almost entirely disappear. Of course type cannot in most cases be set right up to the edge of the paper, which would hinder legibility. In small items of printed matter, 12 to 24 points are the minimum margin required; in posters 48 points. On the other hand, borders of solid red or black can be taken right up to the edge, since unlike type they do not require a white margin to achieve their best effect. Blocks too can be bled off the page provided the trim is accurate.

Colour

In contrast with the old typography, in which colour as well as form was always used decoratively, in the New Typography colour is used function-

ally, i.e. the physiological effect peculiar to each colour is used to increase or decrease the importance of a block of type, a photograph, or whatever. White, for example, has the effect of reflecting light: it shines. Red comes forward, it seems closer to the reader than any other colour, including white. Black on the other hand is the densest colour and seems to retire the furthest. Of the other colours, yellow, for example, is close to red, and blue to black. (We do not accept a "literary" identification of colours, for example red = love, yellow = envy, as not being natural.)

We have today a strong feeling for light, therefore for white, which explains its importance in the New Typography. The liveliness of red corresponds to our own natures, and we prefer it to all other colours. The already strong contrast between black and white can be greatly enhanced by the addition of red. (This is admittedly not a new discovery: but we have perhaps made sharper use of this combination than the earlier typographers, who also much enjoyed using black-red on white, especially in the Gothic and Baroque periods.)

The combination of black-red is of course not the only possibility, as is often mistakenly supposed, but it is often chosen because of its greater intensity. Colour should be used, in general, to help express the purpose of the work: a visiting-card does not require three colours, and a poster generally needs more than just black and white.

Pure red, yellow, and blue, unmixed with black, will generally be preferred, because of their intensity, but other mixed colours need not be excluded.

Type

None of the typefaces to whose basic form some kind of ornament has been added (serifs in roman type, lozenge shapes and curlicues in fraktur) meet our requirements for clarity and purity. Among all the types that are available, the so-called "Grotesque" (sanserif) or "block letter" ("skeleton letters" would be a better name) is the only one in spiritual accordance with our time.

To proclaim sanserif as the typeface of our time is not a question of being fashionable, it really does express the same tendencies to be seen in our architecture. It will not be long before not only the "art" typefaces, as they are sometimes called today, but also the classical typefaces, disappear, as completely as the contorted furniture of the eighties.

There is no doubt that the sanserif types available today are not yet wholly satisfactory as all-purpose faces. The essential characteristics of this type have not been fully worked out: the lower-case letters especially are still too like their "humanistic" counterparts. Most of them, in particular the

newest designs such as Erbar and Kabel, are inferior to the old anonymous sanserifs, and have modifications which place them basically in line with the rest of the "art" faces. As bread-and-butter faces they are less good than the old sans faces. Paul Renner's Futura makes a significant step in the right direction.

But all the attempts up to now to produce a type for our time are merely "improvements" on the previous sanserifs: they are all still too artistic, too artificial, in the old sense, to fulfil what we need today.

Personally I believe that no single designer can produce the typeface we need, which must be free from all personal characteristics: it will be the work of a group, among whom I think there must be an engineer.

For the time being it seems to me that the jobbing sanserifs, like those from Bauer & Co. in Stuttgart, are the most suitable for use today, because of their functionalism and quiet line. Less good is Venus and its copies, owing to the bad design of caps E and F and the lower-case t with its ugly slanted crossbar. In third place, when nothing better is available, come the "painterly" (malerischen) block letters (light and bold, etc.) with their seemingly gnawed-off edges and rounded finials. Of the roman types, the bold romans (the Aldine, and bold Egyptians), with their exact drawing, are best, as far as types for emphasis are required.

The essential limitation of this restricted range of typefaces does not mean that printers who have no or too few sanserif faces cannot produce good contemporary typography while using other faces. But it must be laid down that sanserif is absolutely and always better. I am aware that to lay down the law like this will offend the romantic predilections of a large part of the printing trade and the public for the old "decorative" faces. These old types can however from time to time find a new use in modern typography: for fun, for example in order to make a typographical parody of the "good old days"; or as an eye-catcher — for example by using a bold fraktur B in the middle of sanserif — just as the pompous uniforms of Victorian generals and admirals have been degraded for flunkeys and fancy dress. Whoever is so attached to fraktur — this sixteenth-century clerk's type — that he cannot let go of it, should also not do violence to it by using it in modern typography where it can never be comfortable. Fraktur, like gothic and Schwabacher, has so little to do with us that it must be totally excluded as a basic type for contemporary work.

The emphatically national, exclusivist character of fraktur — but also of the equivalent national scripts of other peoples, for example of the Russians or the Chinese — contradicts present-day transnational bonds between peo-

Fraktur
Schwabacher **Gotisch**
Griechisch
Cyrillisch
(= Russisch und Bulgarisch)
Türkisch (= Arabisch)
Chinesisch (= Japanisch)
Indisch
Schriften der Exoten
(Zulukaffern, Papuas usw.)

=NATIONALISMUS

ple and forces their inevitable elimination.[*] To keep to these types is retrograde. Roman type is the international typeface of the future. These important changes must come, since they express the actual spirit of our age and are required by the technical forms of the present and indeed the future.

As undesirable as fraktur are those roman types with extraordinary forms, such as script and decorated, like Eckmann and others. The details of these faces distract from the meaning and thus contradict the essence of typography, which is never an end in itself. Their use for parody, in the sense described above, of course remains legitimate.

As a bread-and-butter type today's sanserifs are only partially suited. A bolder face is out of the question because continuous reading matter in bold sanserif is not easy to read. I find the best face in use today is the so-called ordinary jobbing sanserif, which is quiet and easy to read. In using it for this book I wanted to show how readable it is; but I still have certain reservations. However it is preferable to all the romans. (In the particular choice of type for this book I was limited to what the printer held.)

The main reason why sanserif is so seldom used today for normal text setting is that in general there is not enough of it available. So for much printed matter and books like the present one, entirely set in sanserif, it

[*] There are movements in Russia, Turkey, and China today to do away with nationalistic typefaces and replace them with roman. In Germany, on the contrary, railway-station lettering in roman is being replaced by gothic — which for foreigners is virtually unreadable!

will remain the exception. In such cases the text face will be a good roman, and sanserif will be reserved for emphasis.

Even more than the historic typefaces, the "artists'" typefaces are disturbing because of their strongly individual character, which is in direct opposition to the spirit of our age and makes them unsuitable for properly designed printing today. No period was so preoccupied with individualism as that from the beginning of the present century up to the outbreak of war. The "artists'" types of this period reached their lowest point. None are in any way better than their predecessors, which are preferable for their superior quality.

Nevertheless the classic faces like Walbaum, Didot, Bodoni, etc. cannot serve as bread-and-butter types today. In terms of their conception they possess romantic associations, they divert the reader's attention into certain emotional and intellectual spheres and clearly belong to a past with which we have no connection. A natural development – not a forced one – would hardly have brought them back again.

To my mind, looking at the modern romans, it is the unpretentious works of the anonymous type-designers that have best served the spirit of their age: Sorbonne, Nordische Antiqua, Französische Antiqua, and so on. These three typefaces and their derivatives are the best designs from the pre-war period.• They are easily legible; they are also above all in a technical sense useful and free from personal idiosyncrasies – in the best sense of the word, uninteresting. They can therefore be used everywhere, when a roman type has to be used because no appropriate sanserif is available.

On the expressiveness of type

Those who claim that sanserif is the typeface of our own age are often told that it does not express anything.

Do other typefaces express anything? Is it really a typeface's job to express spiritual matters?

Yes and no. The widely held belief that every typeface has some "spiritual" content is certainly not true of either gothic type (textura) or sanserif. The enormous number of typefaces available today, which express only an absence of creativity and are the result of the feebly eclectic nature of the pre-war period, may lead to the erroneous conclusion that gothic type

• In the postwar period, the type foundries repeated their old mistakes in an even worse form; their daily "best sellers" have not the slightest importance for the future.

expresses peace, solemnity and religion, and italic, on the contrary, expresses cheerfulness and joy. However, all the innumerable things that can be expressed in writing, of *whatever kind,* at any time, are set down in one — or at most two — kinds of lettering or type. Yes, the character of gothic is religious and solemn, that of rococo (as far as the wealthy class is concerned) is light-hearted, but the typography of those times, even when expressing something contrary to the "zeitgeist," is always logical and stylistically consistent. In the Gothic period even profane texts were set in textura, and in the Rococo period an invitation to a funeral looks in no way different from any light-hearted printed matter of the same period (cf. illustration on p. 20).

All lettering, especially type, is first and foremost an expression of its own time, just as every man is a symbol of his time. What textura and also rococo type express is not religiosity, but the Gothic, not cheerfulness, but the Rococo; and what sanserif expresses is not lack of feeling but the twentieth century! There is no personal expression of the designer, nor was it ever his aim, except in the first years of our century. The different kinds of type get their character from the different ideas of form in every age. Every punch-cutter wished to create the best possible typeface. If Didot did something different from Fleischmann, it was because times had changed, not because he wanted to produce something "special," "personal," or "unique." The conception of what a good typeface should look like had simply changed.

The eclectic nature of the pre-war period led people to play with typefaces of every period, thus revealing their own artistic poverty. A book about the Thirty Years' War had to be set in a different face from Mörike's poems or an industrial catalogue. But St Augustine was set in textura, not in uncial!

All printed matter of whatever kind that is created today must bear the hallmark of our age, and should not imitate printed matter of the past. This applies not only to the typeface but of course to every element of the manufacture: the illustrations, the binding, etc. Earlier periods, unlike us ever conscious of themselves, always denied the past, often very crudely; that can be seen in the building of cathedrals, in the general development of culture, and in typography. The punch-cutter Unger, creator of Unger-fraktur (c. 1800) and a famous typographer, declared that Schwabacher was an ugly type and introduced letter-spacing for emphasis in fraktur (previously, Schwabacher had been used for emphasis in fraktur). He was absolutely right. His age, the Rococo, found that gothic, and its ways of expression, including Schwabacher, were out of harmony with their own

times, and hence ugly: Unger was merely its mouthpiece in our field of typography.

An art historian may prize the good qualities of the old Schwabacher type, and we too can see that it was an excellent face of its period, but we must not use it today, it is totally unsuitable for the 20th century. So are all the other historical typefaces.

Like everyone else, we too must look for a typeface expressive of our own age. Our age is characterized by an all-out search for clarity and truth, for purity of appearance. So the problem of what typeface to use is necessarily different from what it was in previous times. We require from type plainness, clarity, the rejection of everything that is superfluous. That leads us to a geometric construction of form. In sanserif we find a type that comes very close to these requirements, so it must become the basis for all future work to create the typeface of our age. The character of an age cannot be expressed only in rich and ornamental forms. The simple geometric forms of sanserif express something too: clarity and concentration on essentials, and so the essence of our time. To express this is important. But it is not important to create special types for advertising perfume manufacturers and fashion shops, or for lyrical outpourings by poets. It was never the task of punch-cutters of the past to create a type for a single kind of expression. The best typefaces are those which can be used for all purposes, and the bad ones those which can be used only for visiting-cards or hymn books.

A good letter is one that expresses itself, or rather "speaks," with the utmost distinctiveness and clarity. And a good typeface has no purpose beyond being of the highest clarity.

Sanserif, looked at in detail, is admittedly capable of improvement, but there is no doubt that it is the basic form from which the typeface of the future will grow.

Other individual expressive possibilities of type have nothing to do with typography. They are in contradiction to its very nature. They hinder direct and totally clear communication, which must always be the first purpose of typography.

Orthography as at present or all in lower case?

In roman type and its simpler form, sanserif, we possess faces that have been made out of not one but two alphabets. This combination took place in the 15th century. The one alphabet, the capitals, known as majuscules, was made by the old Romans as a form shaped by the chisel, at the beginning of our era. The other alphabet, the small or lower-case letters, called

minuscules, dates from the time of the emperor Charlemagne, about A.D. 800; the so-called Carolingian minuscule, a written letter made with a pen, with ascenders and descenders. This script too was originally complete in itself. The concept of "capital letters" was foreign to it. It was during the Renaissance that these two forms of letter, the roman capitals and the Carolingian minuscules, were combined to make one alphabet, the "Antiqua" or "roman." This is the explanation of the dichotomy, especially noticeable in German, between the capitals and the smaller letters. It is much less noticeable in other languages, especially French and English, because they use capital letters much less often than in German. Settings in roman type in English always look better than in German because they employ fewer accents and in particular do not use capitals for the first letters of nouns.

For a long time now there have been efforts to abolish the use of capital initial letters for nouns and make German writing conform with the international style. This signalling of nouns with capitals started in the Baroque period and seems to us now no longer useful. The rules governing our use of capitals make teaching at school more difficult and also present problems in later life because of the many exceptions. Jakob Grimm, one of the founders of German studies, advocated its abolition already a hundred years ago, and referred to the Old and Middle High German literature in which capitals were used only for proper names and beginnings of sentences. Following him, capitals have been used by Germanic scholars only in this way.

The aesthetic critic finds this mixture of two such differently designed faces unpleasing. For this reason many artists prefer to use capitals only, to avoid mixing them with lower case. In France recently there have been many examples of the independent use of lower case only (see the advertisement on this page) — mainly in fashion publicity and the announcements in fashion-shop windows. Besides the exclusive use of lower case for text can be seen the use of capitals alone for headings — and vice-versa, capitals for text and lower case for headings. From this one can see that it is now recognized that the two alphabets of roman are really two different styles, and should be used in parallel, but not mixed.

The New Typography does not accept either of these alternatives to the previous system — adjustment to the international writing method, or division of roman type into capitals and lower case and regarding them as separate alphabets, even if this is against current opinion. It accepts neither the view of the Germanists nor that of the artists following the eclectic

Advertisement from the French fashion magazine *Vogue*.
All words are set in lower case.

French fashion. The New Typography demands *economy in type design.* To redesign our letters completely — as in shorthand and lettering for the blind — would be quite impractical and unacceptable. So we have to make do with the type we have, the capitals and the lower case. To decide which to choose is not difficult, because capitals in continuous text are too difficult to read. Lower-case letters are far easier to read, because of the ascenders and descenders which make complete words easier to recognize.

A completely one-type system, using lower case only, would be of great advantage to the national economy: it would entail savings and simplifications in many areas; and would also result in great savings of spiritual and intellectual energy at present wasted: we can mention here the teaching of writing and orthography, a great simplification in typewriters and typing technique, a relief for memory, type design, type-cutting, type-casting, and all composition methods — and so on.

At the same time as economic advantages, the use of minuscule would give us a stylistically faultless letter, so scientific advantage would be combined with aesthetic.

80

So there cannot be any change in orthography if it means abandoning the concept of capitals and lower case. We can go on using the small letters, only the use of capitals is discontinued. (A subsequent continuance of capitals in some special kinds of writing could be considered.)

But whether roman and also modern sanserif lower case can continue to express the opinions and claims of the present is open to doubt. Their form has always too much of writing and too little of type, and the efforts of the future will be directed towards suppressing their written character and bringing them closer to true print form.

German orthography if it is to be truly contemporary must see changes, which will undoubtedly influence typeface design. Above all we must lose the burden of too much heavy philology in linguistics, and provide ourselves with self-explanatory signs for sch, ch, dg, drop the unnecessary letters (z, q, c) and aim at the rule "Write as you speak!" and its counterpart "Speak as you write!" On this basis a new and more practical orthography could be achieved, without which literature cannot succeed.

Of course such a revolution in orthography and type will not happen in a day, but its time will assuredly come. Whether consciously or unconsciously, cultural developments take place and men change with them. The typeface of the future will not come from a single person but from a group of people.

It is significant that one of the best new books on speech, type, and orthography has been written not by an architect or a philologist but by an engineer: *Sprache und Schrift* (Speech and writing) by Dr W. Porstmann. Anyone interested in these problems will find this essential reading.

At the same time, while the New Typography regards the removal of capitals as desirable, it is not an absolute demand. But it lies, like a more logical design for our orthography, in our path: an unmistakable design for typography that is in harmony with the desires and demands of our time.

Mistakes often met

In the beginning, many saw a new formalism in the New Typography; that is, they adopted some of its most obvious features — circles, triangles, rules — as geometrical features and used them as if they were the old kinds of ornament. The "elementary ornaments" (itself a contradiction in terms) brought out by some foundries under various names further helped to spread this misunderstanding. These basic geometric forms which we like to use must however be functional: they must emphasize words or paragraphs or be justified by the formal harmony of the whole. But instead of

this we still find truly childish, pseudo-constructive shapes, which are totally contradictory to the spirit of the New Typography.

The newspaper advertisement shown here is a typical example of pseudo-constructivism, found all too commonly. Its form is not natural but comes from an idea before it was set. The advertisement is no longer typography but painting with letters, it turns good typography into borrowed, misunderstood, and thoughtless shapes.

A similar example is in the two-colour business announcement on this page. Again, a previously conceived and meaningless shape is used, which has no connection with the text or its logical arrangement and in fact conflicts with it. Another serious fault is the lack of contrast in colour, which emphasizes the bland and boring look of the whole.

The magazine cover on the facing page is an even worse example. It attemps to be "technical" but contradicts the whole nature of what actually

JAN TSCHICHOLD: Typographic poster for a concert. Red and black on silver.

is technical. Here we see the mixing-in of that "art" against which we are fighting — an artificiality which neglects truth and merely makes a "pretty shape" which fails to express the purpose of the design. Imagination must be used on the basis of actual purpose, if truth in design is to be achieved. (In painting it is different: no restrictions are laid down, because the work does not have a fixed purpose.)

One also often finds the use of historical typefaces (Schwabacher, gothic, fraktur) in the manner of contemporary typography. But it is wrong to use these historical forms in this way — they are foreign to our time and should be used only in a manner suitable to their own age. Can you imagine an airline pilot with a beard? The juxtaposition of positive and negative (reversed black to white) type, first introduced by commercial artists, can also be found in purely typographic work. There is no objection to this if it is based on logic (an important part of a word can be emphasized in this way) — but that is not often the case. A word is often broken for purely formal reasons. This is not a sign of the New Typography. Independent negative lines can of course be beautiful and are usually very effective.

Equally, setting in which blocks of text are arranged alternately on the left and right of an imaginary vertical line usually has a forced and unsatisfactory effect. The resulting uneven spacing and the violence of the block-shapes are merely unpleasing repetitions of old mistakes.

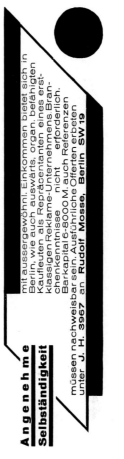

An example of pseudo-modern typography.
The compositor has the idea of a prefabricated foreign shape and forces the words into it. But typographic form must be organic, it must evolve from the nature of the text.

Wrong!

It looks functional but when examined more closely we find it is superficial and does not express the text. In the middle, it is very difficult to find where to go on reading. Certain forms of abstract painting, understood only superficially, have been used in this piece, but typography is not painting!

<div style="text-align:center">

J. HERRMANN JUNIOR
MÜNCHEN · SCHILLERSTRASSE 34 · 35 · TEL 55428 · 54386
SCHAUFENSTER- U LADENEINRICHTUNGEN

</div>

EW. HOCHWOHLGEBOREN

Wenn Ihre Entwürfe für Innenarchitektur geschäft-
licher Art ausgeführt werden sollen, wird Ihnen die
Zusammenarbeit mit einer leistungsfähigen Firma
erwünscht sein, die besondere Erfahrung auf diesem
Spezialgebiet hat und die peinlich bemüht ist, auf
alle Ihre Wünsche und Ideen genau einzugehen ●
Unsere seit dem Jahre 1886 bestehende Firma fa-
briziert in ihrer modern eingerichteten Möbelfabrik
in erster Linie alle Arten von LADEN- UND ■ für Geschäfte aller Art, Mode- u.
Sie hat durch jahrelange SCHAUFENSTER- Kaufhäuser, Konditoreien, Fein-
Praxis wertvolle technische EINRICHTUNGEN kosthandlungen u. Gaststätten
Erfahrungen gesammelt und kann mit zahlreichen
Einteilungsmustern für Spezialschränke u. -Tische,
für Stellagen und Warenaufbauten aufwarten. Wir
bitten Sie deshalb, sich bei der Ausführung Ihrer
Arbeiten mit uns in Verbindung zu setzen oder un-
sere Firma zu empfehlen und sind mit Vergnügen
bereit, Ihnen in diesem Falle besondere Vergün-
stigungen einzuräumen. Kostenvoranschläge und
beste Referenzen jederzeit gerne zu Diensten.

Mit vorzüglicher Hochachtung

J. HERRMANN JUNIOR

But no one will hold the New Typography responsible for all the mistakes made under its name. The value of the work of printers striving to create the typographical expression of our time cannot be lessened by failures always inherent in any new movement.

Wrong!
The word "Revue" is hard to read because of the complicated type: and the abstract forms are used thoughtlessly, purely for decoration, including the crossed thick-thin rules. The white paper background plays no part in the design. The whole shows a complete misunderstanding of the aims of the New Typography—which does not arrange decorative forms, but designs—that is, it resolves the given text, which itself must show the simplest forms, into a harmonious whole.

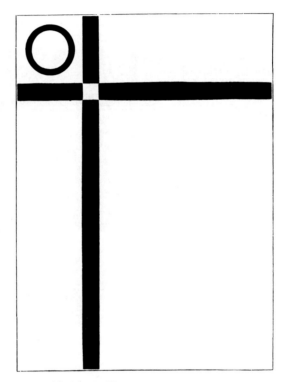

Away with Scheme F!

An ornamental scheme much loved in would-be contemporary typography. A square is often found instead of the circle shown at the top. It is considered especially beautiful if the square is not in the same weight as the "conventional" bold rules but is in thick/thin or some other "more interesting" variety of rule. How subtle is the blank magic square where the rules cross!

This schematic form has nothing to do with designed typography!

PHOTOGRAPHY AND TYPOGRAPHY

The artistic value of photography has been argued about ever since it was invented. First it was the painters, until they realized that it presented no threat to them. To this day, the art historians argue about some of the problems which photography has thrown up. Book craftsmen still deny photography the right to form any part of a "beautiful book." They base their objection on the alleged aesthetic dichotomy between the purely graphic and material form of type and the more visibly "plastic" but materially weaker halftone block. They see the greatest importance in the outer appearance of both printing surfaces, and find the halftone block not "bookish." Their objection is really not valid, since the halftone block is composed of many little raised dots, to which type is in fact related.

All these theories, however, especially after the war, have been unable to stop the unique triumphal progress of photography into book production. Its greatest purely practical advantage is that by a simple mechanical method — certainly easier than any manual method — a true reproduction of an object can be obtained. The photograph has become such a remarkable characteristic of our age that it is now impossible to imagine its non-existence. The picture-hunger of modern man is satisfied today chiefly by photo-illustrated newspapers and magazines; and advertising, especially in the USA, including more and more the poster, is making ever-increasing use of photography. The great demand for good photography has advanced photographic technology and art to an extraordinary degree: in France and America there are fashion and advertising photographers who surpass many painters in quality (Paris: Paul Outerbridge, O'Neill, Hoyningen-Huene, Scaioni, Luigi Diaz; America: Sheeler, Baron de Meyer, Ralph Steiner, Ellis, and others). The work of the mostly anonymous photographic reporters is of the highest standard: their pictures, not least in purely photographic terms, often give more pleasure than the allegedly artistic prints of professional portrait photographers and amateurs.

It would be absolutely impossible today to satisfy the enormous demand for printed illustrations with drawings or paintings. There would be neither enough artists of quality to produce them, nor time for their creation and reproduction. Without photography we would never know very much of what is happening in the world today. Such an extraordinary consumption could never be satisfied except by mechanical means. General social conditions have changed considerably since the middle of the 19th century, the number of consumers has grown enormously, the spread of European urban culture has greatly increased, all means of communication have advanced, and these changes demand up-to-date processes. The medieval

woodcut, worshipped as an ideal by book craftsmen, is now obsolete and can no longer satisfy our demands for clarity and precision.

The special charm of photography lies precisely in its great, often miraculous, clarity and its incorruptibility. As a consequence of the purity of its appearance and of the mechanical production process, photography is becoming the obvious means of visual representation in our time. That photography by itself, even almost accidental photography, is an art, may be disputed. But does art matter, in every case when photography is used? Straightforward and often completely inartistic photography is often all we want from reporters or photographers of objects: because what is wanted is information in visual form, not art. Where higher requirements exist, a way to satisfy them will be found. However little photography at the moment is an art, it contains the seed of an art which must of necessity be different from all other art forms.

On the borderline of art is the "posed" photograph. The effects of lighting, arrangement, and composition can come very near to fine art. A simple example is the whole-page advertisement in the Paris magazine *Vogue* shown opposite. It is remarkable purely as a photograph, but also especially interesting as an advertisement, since no lettering is used except that on the objects photographed — yet the result is perfect and successful.

There are two forms in which photography can become art: photomontage and photogram. By photomontage we understand either an assembly of separate photos which have been mounted together, or the use of a photo as one element in conjunction with other pictorial elements (photo-drawing, photo-sculpture). There are many overlaps between these methods. In photomontage, with the help of given or selected photographs, a new pictorial unity is created, which, being deliberate and no longer accidental design, has an axiomatic claim to the title of art. Naturally not all photomontages are works of art, any more than all oil-paintings. But the works in this medium of Heartfield (who invented photomontage), Baumeister, Burchartz, Max Ernst, Lissitzky, Moholy-Nagy, Vordemberge-Gildewart, certainly deserve that title. They are not random assemblies but logical and harmonious constructed pictures. An ordinary photograph starts with accidental form (grey tonal values, structural effect, movement of line) but achieves artistic meaning from the composition of the whole. What differentiates photomontage from previous art is that the object is missing. Unlike earlier art it is not a statement about an objective fact but a work of imagination, a free human creation independent of nature. The "logic" of such creation is the irrational logic of a work of art. Photomontage achieves a really "super-natural" effect through the deliberate

Whole-page photo-advertisement (without any additional lettering) from the
French periodical *Vogue*. 1926.

contrast of plastic photographs against an area of dead white or colour. This effect could never have been achieved by drawing or painting. The possibilities of contrast in size and shape, in closeness and distance of objects represented, and in flat or three-dimensional form, allow infinite variations in this art-form, making it highly suitable for thoughtful advertising. It is only rarely that a "work of art" will emerge through the balance achieved by relating each individual part to equilibrium in the whole — because the restrictions imposed by the necessary logical consistency of the whole, the logic of size, the given type, etc. can be very inhibiting. In any case the commercial artist's job is not to create a work of art but a good advertisement. It may, or may not, be both. In the field of advertising photomontage, among the best examples are the Malik book-bindings by

MAX BURCHARTZ:
Jacket of a folder for
leaflets. Silver back-
ground, white lettering
on red. Photomontage:
reproductions of typical
products of the Bochum
Association. Format
DIN A4.

John Heartfield and the industrial advertisements designed by Max Burchartz.

We show here a good example: the cover of a folder for industrial leaflets designed by Burchartz. The illustration sadly gives only a hint of the intense and rich effect of the original. Further examples of photomontage will be found elsewhere in this book.

Photograms are photos created with the use of light-sensitive paper without a camera. This simple technique is not new; photograms of flowers, for example, made by simply laying the object on photographic paper, have been known for a long time.

The inventor of the photogram as an art form is the American Man Ray, now living in Paris. He published his first works in this field in 1922 in the American magazine *Broom*. They reveal an unreal, supernatural world created purely by photography. These poetic images have nothing in common with reporters' or ordinary photographers' work, with which they have as much connection as poetry has with daily speech. It would be naive to call these productions either accidental or clever arrangements: any expert will recognize the difference. In them, the potentials of autonomous photography (without camera) have for the first time been realized in pure form: by the use of modern materials the photogram has become the modern poetry of form.•

Photograms, too, can be used in advertising. El Lissitzky was the first to make photogram advertisements, in 1924. A splendid example of his work in this field is the photogram for Pelikan ink (see opposite). Even the lettering is photo-mechanical.•• Although the mechanics of making a photogram are simple, they are nevertheless too complicated to describe in a few words. Anyone who sets himself such a task will, by his own experiments, find a way to achieve the desired effect. All that is needed is light-sensitive paper and a darkroom. We may mention here the book *Malerei, Photographie, Film* by L. Moholy-Nagy, which deals with this subject at length and most instructively.

The typographer who has to integrate halftone photographic blocks with given type must ask what typeface should be used in these conditions. The pre-war artists who rejected photography, as I described above, tried to

• Two of Man Ray's photograms are shown on pp. 48 and 49.
•• Only an unthinking observer could argue that the use of roman type for one word in this photogram was illogical. The desire to use simple means for the design led to the use of a non-manual standard type — a stencil letter, which had to be in roman because stencil sanserif is not yet available.

solve this problem but could not do so because they regarded all combinations of type and photos as compromise.

We today have recognized photography as an essential typographic tool of the present. We find its addition to the means of typographic expression an enrichment, and see in photography exactly the factor that distinguishes our typography from everything that went before. Purely flat typography belongs to the past. The introduction of the photographic block has enabled us to use the dynamics of three dimensions. It is precisely the contrast between the apparent three dimensions of photography and the plane form of type that gives our typography its strength.

The question, which type should be used with photographs, used to be answered in the most obvious way by choosing type that looked grey or was even printed in grey; also by using very thin or very individualistic types, and other methods. As in other kinds of work, the solution was superficial, reducing everything to one level: everything became a uniform grey, which hardly concealed the compromise.

Uninhibited and so contemporary, the New Typography found the solution at once. Since its aim was to create artistic unity out of contemporary and fundamental forms, the problem of type never actually existed: it had to be sanserif. And since it regarded the photographic block as an equally fundamental means of expression, a synthesis was achieved: photography + sanserif!

At first sight it seems as if the hard black forms of this typeface could not harmonize with the often soft greys of photos. The two together do not have the same weight of colour: their harmony lies in the contrast of form and colour. But both have two things in common: their objectivity and their impersonal form, which mark them as suiting our age. This harmony is not superficial, as was mistakenly thought previously, nor is it arbitrary: there is only one objective type form — sanserif — and only one objective representation of our times: photography. Hence typo-photo, as the collective form of graphic art, has today taken over from the individualistic form handwriting-drawing.

By typo-photo we mean any synthesis between typography and photography. Today we can express ourselves better and more quickly with the help of photography than by the laborious means of speech or writing. The photographic halftone block joins letters and rules in the compositor's case as a contemporary but differentiated typographic element in design. In a purely material sense it is also basically similar, since, at least in letterpress printing, it shares the same kind of relief printing surface and type-height. In the modern printing processes of gravure and offset-litho this is not so:

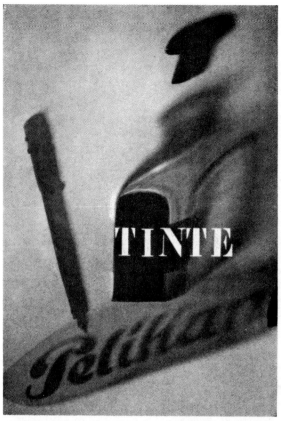

EL LISSITZKY 1924: Photogram (advertisement)

here a completely opposite kind of material form does not support any sup-
position of inequality.

The integration of halftone blocks in typesetting is a condition of good
typography and harmonious design. Since we of today do not recognize the
old book-designers' rejection of photography in book production and the
luxury-concept of the "Book Beautiful" belongs to the past, the modern
book designer sees the photographic block as equal in value to type in the
production of fine books. A splendid example of typo-photo in advertising
is shown facing, designed by Piet Zwart. Here also is a photogram used for
publicity (paper-insulated high-tension cables). The word "High" begins
with a tall H, the word "Low" with a small L. The balance of the chosen

93

PIET ZWART (Holland): Advertisement leaflet. Black and red on white. Format A4.

types and the areas of black and red are superb and the whole is a composition of enchanting beauty. The two red rules show how the effectiveness of a photo can be increased by the use of colour. Equally, the flat red area of the bold L contrasts well with the delicate plastic forms of the photogram. The typography and the photo echo each other: the centre of NKF with the centre of the cable cross-section, the red lines of type with the cable circumference, and so on.

It can be affirmed that typo-photo is one of the most significant means of graphic expression in today's typography and advertising. It will not be long before the popular forms of typo-photo, particularly in newspapers and some advertising, by means of conscious and logical contemporary design, reach the cultural highlights of the present time.

The enormous possibilities of photography itself have so far hardly been recognized, outside a small group of a few specialists, and certainly not exhausted. There is no doubt that the graphic culture of the future will make a far greater use of photography than today. Photography will be as expressive of our age as the woodcut was of the Middle Ages. For this reason it is absolutely necessary for every graphic professional, even today, to develop creatively all the techniques of photography and reproduction as far as possible and prepare them for the higher demands that will surely be made of them in the near future.

SASCHA STONE:
Advertisement
(photomontage)

NEW TYPOGRAPHY AND STANDARDIZATION

The New Typography, in its concern to satisfy the needs of our own period and to make sure that every single piece of printing is in harmony with the present, has always taken the greatest interest in every move towards standardization. The need for standardization, in whatever area, derives from the problems of today, which it aims to solve.

The use of standard practices in the book trade is therefore an integral necessity in modern typography: no piece of printing can be called satisfactory if it ignores such an outstanding element in the organization of book production. It is indeed an economic necessity.

This applies above all to formats, where for a long time the lack of standardization has been conspicuous. Choice of format used to be made primarily on aesthetic grounds, but must now be revised and made on higher grounds, because of the enormous increase — in the 19th and especially the 20th centuries — in the amount of printed matter. Until now the rationalization of paper sizes played a minor role, since the number of pieces of printing was so much less. Each document and piece of printing was individually planned: the result, to our eyes, often makes them appear to be art-objects of their time. The personal taste of the author, and chance, determined their format. Sheets of paper were made by hand singly in various sizes; but parchment sheets depended entirely on the size of the skin and could never be planned in advance.

The resulting chaos was recognized by forward-looking minds. Already in 1796 the German Lichtenberg recommended the introduction of some kind of standardization. Lichtenberg proposed a basic rule that formats should always be decided by successive halving of the original sheet size.

In the early years of the French Revolution the principle that he discovered was given partial recognition, for the French authorities made a rule about the formats of official documents and forms that, in mathematical terms, every page size should be in the proportions of $1:\sqrt{2}$ or $1:1.41$. The French linked this with the metric system they had just introduced, and by ordering the original size of sheets to be 1 m^2 and the proportions to be $1:\sqrt{2}$, they arrived at exactly the same scheme as today's A-series in DIN formats.[*] But the French attempts to introduce standardization had no permanent result; it was not until the 20th century that the great research scientist Wilhelm Ostwald, through "Die Brücke" (The Bridge), the international institute founded by him and K. W. Bührer in 1912 in Munich, made a new

[*] DIN = Deutsche Industrie-Normen

96

advance in regulating format sizes. Ostwald likewise proceeded from the Lichtenbergian principle of constant ratio but depended on measuring in centimetres. The proposed "World-formats," to be adopted worldwide, did not however win many friends; probably because the main format 230x320 mm (letterheads) turned out to be rather unpractical. Nevertheless the work of "Die Brücke," whose work was interrupted by the war, had the very great merit of making people think. The publications of "Die Brücke" are among the most interesting studies in this field.

Soon after the war the German Standards Committee introduced the metric-based DIN• 476 paper standardization system. It was evolved after lengthy discussions involving government departments, business interests, printers, and paper merchants and manufacturers. Government and industry agreed that DIN formats were to be the basis for all questions of format. The new DIN system has now for some time replaced the old "folio" system. The old "quarto format" is also disappearing.

DIN formats are being used not only in Germany but also in many other European countries. Everyone concerned in the ordering or production of print should now use only DIN formats, which have the following **advantages**, among others (from the book *Formate und Vordrucke*):

FOR THE USER:

> Paper ordering will be simpler and cheaper.
>
> The storing of all printed matter will be easier and more practical.
>
> Organization in the paper trade will be more sensible, and as the manufacture of large quantities will now be easier, paper must become cheaper.

FOR THE PRINTER:

> Paper ordering will be easier.
>
> DIN formats allow simultaneous printing in different sizes, leading to better use of machine time — also a saving of time and materials in the composing and machine rooms. More productivity will be achieved in the bindery owing to repetition of identical sheet sizes.

FOR THE TRADESMAN:

> Unnecessary investment in seldom-used sizes will be avoided.
>
> Fewer paper sizes will save space in stock rooms; attention to customers will be speeded up.
>
> Price lists will be simplified.

The specification sheets of DIN 476 and 198 follow, with the approval of the German Standards Committee (DIN). The latest authoritative Standard publications are obtainable from Beuthverlag, Berlin S14, Dresdener Strasse 97.

PIET ZWART: Page of advertising leaflet. Format A6. Black and red on white. (Original in Dutch.)

PIET ZWART: Page from an advertising leaflet. Format A6. Black and red on white. (Original in Dutch.)

FOR THE MANUFACTURER:

The number of uncut sheet sizes and roll-widths will be decreased. Manufacturing will be cheapened, storage simplified. In quiet periods storage can be undertaken (cheaper buying).

Price lists will be shorter and simpler, complicated supply calculations greatly simplified.

The number of different printing and paper machines required will be less.

Besides a showing of the different sizes in the DIN 476 range and the relevant explanations, we give in the following pages a reduction of the DIN 198 standard with instructions for use in the A-range.

In any case, all those who manufacture and use printed matter would not merely make use of the standard formats but also examine, and use, all the other standardizations in the book trade, on which the second part of this book gives information. Only then will the standardization programme in the book trade make sense.

Finally we would like to quote some passages from an essay by Dr Engineer E. H. Neuhaus, published in no. 23 (November 1926) of the *Zeitschrift für Deutschlands Buchdrucker:* "I feel obliged to give double and treble emphasis to my prayer to our leaders of industry, that they use the full weight of their influence to introduce the DIN standards in their businesses. We can no longer, in fairness to the reputation of our work, put up with lame excuses of any kind, but must ensure, as German engineers, that the results of our long and wearisome efforts come to fruition to help German trade. Production and distribution of goods are not ends in themselves. They both make sense only when they make it possible for every citizen to receive the goods in the greatest quantity and the finest condition. And standardization is justified when the goods become better and cheaper. The fact that standardization is a guarantee for the raising of quality and lowering of prices can no longer be ignored. "It depends entirely on ourselves whether we want to accept this fully recognized principle in our business.

"It is useful to observe the inhibitions that impede the introduction of these sound principles into our business.

"First, of course, there are the inhibitions arising from the self-interest that gains from ignoring the principles of standardization. Where self-interest is enriched by the increased cost of products, and thereby deceives and misleads people, it must for everyone's sake be fought. But there are also inhibitions which come not from an antisocial attitude but from an instinctive

Papierformate

Bezeichnungsbeispiel

Das Format 210×297, Klasse 4 der Vorzug-
reihe A, heißt

Format A 4

Die Abmessungen gelten als G r ö ß t m a ß e ,
Toleranzen sind nach unten zu legen und auf
das äußerste zu beschränken.

Als **Fertigformate** für alle **unabhängigen**
Papiergrößen, wie Zeichnungen, Akten, Ge-
schäftspapiere, Betriebvordrucke, Karteikarten,
Werbsachen, Zeitschriften, Zeitungen, Bücher,
gelten die

Formate der A-Reihe

Einzelheiten sind folgenden Normblättern zu
entnehmen:

DIN 198 Papierformate — Ahwendungen der
A-Reihe

DIN 676 Geschäftbrief — Format A 4

DIN 682 Rahmen für Bilder und Tafeln

DIN 820 Normblatt — Abmessungen und Aus-
gestaltung

DIN 823 Zeichnungen — Formate, Maßstäbe

DIN 824 Zeichnungen — Falten auf A4 für Ordner

DIN 825 Schildformate

DIN 826 Zeitschriften — Format A4, Satzspiegel,
Druckstockbreite

DIN 827 Papier (Normalpapier) — Stoff, Festig-
keit, Verwendung

DIN 829 Buchformate

Für **abhängige** Papiergrößen, wie Briefhüllen,
Ordner, Mappen, gelten die

Formate der Zusatzreihen B, C, D

Einzelheiten sind folgenden Normblättern zu
entnehmen

DIN 678 Briefhüllenformate

DIN 680 Fensterbriefhüllen

DIN 828 Mikrophotographische Bilder

DIN 829 Buchformate

Format-Klasse	Reihe A Vorzugreihe mm	Reihe B mm	Reihe C mm	Reihe D mm
		1000×1414		
0			917×1297	
	841×1189			
				771×1090
		707×1000		
1			648×917	
	594×841			
				545×771
		500×707		
2			458×648	
	420×594			
				385×545
		353×500		
3			324×458	
	297×420			
				272×385
		250×353		
4			229×324	
	210×297			
				192×272
		176×250		
5			162×229	
	148×210			
				136×192
		125×176		
6			114×162	
	105×148			
				96×136
		88×125		
7			81×114	
	74×105			
				68×96
		62×88		
8			57×81	
	52×74			
				48×68
		44×62		
9	37×52			
10		31×44		
	26×37			
11		22×31		
	18×26			
12		15×22		
	13×18			

Juli 1925 2 Ausgabe (erweitert)

101

feeling that here is a circumstance which will make our inner life poorer, more one-sided and less desirable. But when we look closer into this we see that man can only develop his personality in the present state of civilization and culture if he stops wearing himself out in an unprofitable struggle against useless detail but makes himself free to find the time and means for developing his true personality.

"We must be clear that countless things today in their ill-founded and largely inappropriate complexity are not at all the result of an earnest striving to form a personality, but simply the product of a far-reaching and arbitrary thoughtlessness in manufacturers and consumers. We must further accept that the overwhelming number of objects of daily need are easier to cope with under the law of pure expediency than under the demands of personal taste.

"All the objections that make bogeys out of sensible and tasteful discipline fall apart when we examine them. It is no less than a deception of public opinion when it is said that unplanned production has more personal value than the production of goods on an honest functional basis and by the collaboration of manufacturers and consumers."

EXPLANATIONS (to DIN 476 page 2)

BASIC PRINCIPLES

1. FORMULA OF HALVING RANGES
Each consecutive format evolves through doubling or halving the previous one.
The areas of both formats relate as 1:2.

➡

2. FORMULA OF SIMILARITY IN RANGES
The formats are similar to each other.
Nos. 1 and 2 in the range give, for the two sides of x and y of one format, the proportions $X:Y = 1:\sqrt{2}$

➡

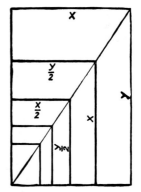

Both sides are therefore in proportion to each other as the sides of a square are to its diagonal.

➡

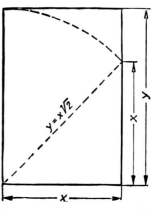

3. FORMULA OF CONNECTED RANGES
The formats are connected to the metric system: the area of the basic norm equals the area of a square metre, i.e. $x \times y = 1$.

(Continuation of explanations to Norm DIN 476)

ORIGINAL FORMAT

For the original format with sides x and y the same two equations apply because of the above 3 principles $x:y = 1:\sqrt{2}$

$$x \times y = 1$$

The original format, rectangle with area of 1 m², has sides of

$$x = 0.841 \text{ m} \qquad y = 1.189 \text{ m}$$

ORIGINAL RANGE A (Preferred range)

Following equation 1, the range in original format continues by consecutive halving to make original range A.

ADDITIONAL RANGES B C D

For connected paper sizes, e.g. envelopes, booklets, wallets, etc., the additional ranges B C and D are listed. The B range formats are the geometric means of the A range. The C and D ranges are again the geometric means of the A and B ranges.

STRIP FORMATS

Strip formats are made by halving, quartering, etc. the main format length:

Format	Abbre-viation	mm
Half length A4	½ A4	105 × 297
Quarter length A4	¼ A4	52 × 297
Eighth length A7	⅛ A7	9 × 105
Half length C4	½ C4	114 × 324
etc.		

Applications: Envelopes, labels, tickets, coupons, technical drawings, etc.

104

Papierformate nach DIN 476

Anwendungen der A-Reihe

Abmessungen der Formate mm	841×1189	594×841	420×594	297×420	210×297	148×210	105×148	74×105	52×74	37×52	26×37	18×26	13×18	9×13
Kurzzeichen der Formate	A0	A1	A2	A3	A4	A5	A6	A7	A8	A9	A10	A11	A12	A13
Abreißkalender, Blocks					A4	A5	A6	A7	A8	A9				
„ Unterlagen			A2	A3	A4	A5	A6	A7						
Adreßbücher					A4	A5								
Amtsblatt					A4									
Akten					A4	A5								
Aktien				A3	A4	A5								
Anlagemarken									A8	A9	A10	A11		
Bescheinigungen					A4	A5	A6							
Bestellzettel					A4	A5	A6							
Besuchskarten							A6	A7	A8					
Betriebsvordrucke				A3	A4	A5	A6	A7	A8	A9	A10	A11		
Brief Einheitsbrief=Akte					A4									
„ Halbbrief						A5								
Bücher (Broschüren)					A4	A5	A6	A7	A8					
Durchschlagpapier					A4	A5								
Einheitsbrief					A4									
Fahrpläne	A0	A1	A2	A3	A4	A5	A6	A7						
Fernsprechbücher					A4	A5								
Fotogramme, technische				A3	A4	A5	A6	A7						
Geschäftsbücher			A2	A3	A4	A5								
Geschäftspapiere				A3	A4	A5	A6	A7						
Karteikarten					A4	A5	A6	A7						
Kataloge					A4	A5	A6	A7	A8					
Klebemarken							A6	A7	A8	A9	A10	A11	A12	A13
Klebezettel							A6	A7	A8	A9				
Kostenanschläge					A4	A5								
Kurvenblätter				A3	A4									
Landkarten	A0	A1	A2	A3	A4	A5	A6							
Mitteilung Halbbrief						A5								
Normblatt (s. DIN 820)					A4									
Notizblocks und Notizzettel					A4	A5	A6	A7						
Paketadressen (zum Aufkleben)						A5	A6							
Patent- u. Musterzeichnungen				A3	A4									
Plakate	A0	A1	A2	A3	A4	A5								
Postkarte							A6							
Preislisten					A4	A5	A6	A7						
Quittungen						A5	A6							
Rechnungen					A4	A5								
Rundschreiben					A4	A5								
Scheck (s. DIN 679)							A6							
Scheckkontenverzeichnisse					A4	A5								
Schilder (s. DIN 825)	A0	A1	A2	A3	A4	A5	A6	A7	A8	A9	A10	A11	A12	
Tabellenblätter					A4	A5								
Taschenbücher						A5	A6	A7						
Versandanzeigen und -zettel					A4	A5	A6							
Vorschriften				A3	A4	A5	A6							
Werbsachen	A0	A1	A2	A3	A4	A5	A6	A7	A8	A9	A10	A11	A12	A13
Zeichnungen (s. DIN 823)	A0	A1	A2	A3	A4	A5	A6							
Zeitschriften (s. DIN 826)				A3	A4	A5	A6							
Zeitungen		A1	A2	A3	A4	A5								

Bei Bedarf kann die Anzahl der vorgesehenen Größen durch Formate der gleichen Reihe vermehrt oder verringert werden.

Schmale Formate (für Fahrscheine, Listen, Schilder, Streifen, Zinsscheine) werden durch Längshälften, Längsviertel, Längsachteln usw der A-Formate gewonnen.

Briefhüllen (Reihen B und C) siehe DIN 678

Fensterbriefhüllen siehe DIN 680

Buchformate (Reihen A und B) siehe DIN 829

Aktendeckel, Hefter und Ordner werden der C-Reihe entnommen:
C4 229×324
C5 162×229

Oktober 1923

PADS, INDEX CARDS, BOOKLETS

With tear-off pads and duplicate-books, the pages detached must be in norm size, so the pad or duplicate-book will be taller or wider than the norm.

Index cards without tabs are in exact norm sizes (A4, A5, A6, A7). Index cards with tabs are larger by the size of the tab.

Booklets, wallets, and files are naturally wider than the norm-format sheets to be inserted in them. Their sizes should as far as possible be chosen from the four ranges.

FURTHER AIMS FOR NORM FORMATS

Since for some special purposes no norm sizes are yet fixed, the ranges A to D define limits for norms for (for example) sheets of paper, envelopes, office furniture, type areas, printing stock sizes, etc. The aim for these circumstances is to establish special norms later.

NORM FORMATS ABROAD

DIN formats agree in general with standard formats in the following countries: Switzerland, Austria, Hungary, Czechoslovakia, Holland, and Belgium.

DINBOOK 1

For exact derivation and history of formats and information on paper and printing technology, see DINbook 1, *Papierformate* (Beuthverlag GmbH, Berlin S14).

PRINCIPAL TYPOGRAPHIC CATEGORIES

THE TYPOGRAPHIC SYMBOL

A good symbol is usually, but not always, the expression of a unified design for advertising and manufacture. It must be original and simple in form, have a very high degree of memorability, and be easily recognized and noticeable. By no means every symbol has these characteristics, a proof of how difficult it is to design a really good symbol for a firm or a range of goods. A brisk propaganda for this elementary method of advertisement has resulted in a real flood of new symbol designs. So truly effective symbols are now doubly rare.

Symbols are mostly designed and drawn today by graphic artists. These drawn designs have no technical restrictions except that as a rule they must be in black and white, without halftones.

A symbol need not be only drawn. It is also possible to design symbols, sometimes even more effectively, by using typography. The advantage of such "typo-symbols" are: no block costs, the facility for reduction and enlargement, and the strength inherent in all things whose appearance comes from a technical manufacturing process. The means available to the printer for designing symbols are the typographic contents of the

KURT SCHWITTERS: Symbol for the word Pelikan

composing-room: rules, straight and curved, geometrical shapes, letters and — not least — imagination. Without that, even the latest materials and types are of no use.

A symbol either brings letters together to make a new form, or illustrates the product, or does both. The effect of the Pelikan symbol depends on the use of the simplest type-forms in strong contrast and movement. The "Heunert" symbol is a representation of the firm's products, made out of the initials of the firm's name. With the initial of the forename Piet and the black square ("Zwart" is the Dutch word for the German "Schwarz," black) an unforgettable device is made. Herbert Bayer's design for a glass-painter

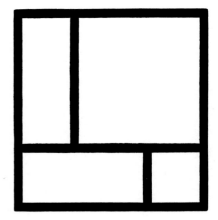

HERBERT BAYER:
Symbol for a glass-painter/artist

represents, like the Heunert symbol, the client's profession with an abstraction of a window frame.

Although it would be good to see printers turning more and more to the design of symbols, a warning must be given against the use of type alone (i.e. monograms) for this purpose. A symbol is something completely different and of higher importance than a monogram, and a faulty symbol is far worse than none at all. Printers today are often tempted to use a type monogram in place of some previous ornament. But in advertising, only a true symbol is suitable; monograms today do not make sense. A monogram as the symbol of a product is always worse than a proper symbol. And a bad symbol can be disastrous to a product. For this reason it is better not to substitute a monogram for a symbol, when there is not enough time to design a symbol, but to use simply type.

In any case the design of a type symbol gives the printer the opportunity of a fascinating and welcome job, and the difficulties of making a good symbol should only be a stimulus to their overcoming.

PIET ZWART: Personal mark (type-symbol)

THE BUSINESS LETTERHEAD*

A letterhead is one of the most important tasks for the jobbing printer and deserves the most careful attention.

Even today most letterheads are produced in the most varied styles and sizes. A collection of contemporary business letterheads would show most of them in the old quarto format, some in miscellaneous "private" sizes, and a small minority in DIN formats. The variation in sizes of the old letterheads was because no recognized standard sizes existed.

The letter is not only the most important instrument of business communication. More than this, it often contains price offers, contracts, and agreements which can make critical its retrieval from the file in which it is placed after arrival. Thus the letter becomes part of a multiplicity, i.e. of a correspondence. Without order, such a multiplicity becomes unmanageable. The old quarto and the various other unique formats, among which the old folio format was an attempt at standardization, were — because of all their different dimensions — difficult if not impossible to file and therefore find.

So the first requirement for the expedient design of business letterheads was the laying down of a single format. This was achieved by the Standards Committee in the 476 Standard. For business letterheads the most suitable format is A4 (210 x 297 mm), a practical and pleasant size. The authorities have used it for many years for government documents, instead of the old folio sizes, and businesses are now using it more and more. Even private individuals are now going over to it. A4 is a bit deeper than the old quarto size and is the same width as folio. It fits comfortably into the old filing systems.

A letterhead designed in the New Typography (in old quarto format) by Theo van Doesburg is shown here as an example of a standard but otherwise contemporary heading. At the time it was made, the standard DIN sizes were not yet recognized, and France, where this letterhead was originated, has not yet joined with the other European countries that have introduced it.

The old formats will presumably remain in use for some time to come, so our example can be justified.

* In the following sections of this chapter we are grateful to the German Standards Committee (DIN) for permission to reproduce the illustrations. The latest edition of the DIN forms should be consulted and is obtainable from Beuthverlag, Berlin S14, Dresdener Strasse 97.
The booklet *Formate und Vordrucke* is also available from this publisher, providing a useful extension of the present work (price 1.20). It is frankly of astonishingly low typographic quality and the examples shown should not be used as models. But the usefulness of both publications is not in question.

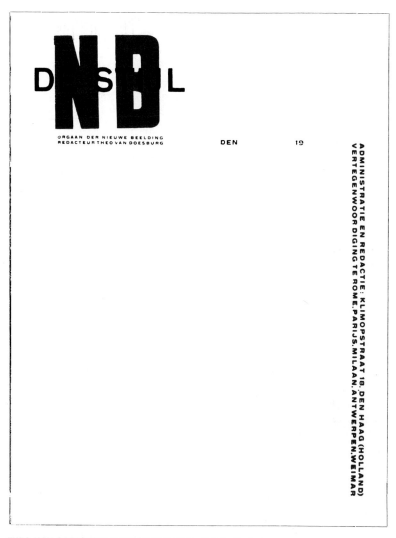

DNSBL

ORGAAN DER NIEUWE BEELDING
REDACTEUR THEO VAN DOESBURG

DEN 19

ADMINISTRATIE EN REDACTIE: KLIMOPSTRAAT 18, DEN HAAG (HOLLAND)
VERTEGENWOORDIGING TE ROME, PARIJS, MILAAN, ANTWERPEN, WEIMAR

THEO VAN DOESBURG: Letterhead (not in standard size)

But the A4 format (210x297 mm) should be used in all new work. It has the advantage of being the same size as nearly all new business literature, periodicals, etc., with which it will be sent out. It can hardly be thought that the old formats are in any way better or more attractive than the new. When A4 is found to be too large for private use (which is however hard to justify), A5 (148x210 mm) can be used upright or horizontal.

Component parts of DIN letterheads

Besides the format, there are also standards for the placing of the component parts of business letterheads, e.g. the size of the space for the firm's name, and so on.

The authority for all these standards is DIN sheet 676: we show examples on the following pages.

Standards exist for:

1. The position of the address, on the left, because once the letter has reached the addressee, it has served its purpose and can therefore be placed in a relatively unimportant position close to the margin.

2. Position for receipt- and treatment-marks (receipt stamp etc.), on the same level, on the right. This space is more important than the address, and must be easy to find and read.

3. Sequence and position for the four main pieces of information: your ref., your letter of, our ref., date. The advantage of the standard over the previous methods is that these can all be typed in one line (beneath the headings). Earlier, such information was usually set in a column, requiring endless readjustments of the typewriter. The standard avoids this nicely, in that neither the height of the line nor the beginning of the treatment-marks is in the way of careful entries. The form also ensures that these items are not overlooked.

4. Sequence and position of the firm's particulars: sender's address, telegraphic address, telephone, business hours, etc. It is a main failing in most of the old "artistic" letterheads that the visibility and clarity of these details was sacrificed to the "artistic" effect. In many of the old letterheads these particulars occupied several long lines: the individual groups were not clearly distinguished from each other; when looking for a particular item one had to read through the whole lot. In standardized headings these items are clearly arranged in specified positions. The standardization of the sequence is another advantage.

5. Side margin of at least 20 mm. In older letterheads this margin was often ignored. This continued not to be noticed because in those days letters

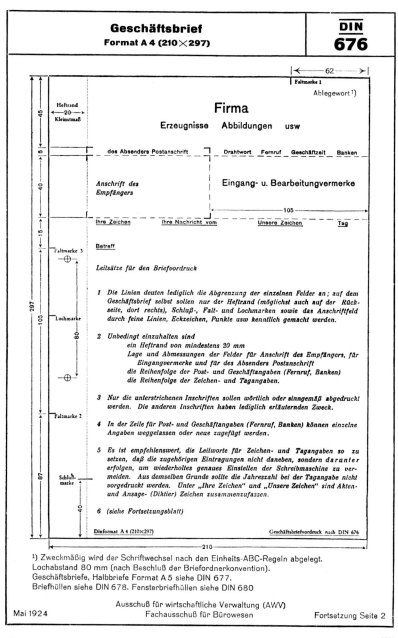

Heftrand
←20→
Kleinstmaß

|←——— 62 ———→|

Faltmarke 1

Ablegewort[1])

Firma

Erzeugnisse Abbildungen usw

des Absenders Postanschrift Drahtwort Fernruf Geschäftzeit Banken

Anschrift des
Empfängers

Eingang- u. Bearbeitungvermerke

←——————— 105 ———————→

Ihre Zeichen Ihre Nachricht vom Unsere Zeichen Tag

Faltmarke 3

Betreff

Lochmarke

Faltmarke 2

Schluß-
marke

Leitsätze für den Briefvordruck

1 Die Linien deuten lediglich die Abgrenzung der einzelnen Felder an; auf dem Geschäftsbrief selbst sollen nur der Heftrand (möglichst auch auf der Rückseite, dort rechts), Schluß-, Falt- und Lochmarken sowie das Anschriftfeld durch feine Linien, Eckzeichen, Punkte usw kenntlich gemacht werden.

2 Unbedingt einzuhalten sind
ein Heftrand von mindestens 20 mm
Lage und Abmessungen der Felder für Anschrift des Empfängers, für Eingangvermerke und für des Absenders Postanschrift
die Reihenfolge der Post- und Geschäftangaben (Fernruf, Banken)
die Reihenfolge der Zeichen- und Tagangaben.

3 Nur die unterstrichenen Inschriften sollen wörtlich oder sinngemäß abgedruckt werden. Die anderen Inschriften haben lediglich erläuternden Zweck.

4 In der Zeile für Post- und Geschäftangaben (Fernruf, Banken) können einzelne Angaben weggelassen oder neue zugefügt werden.

5 Es ist empfehlenswert, die Leitworte für Zeichen- und Tagangaben so zu setzen, daß die zugehörigen Eintragungen nicht daneben, sondern darunter erfolgen, um wiederholtes genaues Einstellen der Schreibmaschine zu vermeiden. Aus demselben Grunde sollte die Jahreszahl bei der Tagangabe nicht vorgedruckt werden. Unter „Ihre Zeichen" und „Unsere Zeichen" sind Akten- und Ansage- (Diktier) Zeichen zusammenzufassen.

6 (siehe Fortsetzungsblatt)

Dinformat A 4 (210×297) Geschäftsbriefvordruck nach DIN 676

←——————————————— 210 ———————————————→

[1]) Zweckmäßig wird der Schriftwechsel nach den Einheits-ABC-Regeln abgelegt. Lochabstand 80 mm (nach Beschluß der Briefordnerkonvention). Geschäftsbriefe, Halbbriefe Format A 5 siehe DIN 677. Briefhüllen siehe DIN 678. Fensterbriefhüllen siehe DIN 680

Ausschuß für wirtschaftliche Verwaltung (AWV)
Fachausschuß für Bürowesen

Mai 1924

Fortsetzung Seite 2

Geschäftsbrief
Format A 4 (210 × 297)

Fortsetzungsblatt
(zweites Blatt und weitere Blätter)

Heftrand
← 20 →
Kleinstmaß

Firma Betreff Empfänger **Tag** **Blatt**

6 *Ist der Absendeort vom Sitz der Firma verschieden, so kann statt des vor-gedruckten Wortes „Tag" der Absendeort vorgedruckt werden.*

7 *Der Betreff und Angaben über die Art der Mitteilung (zB Auftragbestätigung) sind links oberhalb des Textes zu schreiben. Anlagen, Verteilvermerke, sowie Angaben über die Art der Versendung (zB „einschreiben") sind links unter dem Text anzugeben. — Die Unterschrift ist rechts unter den Text zu setzen.*

8 *Die Lochung erfolgt zweckmäßig im voraus. Die Lochmarke wird dadurch überflüssig.*

9 *Auf dem Heftrand können Druckvermerke (Auflagehöhe, Auflagetag), Blatt-gewicht, Felder für Gegenzeichnung usw aufgenommen werden.*

10 *Faltmarken Die Faltmarken sind nur zu drucken, wenn der Brief in Fenster-hülle verschickt werden soll.*

11 *Fortsetzungsblatt Unbedingt einzuhalten ist die Reihenfolge der An-gaben auf dem Fortsetzungsblatt und zwar auch dann, wenn für die Fort-setzungsblätter Papier ohne jeden Aufdruck verwendet wird. Bei Anfertigung eines Vordrucks können die Angaben „Firma", „Betreff" und „Empfänger" weggelassen oder neue Angaben zugefügt werden.*

12 *Dem Werbfachmann und dem Künstler sind alle Freiheiten eingeräumt, die den Sätzen 2 und 11 nicht widersprechen.*

237

Schluß-marke

40

DIN-format A 4 (210×297) Geschäftsbriefvordruck nach DIN 676

← 210 →

5. Side margin of at least 20 mm. In older letterheads this margin was often ignored. This continued not to be noticed because in those days letters did not need to be so systematically organized as they are today.

A standardized letterhead, before it is written, often gives the impression that not enough room has been left for the letter itself. This is a deception, caused by the line of "your ref" etc. People forget that the address of the addressee goes above: the remaining space for the actual letter is larger than in many old letterheads.

Typographic design of standard letterheads

Printers must now find a typographic form that fits the standards for letter-headings and looks well.

The necessary left-hand margin by itself points to an asymmetric design. It is really against sense, in order to achieve symmetry, to repeat the margin on the right purely for decorative reasons. Why should the details of a let-terhead be made hard to read? If the two punch-holes for filing are included, symmetry is in any case impossible (assuming that apart from a few snobs nobody writes a letter itself symmetrically. In general, the typog-raphy of the old letterheads took no notice of the fact that the letter as received would be written, signed, and folded. Only when it is a completed whole can it look beautiful!).

The margin should not be marked by a fine rule or anything else, but should be left white. The lines of type begin on its left-hand edge, and aligned exactly below them the typing starts. In this way the typed letter has a pleasant and prominent white stripe (provided that the writing continues to the edge of the paper on the right, and does not stop 2 or 3 centimetres from it, which is quite unnecessary).

The punch-holes can be made in advance, if desired, as the Standard rec-ommends, and it is even possible that the holes, as a conscious part of the design, can enrich the general effect. I find it desirable so to position the left-hand edge of the type matter that the holes are exactly in the middle of the white margin. That usually makes a margin of 25 mm necessary.

The space for the firm's name etc. should preferably be filled as completely as possible, the white spaces between the lines having the same weight as the black lines of type. The print not only can but should extend to the right-hand edge of the paper, leaving only one pica of space there. Only in this way will the left-hand margin have its full effect. There is also basically no reason for beginning the design more than one pica down from the top

of the page, but it depends on the shape of the main heading and the general design whether it is desirable to start so close to the top.

Because the letter will finally be folded (asymmetrically, for standard window envelopes) it is necessary, to achieve a good total effect, to relate the type-setting to the position of the folds, i.e. to avoid lines of type in the heading being on the fold-lines, and other vertical divisions (see the letterhead "Arbeitsgemeinschaft" on p. 120). For letters that are to be put in window envelopes this is vital: for letters sent in ordinary envelopes it is not vital, but the central fold-line must be observed. This fold-line is also important when we come to the firm's particulars. It would be wrong, and against the whole principle of standardization, to set these details in long lines, as they used to be in the old letterheads. They should be placed in groups and in columns, rather than in continuous lines.

It neither looks well nor is it clear to centre the lines in the individual groups. In an asymmetric design it would be a contradiction of style. The best solution for columns is to align them left, ragged right. These groups will usually go in two lines: the title ("sender's address," "telegraphic address," etc.) comes above, the information in the second line below (see the "Gebühren-Rechnung" heading by Molzahn, p. 126). The groups can be separated by fine vertical rules if this seems necessary, but about 1 pica space between them should make further separation unnecessary. For example:

The main division is shown in the centre of the page by a pica-wide white space that begins either to the left or to the right (better right) of the centre (see the letterheads "Arbeitsgemeinschaft" and "das bauhaus in dessau"). The central dividing line should never be allowed to come in the middle of the white pica-space.

To show a solution for more complicated groups of this kind, we give here a design for the letterhead of the Deutsche Werke with the groups in a better and clearer form.

Postanschrift:	Drahtwort : Deweka	Telefon:	Banken:		Postscheckkonto:
Kiel, Schließfach 152/162	(ABC-Code 5th Ed.)	6300-14	Kiel: Reichsbank		Hamburg 36175
	Ingenieur-CodeGallané		Vereinsbank		
			Commerz - u.Privatbk,		
			Berlin: Reichs-Kredit-Ges. AG		

A further problem is how to define the position of the window space for the address. The four corners of the space can be shown by angles \ulcorner or points

• unless it is desired not to use these means and indicate its position less directly. The latter is preferable. It is possible, if for example the line containing the sender's address can be continued to the page centre (which can often be done by abbreviation or judicious expansion — but also the next groups, telegraph address, telephone, etc., may be moved to the left half of the page) and the group "your communication of" can end at the middle (see the "das bauhaus in dessau" and "Arbeitsgemeinschaft" headings). The beginning and end of the address line and the beginning of "your ref" and end of "your communication of" will then themselves define the window.

The address of the recipient is best written thus:

An die Büchergilde Gutenberg
Dreibundstr. 5

Berlin SW 61

The town name must for clarity be emphasized by a rule. (Do not letterspace; if need be use capitals, not letterspaced, for emphasis!)

This method has the advantage that it is clearer and easier to type than the older method, in which for every line the carriage must be shifted to the right and cannot be brought back automatically. The beginning of the typed lines must align with the printed lines, to give an even and satisfactory appearance.

For the same reason it is not recommended to surround the address area with a border, which would make perfect alignment of all the lines impossible.

It is generally the case — and especially with letterheads — that printed matter looks better the less use is made of secondary matter such as rules, points, and so on. A letterhead is already a complicated typographic job whose clarity should not be hindered by trimmings.

With the name of the addressee, the contents of the letter begin, aligning with the invisible vertical established by the print above. A typewritten letter looks stronger when the typed lines are "solid," without spacing between the lines.

The end-point is best marked by a dot (see the "Arbeitsgemeinschaft" heading) rather than by a rule, which has no meaning and can be confusing above or below a word.

Arbeitsgemeinschaft

des Bayerischen Kunstgewerbevereins und
des Münchner Bundes

Postanschrift: München Akademie der Künste · Fernsprecher 12345 Postscheckkonto München 124353

Ihre Zeichen Ihre Nachricht vom Unser Zeichen **Tag**

Betreff

JAN TSCHICHOLD: Design for a standard letterhead.
A legible arrangement for the many names and titles.
This design was turned down by the firm and the heading opposite used instead.

120

ARBEITSGEMEINSCHAFT
BAYERISCHER KUNSTGEWERBEVEREIN UND MÜNCHNER BUND

Erster Vorsitzender Geheimrat G. BESTELMEYER, Architekt, Präsid. der Akademie der bildend. Künste / Zweiter Vorsitzender KARL BERTSCH, Dir. der Deutschen Werkstätten / Landesgewerberat JOS. LEIPFINGER / Dr. PAUL WENZ, Arch. / Professor EDUARD PFEIFFER, Arch. / Regierungsbaurat FRITZ GABLONSKY, Architekt / Dr. von PECHMANN, Abteilungsleiter am Nationalmuseum / Oberstudiendirektor O. RÜCKERT, Maler, Leiter d. Städtisch. Malerfachschule / FRIEDR. HEUBNER, Maler / Geschäftsführender Vertrauensmann Oberstudiendirektor WIEDERANDERS, Architekt, Leiter der Städtischen Holzbearbeitungsfachschule

MÜNCHEN ⸼ AKADEMIE DER BILDENDEN KÜNSTE ⸝ TELEPHON 31690

MÜNCHEN, den

Anonymous:
Example of a non-standard and poorly designated business heading. No one could read comfortably the matter below the red rule.
This design was printed, although the design opposite was offered to the firm!

121

The punch-hole mark is unnecessary

1. when the letter is posted in an ordinary, not a window, envelope. It will then be folded once across and once down, and the middle point of the paper height (the punch-hole mark) does not need to be printed.
2. when the letter has been punch-holed in advance, which happens only too rarely.

Otherwise they must be printed, best in the form of a short one-point-thick rule printed on the margin.

Fold-marks need to be printed only when window envelopes are to be used. They are usually short and fine dashes printed on the margin; but I find it better to use six-point figures 1, 2, 3, on the folding positions. As these are set right at the edge of the type matter, unprotected, it is better to get them made in brass.

How little thought-out is the "Deutsche Werke" heading, however thoroughly corresponding to the standard, is perhaps worth considering here.

The formal idea is centred composition. But the left-hand margin has the effect of making the central device look pushed over to the right, completely destroying the intended symmetry of the whole. The groups to left and right of the device are not truly symmetrical, and the groups beneath the unsightly heavy rule, each of which has been set centred, make a harmony for the whole absolutely impossible. To this is added the unneeded indication of the margin by a dotted rule, the silly and totally superfluous two short rules beside "Kiel," the amateurish marking of the address-window area, and the unsatisfactory end-mark. And why do the words "Dinformat A4 (210 x 297)" suddenly go across the margin?

Such a defectively designed letterhead of course looks even worse when carrying a letter. It is very important when designing a letterhead to remember that the recipient will see the letter only when it has been written on. It is best to place the layout on a proof with address to test the final appearance.

In spite of all the restrictions placed on the designer of a standardized letterhead, it is indeed possible to produce an artistically faultless result. Anyone who does not believe this will not be able to cope with any other problems either. In any case, the letterheads reproduced here, and the numberless correctly standardized letterheads in my typography evening classes and courses at the "Meisterschule für Deutschlands Buchdrucker," prove that despite all limitations, excellent and typographically faultless solutions are possible. And should not difficulties be a spur? It is in any case possible that the rules given here for the typographic design of standard letterheads may sometimes be broken, in order to achieve a harmo-

Standardized but not designed letterhead.
Too many superfluous rules. An unhappy mixture of written and printed forms. The margin is obviously no longer seen to belong to the letterhead, because otherwise one would certainly be forced to abandon the beloved principle of symmetry. Even so, the attempt to follow the principle through is only successful in parts: it proves here again that centred composition is uncontemporary.

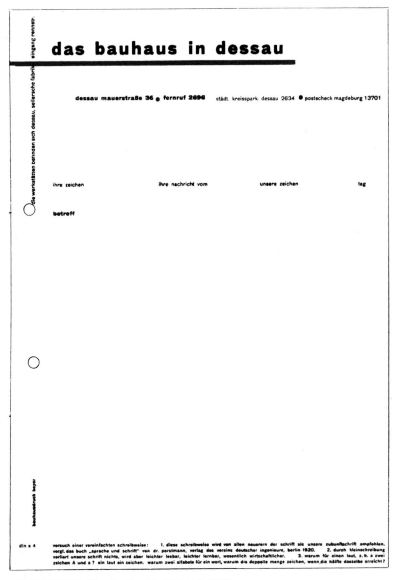

HERBERT BAYER: Standardized letterhead. 1925.

nious design. This must be said, to comfort the doubts of those who are worried by the new problems they may now be facing.

Invoices and order forms are treated also in DIN 676. Example: the invoice form by Molzahn (on the next page).

Because the DIN formats have proved themselves successful, more and more firms are going over to them. Much can be done by the printing trade to help spread the knowledge of them: many firms, especially the smaller ones, still know nothing about them.

A standardized letterhead will admittedly cost more than the ordinary kind because of the extra care and accuracy required. Their increased usefulness will compensate for that. Unprinted stock, in standard sizes, can be stored and used for later jobs, which will save money.

JOHANNES MOLZAHN: Invoice following DIN 676. Grey and black type on white.
The large device is the designer's personal mark.

THE HALF LETTERHEAD

There is also a standard for the A5 format (148x210 mm), for use both as upright and horizontal. Standard 677 covers both, reduced reproductions of which are shown on the following pages.

Neither of these alternatives is really practical. A5 used vertically is similar in general form to a letterhead in standard A4, but is obviously smaller and is therefore less easy to find in a file. In horizontal form it has only its width in common with A4, but loses in lucidity because the firm's name and details seem to be separated.

The space for writing on both is rather small, but since they are intended for shorter messages that is not a fault.

A5 letterheads are used chiefly for two reasons:

1. A short message on an A4 page leaves a large space which may be thought unsightly. But a letter is first and foremost a communication, and aesthetic appearances must be less important than the purpose of the document. We said above that the purpose of a letter is not finished when it has been received and read. It will be put aside and needed again, and must therefore be looked for. The more different formats and sizes the more labour! One format, one standard!

2. To save paper. But even on longer runs there will be little saved: the extra cost of paper is negligible. In shorter runs the cost of printing the other half of an A5 sheet will cost as much as an A4 sheet.

It is therefore always better to use A4 rather than A5! As for the typography of A5 letterheads, the rules laid down in the sections on A4 are just as binding. In both kinds of A5 a strict observance of the normal rules will bring an excellent typographic result.

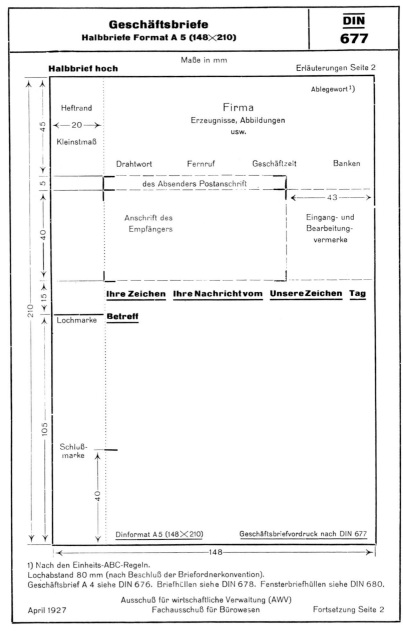

Geschäftsbriefe
Halbbriefe Format A 5 (148×210)

$\overline{\text{DIN}}$
677

Maße in mm

Halbbrief hoch

Erläuterungen Seite 2

Ablegewort[1])

Heftrand

←—20—→

Kleinstmaß

Firma
Erzeugnisse, Abbildungen
usw.

Drahtwort Fernruf Geschäftzeit Banken

des Absenders Postanschrift

←——— 43 ———→

Anschrift des
Empfängers

Eingang- und
Bearbeitung-
vermerke

Ihre Zeichen Ihre Nachricht vom Unsere Zeichen Tag

Lochmarke **Betreff**

Schluß-
marke

Dinformat A 5 (148×210) Geschäftsbriefvordruck nach DIN 677

|←————————— 148 —————————→|

1) Nach den Einheits-ABC-Regeln.
Lochabstand 80 mm (nach Beschluß der Briefordnerkonvention).
Geschäftsbrief A 4 siehe DIN 676. Briefhüllen siehe DIN 678. Fensterbriefhüllen siehe DIN 680.

Ausschuß für wirtschaftliche Verwaltung (AWV)
April 1927 Fachausschuß für Bürowesen Fortsetzung Seite 2

128

Geschäftsbriefe **Halbbriefe Format A 5 (148×210)**	**DIN** **677**

Leitsätze und Erläuterungen

1. Die Linien deuten lediglich die Abgrenzung der einzelnen Felder an; auf dem Halbbrief selbst sollen nur der Heftrand, die Schluß-, Falt- und Lochmarken sowie das Anschriftfeld durch feine Linien, Eckzeichen, Punkte usw. kenntlich gemacht werden.

2. Unbedingt einzuhalten sind:
 Heftrand von mindestens 20 mm Breite,
 Lage und Abmessungen der Felder für Anschrift des Empfängers, Eingangsvermerke und des Absenders Postanschrift,
 Reihenfolge der Post- und Geschäftangaben (Drahtwort, Fernruf usw.; das Wort Betreff kann in den Heftrand hineingerückt werden),
 Reihenfolge der Zeichen- und Tagangaben.

3. Nur die unterstrichenen Angaben sollen wörtlich oder sinngemäß eingedruckt werden, die andern Angaben des Normblattes dienen lediglich zur Erläuterung.

4. In der Zeile für Post- und Geschäftangaben (Drahtwort, Fernruf usw.) können einzelne Angaben weggelassen oder neue zugefügt werden.

5. Es ist empfehlenswert, die Leitworte für Zeichen und Tagangaben so zu setzen, daß die zugehörigen Eintragungen nicht daneben, sondern darunter erfolgen können. Dadurch wird wiederholtes genaues Einstellen der Schreibmaschine vermieden. Aus demselben Grunde soll die Jahreszahl bei Tagangaben nicht vorgedruckt werden. Unter „Ihre Zeichen" sind Akten- und Ansage- (Diktier-) Zeichen zusammenzufassen.

6. Ist der Absendeort vom Sitz der Firma verschieden, so kann statt des vorgedruckten Wortes „Tag" der Absendeort und dahinter das Wort „am" vorgedruckt werden.

7. Anlagen- sowie Verteilvermerke sind links unter dem Text, Angaben über die Art der Versendung (z. B. Einschreiben, Rohrpost) sind im Anschriftfeld über der Anschrift anzugeben.

8. Auf dem Heftrand können Druckvermerke (Auflagehöhe, Auflagetag), Blattgewicht, Felder für Gegenzeichnung usw. aufgenommen werden.

9. Beim Halbbrief quer kann die Zeile der Zeichen- und Tagangaben bis an den oberen Rand gerückt werden, wenn auf die Firmenangabe an dieser Stelle verzichtet wird. Dadurch wird Schreibfläche gewonnen.

Fortsetzung Seite 3

Geschäftsbrief
Halbbriefe Format A 5 (148×210)

DIN
677

Halbbrief quer

Erläuterungen Seite 2

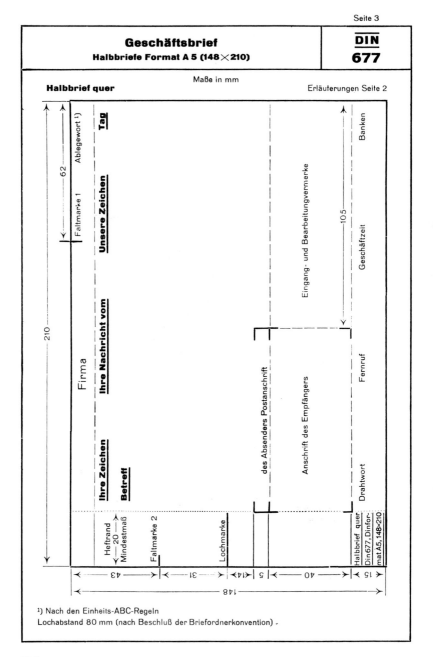

¹) Nach den Einheits-ABC-Regeln
Lochabstand 80 mm (nach Beschluß der Briefordnerkonvention) .

ENVELOPES WITHOUT WINDOWS

For the standard letter size A4, the envelope size is DIN C6. Besides this main size other sizes are in use, for various reasons, to be seen in Standard 678 (see reproductions on the following pages).

According to the latest Post Office rules, the firm's address, and advertising matter, may be placed only on the left-hand third of the front, and on the back, where however a margin of not less than 2½ cm must be left at the top. It is recommended that about 3 cm be left free on the top margin on the front, in whatever size of envelope, to avoid the postmark obliterating any of the print. Stamps (including franking) and address should be incorporated in the typographic design since that is how the addressee receives it. It is therefore desirable to stick a stamp down on the layout.

Our reproductions show two good examples of typographically designed envelopes. The envelope by Piet Zwart conforms to German Post Office rules except for the recommended but not obligatory 3 cm clear strip at the top; it is a fine example of an envelope in C6 format. The envelope for Gerasch, because the design extends over half the front, admittedly does not conform to present Post Office rules, but is included here only as an example of design in general.

PIET ZWART: Envelope with designer's device (reduced). Black and red on grey. Format C6 (114x162).

Bezeichnung einer Briefhülle im Format C 6 (114 × 162)

Hülle C 6

Briefhüllenformat		Einlagenformat		Einlagenbeispiele
Kurz-zeichen	mm	Kurz-zeichen	mm	
C 7	81 × 114	A 7	74 × 105	Besuchskarten, Glückwunschkarten, Karteikarten, Anschriftkarten
C 6	114 × 162	A 6	105 × 148	Postkarten, gefaltete Briefe und Akten, Broschüren, Werbsachen, Karteikarten
C 5	162 × 229	A 5	148 × 210	Briefe, Akten, Broschüren, Werbsachen, Karteikarten, Zeichnungen, Normblätter, Aktien
C 4	229 × 324	A 4	210 × 297	
1/2 C 4	114 × 324	1/2 A 4	105 × 297	lang gefaltete A 4-Formate
B 6	125 × 176	C 6	114 × 162	A 6-Formate mit C 6-Deckel, Briefhüllen C 6, dicke A 6-Sendungen
B 5	176 × 250	C 5	162 × 229	A 5-Formate mit C 5-Deckel, C 5-Briefhüllen, dicke A 5-Sendungen
B 4	250 × 353	C 4	229 × 324	Schriftstücke in C 4-Mappen und -Aktendeckeln
1/2 DB 4	136 × 353	1/2 C 4	114 × 324	lang gefaltete C 4-Formate

Bei der Bestellung sind Qualität, Farbe, Art und Ausführung anzugeben.
C 7 ist die kleinste bei der Post aufzuliefernde Briefhülle.
C 6 ersetzt Quart- und Foliobriefhüllen.
Papierformate — Anwendungen der A-Reihe - siehe DIN 198
Papierformate — Metrische Formatordnung — siehe DIN 476
Fensterbriefhüllen siehe DIN 680
Ausführung: Umschlag, Tasche oder Beutel

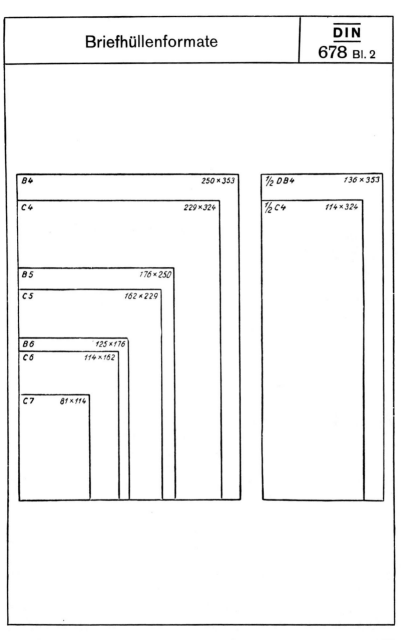

Briefhüllenformate	$\overline{\text{DIN}}$ 678 Bl. 2

B4 250 × 353

C4 229 × 324

B5 176 × 250

C5 162 × 229

B6 125 × 176

C6 114 × 162

C7 81 × 114

½ DB4 136 × 353

½ C4 114 × 324

JAN TSCHICHOLD: Envelope for advertising matter. Red on white. Reduced.

WINDOW ENVELOPES

To avoid repeating the address on the envelope and to make putting a letter into a wrongly addressed envelope impossible, window envelopes are used, whose sizes are laid down in Standard 680 (see reproduction).

The common envelopes with rounded windows should be replaced by windows with square corners.

If the standard letter is folded in the simplest way — once across and once longways — the corresponding window envelope must have a horizontal window. Since this is not yet agreed by the Post Office, the less convenient triple fold as shown in DIN 676 is necessary.

The postal address of the sender appears in the standard window, so it is not absolutely necessary to print it on the envelope. But if the sender wishes to make his envelopes recognizable, the firm's address can of course be printed outside. Example: Tapetenhaus Rühl.

Fensterbriefhüllen

Maße in mm

Fensterbriefhülle	Faltung des Geschäftsbriefes Format A 4 DIN 676	Faltung der Halbbriefe Format A 5 DIN 677

Format C 6 (114×162)

Bezeichnung:
Fensterbriefhülle C 6 DIN 680

Format 114×229

Bezeichnung:
Fensterbriefhülle 114×229 DIN 680

Format C 5 (162×229)

Bezeichnung:
Fensterbriefhülle C 5 DIN 680

Die Formate C 6 und C 5 sind DIN 476 entnommen, das Format 114 × 229 ist von diesen abgeleitet.
Die Ecken der Fenster können gerundet sein.
Die Breite der Fensterumrahmung ist nicht festgelegt.
Für einwandfreie postliche Erledigung ist beste Durchsichtigkeit des Fensters erforderlich.
Die Rückseite und das linke Drittel der Vorderseite dürfen für Firmen- und Werbeaufdruck benutzt werden
Freimarken sind in die obere rechte Ecke zu kleben.
Ausführung: Umschlag oder Tasche
 Bei Bestellung sind Güte, Farbe, Art und Ausführung anzugeben.

Papiergüten siehe DIN 827
Briefhüllen ohne Fenster siehe DIN 678

Umschlag

Tasche

Oktober 1926 Ausschuß für wirtschaftliche Verwaltung (AWV)

Also on the window envelope, according to the latest rules of the Post Office for business addresses and advertising, only the left-hand third of the front may be used, and the back, where not less than 2½ cm on the top must be left clear. About 3 cm is recommended to be left clear along the top on the front, on all sizes, to avoid a postmark obliterating any type. Stamps (including franking) should be incorporated in the typographic design, since the receiver usually receives franked envelopes.

HERBERT BAYER: Standard window envelope (reduced). White paper. Printing in black and red. Format C6, DIN 680.

THE POSTCARD

A standard for postcards has been withdrawn, because the Ministry for Posts raised an objection. A new standard is in preparation.

The standard for postcard sizes is DIN A6 (105x148 mm), the largest permissible in Germany and also the standard world size. Postcards in A6 can therefore be sent to any country.

The Post Office prescribes that the right half of the card be left free. The left half is for the use of the sender. To print the word "postcard" is unnecessary.

Since no standard for the layout of postcards is yet laid down, the design is left almost completely to the individual. The following pages show some good typographic solutions for ordinary postcards. In the design of a postcard, as in letterheads, the writing of the address and the stamp must be integrated in the design (postcards are always received written; only the sender and printer see them without writing). It is better to stick a stamp on the actual design. Stamps must not have a border (for example, a twelve-point rule) round them, which might make the postmark illegible.

The most usual form of laying out the address:

Herrn
 Fritz Meyer

 Berlin-Charlottenburg 2
 Goethestrasse 40

based on handwriting, is unsightly and unsuitable for the typewriter.

The aligned way:

 Herrn Fritz Meyer
 Goethestr. 40

 Berlin-Charlottenburg 2

is better: it is standard practice in the USA. Its clearer arrangement fits typographic design far better.

It is advisable to leave a margin of at least 20 mm round both front and back of the postcard. Like every other kind of stationery it must be capable of being read in a file without having to take it out. In some of our examples this recommended margin is left free. The upper 25 mm of the (gummed) address side is better left unprinted, as the postmark may make it unreadable. (The Postal authorities however guarantee that in the future this will not happen, on postcards.) The design of some of the postcards reproduced here has taken account of that.

The use of bold rules to underline the main address in some of our examples has not proved to be very functional. It sometimes requires a time-

wasting adjustment of the typewriter. It is better to underline the address on the typewriter, as shown on the previous page.

Type matter should not be "killed" by the typewriting — another reason for using sanserif, especially in semi-bold and bold weights.

On ordinary postcards the writing side should be so written and printed that it can be read lengthways (with postcards with flaps that happens any-way). Lengthways is the natural way to read: postcards are not book pages. A properly written postcard has the writing as on a book page turned side-ways.

FOR POSTCARDS WITH FLAPS SEE PP. 144–147

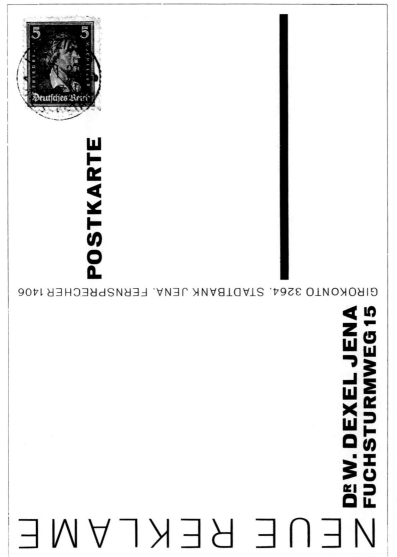

POSTKARTE

GIROKONTO 3264, STADTBANK JENA, FERNSPRECHER 1406

Dᴿ W. DEXEL JENA
FUCHSTURMWEG 15

NEUE REKLAME

WALTER DEXEL: Postcard in A6. Black type on yellow card.

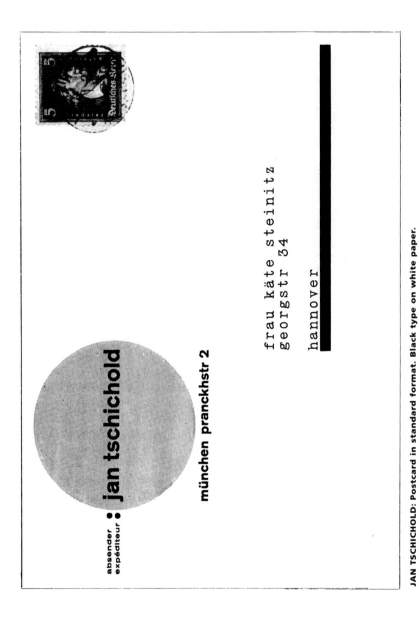

JAN TSCHICHOLD: Postcard in standard format. Black type on white paper.

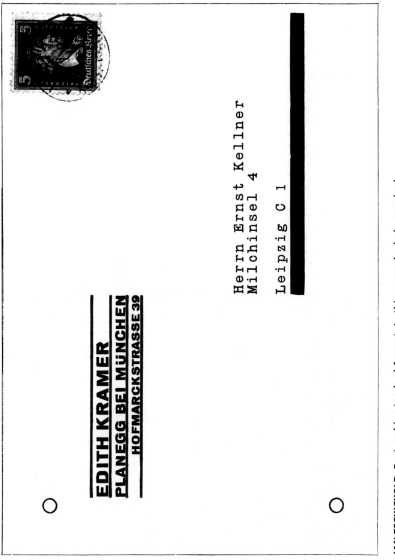

EDITH KRAMER
PLANEGG BEI MÜNCHEN
HOFMARCKSTRASSE 39

Herrn Ernst Kellner
Milchinsel 4

Leipzig C 1

JAN TSCHICHOLD: Postcard in standard format. In this example, hole-punched.
Original in black and red on yellow card.

141

JOOST SCHMIDT: Postcard in standard format. Black type on white.

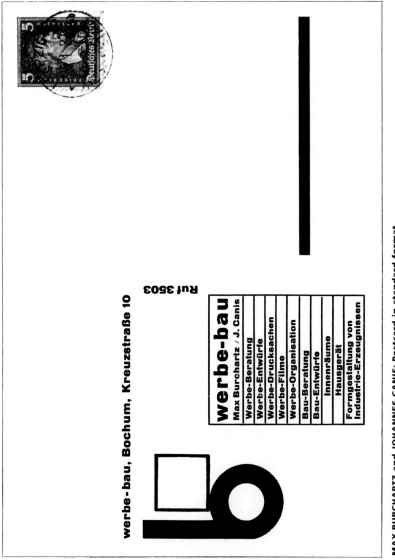

werbe-bau, Bochum, Kreuzstraße 10

Ruf 3503

werbe-bau

Max Burchartz / J. Canis

Werbe-Beratung
Werbe-Entwürfe
Werbe-Drucksachen
Werbe-Filme
Werbe-Organisation
Bau-Beratung
Bau-Entwürfe
Innenräume
Hausgerät
Formgestaltung von
Industrie-Erzeugnissen

MAX BURCHARTZ and JOHANNES CANIS: Postcard in standard format

143

THE POSTCARD WITH FLAP

offers great advantages in economy of time and effort, especially to firms
with extensive correspondence. The basic DIN A6 (105x148 mm) gives the
lengthways format 2 DIN A8 (52x148 mm) (see illustration). The address
can thus be typed on the same side as the message. The flap is folded back
and stuck down. This allows the omission of the address on the correspon-
dence side (which otherwise, only because of the carbon copy, must be
included) and enlarges the space available for correspondence, which has
at its head the four main headings and the "subject."

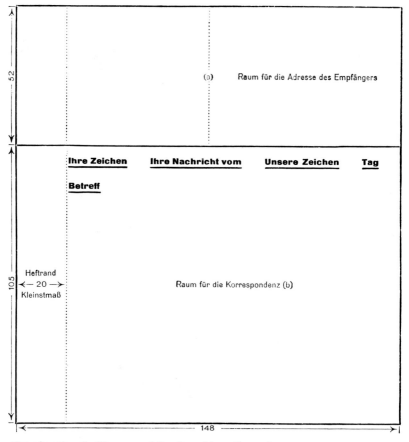

Size of postcard with gummed flap for address (in mm).
Both parts can be typed in one sequence, and then part (a) is folded back and pasted down on
part (b).

Since so much of today's correspondence is on postcards, it becomes more and more necessary to follow these general rules.

For the firm's details on the front of such postcards, the whole left half — or the upper/lower left quarter (to be finally stuck down) of the address area — can be used. It is expedient to use the lower left quarter for the firm's details. In this way (provided the printing is in one colour) only one printing is required for both sides of the card (see the Lechner-Norkauer postcard on the following two pages).

On such postcards, which for reasons of economy carry the sender's details below left, it is not always easy to make the necessary distinction of the addressee's address quite clear. A simple vertical rule, running only to the middle, usually looks ugly. The best solution is to put a rule round one of the halves, as on the Lechner-Norkauer card. This shows the most practical kind of modern postcard.

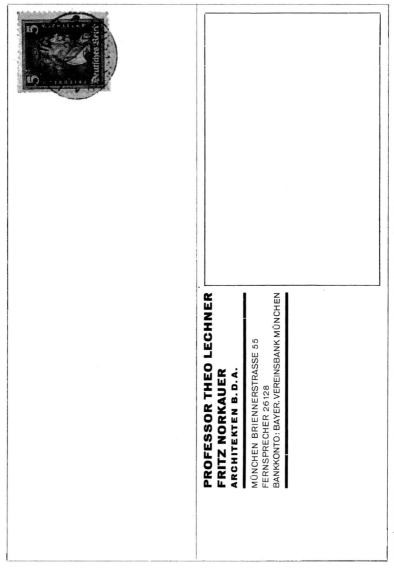

JAN TSCHICHOLD: Front of postcard with gummed flap for address. Black type on white.

IHRE ZEICHEN IHRE NACHRICHT VOM UNSERE ZEICHEN TAG

BETRIFFT

Reverse side of above postcard

THE BUSINESS CARD

The business card format is A7 (74x105 mm). If business cards were not as formerly in completely random sizes, but in this uniform and suitable size, with a catchword heading for filing (see scheme), then the arrangement of an address file — in either alphabetic, subject, or geographical order — would be made possible, and unlike the present lack of system could easily be kept in perfect order, with additions or deletions as needed.

A norm for business cards does not yet exist. It is recommended that besides being made in the uniform size already mentioned, all cards should have headings as in this example:

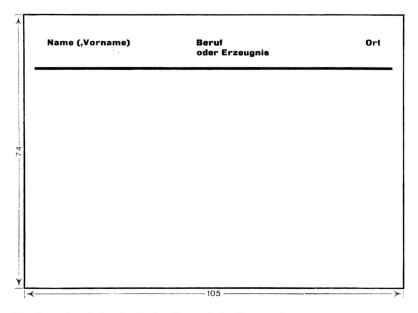

Size (in mm) and plan for the headings of a business card.
The space beneath the rule is for remaining information: the full name of firm, town (and street) telegraphic address, telephone, business hours, bank, list of products, trademarks, agents, etc.

Good solutions of every kind, even in the old-fashioned centred typography, must use the specified format and headings. The business card "werbe-bau" shows that the required format and headings need not spoil the card's effectiveness.

werbe-bau Werbe-Beratung Bochum, Kreuzstr. 10
Bau-Beratung Ruf 3503

werbe-bau

Max Burchartz / J. Canis

| Werbe-Beratung |
| Werbe-Entwürfe |
| Werbe-Drucksachen |
| Werbe-Filme |
| Werbe-Organisation |
| Bau-Beratung |
| Bau-Entwürfe |
| Innenräume |
| Hausgerät |
| Formgestaltung von Industrieerzeugnissen |

Es besucht Sie Herr Canis

Bitte wenden!

Diese Besuchskarte ist durch Format und Satzanordnung als Adressen-Kartei-Karte verwendbar. (Näheres: Din-Buch 1 Papierformate Beuth-Verlag Berlin S14)

Normrechte Drucksachen in Dinformat entwirft **werbe-bau**

MAX BURCHARTZ and JOHANNES CANIS:
Front and back of a filing-adapted business (address) card. Actual size. Format A7 (74x105). Black type on white card.

149

In view of the present chaos in business-card design — even worse than that in pre-standardized business letterheads — the recommendations made here are most urgently required. Even if the system of headings is not followed, at least the A7 format should be adhered to.

THE VISITING-CARD

A private visiting-card naturally does not carry headings. Most important: the prime requisite for a satisfactory result is to keep the printed information down to the barest essentials. Since for various reasons it is most desirable that the dimensions of business and private cards should be the same, the format DIN A7 (74x105 mm) must be used. The former distinctions between "ladies' cards" and "gentlemen's cards" and countless similar nuances must be forgotten: they have now become stupid and in addition unpractical. Example:

Visiting-card in standard format (DIN A7, 74x105). Black type on white. Actual size.

ADVERTISING MATTER
SLIPS CARDS LEAFLETS PROSPECTUSES CATALOGUES

It is difficult to lay down standards for the design of advertising matter since this appears to contradict the whole essence of the business. Advertising depends on variety, departure from rules, and surprise. It would be wrong to insist on wholesale restrictions in its design.

Format

The belief that form does not have the same importance in advertising as the text, the typography, photography, and colour, is not valid. Everyone who sends advertising matter out into the world hopes that it will not be thrown carelessly away, but read carefully and, where possible, kept for reference. It will not often lead to a direct sale; but if the subject matter is of interest, the recipient will remember it and when opportunity offers will come back to it. Advertisements, leaflets, and catalogues accumulate and begin to acquire a significance whose purpose is lost if they cannot easily be stored and a particular item cannot be found when it is wanted. And the effort to make advertising matter conspicuous by means of its format is wasted if everything is the same size. Would-be attractive smaller formats disappear beneath larger ones, and giant formats are a nuisance to those who must store them. In addition, formats all of different sizes will eventually become torn or otherwise damaged. Sadly today, out of any 100 advertising items collected in exhibitions or elsewhere, 95 will be in different shapes and sizes. It would be a great advantage if standardization in these areas could be consistently followed. It would mean less work for those who receive advertising matter, and for the manufacturers it would be a recommendation and probably profitable.

The introduction of standard formats in advertising will bring with it all the other advantages of standardization: greater economy, real organization of print production, etc. In addition, advertising items would fit into filing systems with most business correspondence, standard format periodicals, etc., and this too offers many advantages. Basically, the sizes of A-range are all that is needed. The main format here is A4 (210x297 mm) and A5 (148x210 mm).

The artistic possibilities of standard formats, which give good page proportions, are unlimited. This is shown by the numerous reproductions in this book of matter printed in standard formats. It is usually a sign of incompetence when a non-standard format is insisted on "for artistic reasons."

KURT SCHWITTERS:
Advertising slip (actual size). Black type on blue paper.

Design

The graphic design of all advertising depends to a high degree on the quality of the text. The writing of text should always be entrusted to an expert: advertising today has become a science, which it is dangerous for laymen to enter. A defective text can endanger the effectiveness of the whole.

As regards the type, an effective and original typographic form must be found. The advertising card for the Kubin Exhibition by Walter Dexel shows the powerful effect which can be obtained from type alone. All secondary matter (rules etc.) has been excluded. It is in fact often necessary to use such secondary matter to obtain a good result, but it must always belong to the whole design and not be introduced like old ornamentation. Bold borders, rules, points, etc. must be *functional*. The decorations which are typical of old typography are always wrong. Rules used in the New Typography are necessary when they provide contrast and emphasize visual effect.

In the advertising slip by Kurt Schwitters, the vertical black strip is most necessary because it provides such a strong contrast to the horizontal lines of type. In this design of contrasting directions, the difference

152

KUNSTVEREIN JENA
PRINZESSINNENSCHLÖSSCHEN
3. BIS 31. MAI 1925

ALFRED KUBIN

AQUARELLE
ZEICHNUNGEN
LITHOGRAPHIEN

MITTWOCHS UND SONNABENDS 3—5 SONNTAGS 11—1
AUSSER DER ZEIT FÜHRUNG DURCH DEN HAUSMEISTER

WALTER DEXEL: Advertising card in standard format A6. Black type on blue card.

153

FAGUS

SCHAFTMODELLE

WENN SIE wissen wollen, was modern ist,

fragen Sie mich

WENN SIE wissen wollen, was praktisch ist,

fragen Sie mich

WENN SIE eines fachmännischen Rates bedürfen,

fragen Sie mich

Vierte und erste Seite

Zweite und dritte Seite

HERBERT BAYER: Four-page advertising leaflet. Black and red on white. DIN A5, horizontal. Hole-punched in advance.

between the free forms of the type and the compact area of black provides the effect.

The Fagus leaflet by Herbert Bayer shows the powerful effect of pica-rules in colour. By themselves of course they do not guarantee the result, but they are used consciously as a means to increase the optical intensity. The large white space on page 2 with the small Fagus trade mark is made noticeable by the red right-angle. The arrow on the same page is used logically as well as harmoniously to contrast with the grey of the type; and the large query sign on page 3, besides by its nature indicating something important, makes a strong and pure visual contribution. And the red circle on page 2 is not decorative but functional; it calls attention to the firm's details. To make filing easier the leaflet has been hole-punched: the holes are incorporated in the typographic design.

The prospectus by Moholy-Nagy (opposite) is another thoughtful design with great visual impact.

Besides typographical contrasts, functional use of colour can increase optical intensity. Contrast between black and white is one of the strongest and simplest ways to achieve an effective result. Further effect can be obtained by the use of coloured papers or card, printed in black or other colours. Further enrichment can be got from the use of a second as well as a single colour on white or coloured paper.

The place of colour in the New Typography has been dealt with in the section on basics, and need not be further emphasized here.

It is especially in advertising that strong contrasts by every possible means must be used for the most effective results. If possible these should be obtained by exploiting the characteristics of type and photography etc. Only when these are not enough should secondary sources of contrast (borders, rules, points) be resorted to. The intentionally very different kinds of design shown here in the two advertising leaflets by Burchartz and Canis are examples of this. On the "werbe-bau" leaflet the heavy form of the symbol and the firm's name contrast with the small type in the open panel above and the isolated panel in the middle. The broken appearance of the short lines just above and below "werbe-bau" are in effective contrast with the tightness of the rest of the type. In the "fährt" leaflet, the angled paragraph and the repetition of "100%" (in green and black) are used as means to gain effect.

An exceptionally important role is played in modern typography, and especially in poster design, by the use of photographic blocks. The invention has introduced a new epoch in graphic design, in whose beginning we now first find ourselves. Nearly everything formerly achieved by drawings,

156

L. MOHOLY-NAGY: Inside double spread from a book prospectus. Black and red on white. 1924.

whether engraved, cut, or etched, can now be done better, faster, and usually more cheaply, by photos and blocks. Sadly the possibilities of photography itself and photographic techniques are still shunned by many, including even printers. My belief that photography is just as much a part of typography as type and rules has been strongly opposed. Photographs, like letters, are a means of communication. The faster and simpler the means of communication the better. The development of our type from pictures to writing was intended to increase, as much as possible, understanding between people. Today there is much that we can "say" more simply with photographs than with words. And are not photographic blocks materially related to type? Certainly progress will bypass those who do not accept the photographic block in typography, or photography in general, and consider them a "non-artistic form." (This problem is dealt with in the section on "Photography and Typography," p. 87.) In advertising, at all events, there is no question of an "artistic representation" of an object. Of these "artistic" forms and oil-paintings that so often were completely "unreadable," we have now had enough. The required object must be shown as clearly, as perfectly, and as truthfully as possible, and nothing can do this so well as photography. Because photography, as a black-and-white form, when combined with type provides totally new possibilities of design by means of the

MAX BURCHARTZ
and JOHANNES CANIS:
Reverse side of an advertising leaflet,
in DIN A4. Black and green.

contrast between (apparent) plastic and flat, it can be said that today's typography is completely different from everything in the past. Typography has thus become "three-dimensional" — an expression of our time, which seeks to conquer space.

Photography has the advantage over drawing that it is free of the often overwhelming "personality" of the artist, whose individuality is out of harmony with the spirit of our time. Indeed, every drawing contradicts the aim of good advertising for greater objectivity and reality. People believe a photograph — a drawing not entirely.

A good example of the integration of photography with typography is provided by the advertising leaflet for the old Bauhaus by Joost Schmidt shown opposite. The grey tones of the photographs combine well with the type. The apparently unnecessary vertical double rule in the middle was needed as a thin grey form in contrast with the heavier greys of the photography.

When the available facilities of type are not exactly what is required, photomontage can offer many possibilities for effective results in advertising design.

On the two following pages the Gerasch fair-invitation shows a premeditated composition of photographs on the inner pages which fits in nicely with the continuity of the whole. (Not only single pages must be legible

unities, but multi-page booklets must be so designed that their arrangement makes the reader unconsciously read on. Printed matter of this kind in the past was just a stringing together of centred groups.) The colour areas on the inner pages help the "plastic" form of the photographs. It is perhaps interesting to note, in detail, how the compulsion to read on was achieved on the first page of the invitation.

Some jobs by their nature cannot be expressed simply by photography, so curves, diagrams, and plans may be used. An interesting borderline case of this kind is the typographic plan by Seiwert for a gallery in Cologne, which is as effective as the Gerasch invitation already mentioned. Curves, diagrams, and so on are significant for our scientific age. Their graphic form can enrich our typography, as industrial prospectuses like Burchartz's Weichenbau and Molzahn's Elektrodrehbank prospectuses (both on the following pages) show.

STAATLICHES BAUHAUS WEIMAR

NEUE SCHACHSPIELE GES. GESCHÜTZT

Das BAUHAUS-SCHACHSPIEL von JOSEF HARTWIG ist ein Spiel mit NEUEN BRETTSTEINEN, die entsprechend ihrer Funktion gestaltet sind. Sie unterscheiden sich grundsätzlich von den alten illustrierenden Spielfiguren, die oft sehr schön, aber sehr schwer spielbar und äußerst kostspielig herzustellen waren. Ebenso von den heute allgemein gebräuchlichen gedrechselten Spielen, die als ein Gemisch von Brettsteinen und Figuren ihren Sinn verloren haben.

DIE NEUEN SPIELSTEINE sind gebildet aus 3 stereometrischen Grundformen: Würfel, Cylinder und Kugel. Einzeln oder kombiniert geben sie durch ihre Form die Gangart, durch ihr Volumen den Wert an.

BAUER und TURM ziehen winkelrecht zum Brettrand: ausgedrückt durch den Würfel

DER SPRINGER bewegt sich rechtwinklig in Hakenform auf 4 Feldern: 4 Würfel rechtwinklig kombiniert.

DER LAUFER zieht diagonal zum Brettrand. ein Schrägkreuz aus dem Würfel geschnitten

DER KÖNIG zieht winkelrecht und diagonal. ein kleiner Würfel übereck auf einem größeren.

DIE DAME, die beweglichste Figur, besteht aus Cylinder und Kugel. Sie sieht in starkem Kontrast zu König, Turm und Bauer, deren Form ein Würfel ist das Symbol des Schweren und Massigen.

Der Spielwert der Steine ist durch Höhe und Volumen bezeichnet: König und Dame sind am größten, die Bauern am kleinsten. Läufer und Springer sind gleich groß und haben je das halbe Volumen des Turmes.

Das bisherige Spielbrett ist ersetzt durch eine GLASTAFEL. Die quadratischen Felder bilden zusammen mit den kubischen Figuren eine Formeinheit von außerordentlicher Klarheit.

Wichtig ist, daß die STEINE in der Ansicht und noch wichtiger in der DRAUFSICHT deutlich zu unterscheiden sind und sich in ihrer mäßigen Höhe RELIEFARTIG über die Spieltafel ausbreiten.

Ihre Größen sind so berechnet, daß sie, in einem kleinen Kasten verpackt, den Raum ganz ausnützen und ihre Vollzahl klar ersehen lassen. JOSEF HARTWIG.

JOOST SCHMIDT 1924: Advertising leaflet (letter format)

Merken Sie sich bitte:

werden wir auch in diesem Jahr, wie bisher, vertreten sein auf der

Verpackungsmittel-Messe

im Leipziger Hof, Reichsstraße 12, 4. Stock, Nr. 474/8

Versäumen Sie nicht, wenigstens eine unserer Messe-Ausstellungen wahrzunehmen, und benutzen Sie die Gelegenheit, uns Ihre Anfragen, Wünsche und Aufträge persönlich zu überbringen.

Emil Gerasch GmbH Leipzig

Lithographie, Stein- und Offsetdruck, Papiergestaltung

GERASCHDRUCK
WARENSCHMUCK

JAN TSCHICHOLD: Advertising leaflet in typography and photography. **Black and red on white.** First and fourth pages.

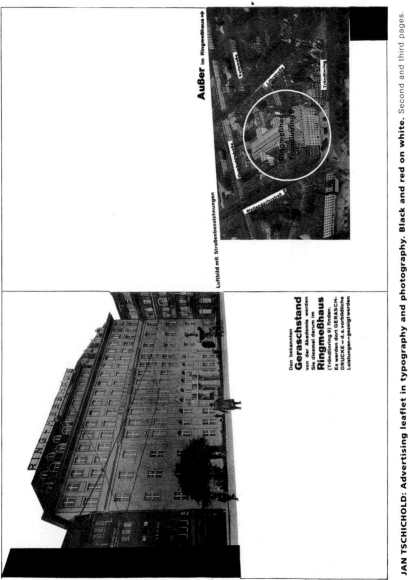

Luftbild mit Straßenbezeichnungen

Außer im Ringmeßhaus →

Den bekannten
Geraschstand
von der Akademie werden
Sie diesmal darum im
RingmeßHaus
(Tröndlinring 9) finden.
Es werden dort GERASCH-
DRUCKE – d. s. vorbildliche
Leistungen – gezeigt werden

JAN TSCHICHOLD: Advertising leaflet in typography and photography. **Black and red on white.** Second and third pages.

163

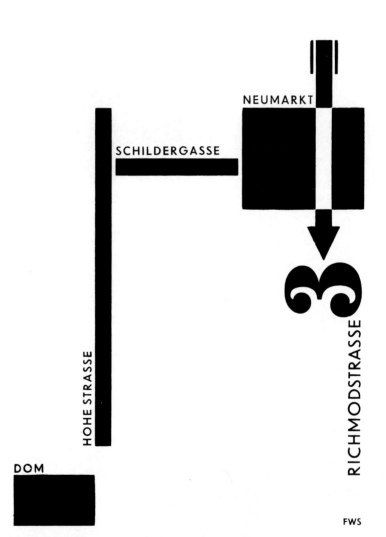

NEUMARKT

SCHILDERGASSE

HOHE STRASSE

RICHMODSTRASSE

DOM

FWS

FRANZ W. SEIWERT: Plan for finding a Cologne gallery

A classic sequence of "typo-photos" (as the combination of photography with typography is called) has been made by Max Burchartz, the designer, and Johannes Canis, author of the text, for a portfolio of advertising leaflets for the "Bochumer Verein für Bergbau und Gusstahl-fabrikation" (Bochumer Mining and Steelworks). A reproduction of the cover is shown in the section on Typography and Photography, p. 90. The reproduction of some of the inside pages that follow does not do justice to their beauty. There are about a dozen separate pages in A4 showing the different products of the firm. Each sheet is printed in black and a different colour (identification by colour). The colour is used not for decoration but functionally to express the form and create colour-form-contrast. I do not hesitate to name this whole work as an example of the spirit of our epoch. Molzahn achieves an almost pictorial effect in his Elektrodrehbank prospectus, by means of most powerful contrasts of colour and form (p. 171). Here photography plays an important part in the composition of the whole, but almost as strong an

LAJOS KASSÁK:
Goods catalogue. 1926

MAX BURCHARTZ and JOHANNES CANIS: Four-page Weichenbau (railway points) prospectus. Fourth and first pages.
Original in black and orange. Design elements: type and photomontage. Format: DIN A4.

MAX BURCHARTZ and JOHANNES CANIS: Four-page Weichenbau (railway points) prospectus. The inside double spread. Original in black and orange. Design elements: type and photomontage. Format: DIN A4.

MAX BURCHARTZ and JOHANNES CANIS:
Prospectus (crankshafts). On facing page, the title. On this page, inside double spread. Original in black and red.
Type and photomontage. Format: DIN A4.

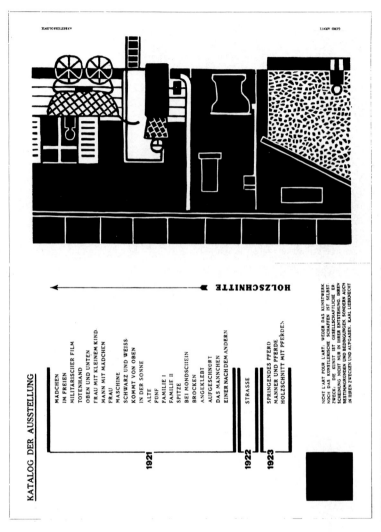

FRANZ W. SEIWERT: Two pages of an exhibition catalogue

MOLZAHN
ENTWURF

**ELEKTRO
DREH-
BANK**

E 26

MIT
ANTRIEB DURCH
POLUMSCHALT
BAREN
DREHSTROM
FLANSCHMOTOR

SÄGENDIAGRAMM

JOHANNES MOLZAHN:
Page from a prospectus. Format A4. Black and green on white paper.

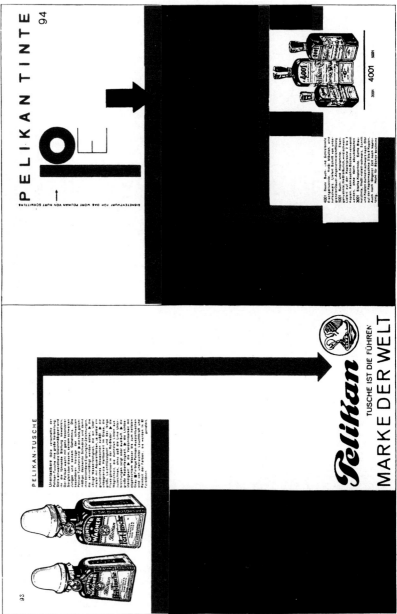

KURT SCHWITTERS: Two pages from the Pelikan number of the periodical *Merz.*

effect can be produced using only areas of colour and ordinary line blocks. On rough papers which (except in offset printing) are not suitable for halftone blocks, photography has to be replaced by functional (non-artistic!) drawing. The two pages opposite from a Pelikan special number show what a fine result can be achieved in this way.

In the two works by Molzahn and Schwitters and the catalogue by Kassák we are moving out of the field of pure typography and coming close to painting. It is dangerous for printers to venture into this area, since such work demands an exceptionally deep study of the laws of space, proportion, colour, and form. It would be better to entrust such work to an artist with relevant experience.

Just as photography is finally only a part of typography, whose effect is achieved by its harmony with the whole, so it is possible to enrich typography with, for example, graphic reproductions or original graphics, as in the exhibition catalogue by Franz W. Seiwert. Here, to achieve visual balance on the double spread, the black square below left became necessary.

So any available block (even if of little artistic value) and any typographic element (so long as it is not merely for ornament) can be used in the New Typography; it simply depends on introducing them harmoniously into the whole.

THE TYPO-POSTER

Format

The official poster sizes laid down since 1 May 1927 are:

2 sheet	**84 × 120** cm.	Half sheet	**42 × 60** cm.
1 sheet	**60 × 84** cm.	Quarter sheet	**30 × 42** cm.

These sizes represent DIN sizes A0, A1, A2, and A3 rounded to cm. Smaller posters (as long as they are not intended for poster pillars) should be in exactly A4 (210 x 297 mm) or A5 (148 x 210 mm).
Label sizes are dealt with in Standard 825 (Label Formats) in a later section (p. 192).

Pillar poster in conventional style:
Centred arrangement, even where it is obviously senseless; borders; "decoration" in the form of thick/thin rules. Inefficient, unfunctional, unpleasing. The thick/thin border rules make the poster look smaller than the redesigned version opposite.

Design

More than in any other kind of printing, poster design requires the strongest effect and utmost clarity. Unfortunately most of today's posters have neither. I am far from blaming the compositors for this, because I know the difficulties that militate against their efforts to produce good designs. The tempo in which posters are set and printed in the cities' printing works are against it. But such difficulties are not insuperable. In the following pages I try to give some guidelines for the design of typo-posters.

A basic fault in nearly all typo-posters is the retention of conventional centred typography. In the beginning, posters were modeled on title-pages, taken from old book-design, and this still happens today. In order to make a poster stand out from its neighbours, it was usually given more or less hideous border rules.

By following the still-prevalent principle of centred typography, modern posters cannot be effective — unless by using unusual coloured papers or

JAN TSCHICHOLD: The same poster redesigned.
Practical, lucid appearance. Type used in the earlier poster has been mostly retained. The effect is gained chiefly by contrasts in type sizes and the use of space. The large F used as eye-catcher. It can be seen how unimportant "beautiful type" is.

inks: they will have a boring uniformity. The purpose of a poster — to attract — can hardly be achieved in this way.[•]

In addition, to surround the type as usual with borders uses up part of the space — which leads to smaller sizes of type, which also, because of the borders, look smaller. Perhaps originally all typo-posters were printed on white paper, so that their edges had to be marked. The fact that today posters can be distinguished from other matter by the use of different-coloured papers removes the need to use borders. About another important yet almost never used method to make typo-posters more effective I will speak later.

Very heavy display lines, characteristic of typo-posters, lead to strong contrasts which contradict the nature of the old typography. Only the new laws of typography allow the rhythmic setting together of large and small lines of type. The asymmetric construction of the new typo-poster also helps the purpose better because the lines can be grouped in such a way as to make reading easier. The need to use large type for important matter, smaller type for less important matter, gives today's printers the opportunity for greater intensity of typographic expression. The possibilities for variety afforded by asymmetric design are incomparably greater than those possible in the old symmetrical typography.

It goes without saying that for posters the clearest typeface, sanserif, is the only one that is right. After that come egyptians, bold roman, or Aldine. Fraktur, gothic, italic, and similar faces are too difficult to read. They can sometimes be used to parody a text (for Nationalism, gothic and fraktur; for over-sentimentality perhaps a comic cursive, etc.). These are however rare exceptions, whose use must be limited to single lines, to show the contrast with sanserif, the type of our time, which in general must be used in all circumstances.

With the given text and clear type a plain, strong typographic form can be obtained. In this way, often type alone can be used successfully, as in the "Fortbildungskurse" poster (p. 175). But it may also happen that to achieve a desired effect, borders, arrows, even circular shapes, must be introduced. However, circles must never be used as decoration, as one unfortunately sees so often in present-day well-meaning and apparently simple posters (I

[•] The artists of the pre-war period produced, as opposed to typo-posters either well or badly set, posters drawn in extravagant letterforms, which relied for their effect on unusual kinds of lettering. Such posters depend on the availability of a suitable artist, and the carrying out of the design is complicated by the use of lithographic stone or linoleum. The results can rarely be interesting and hardly ever effective. It is naive and wrong to try to work with the pretentious means of special (= less legible) kinds of lettering.

once counted eight of these on a poster wall). If a circular or other such "secondary" form is used, it must have a function (as pointer, or for emphasis), otherwise it is purely decorative. In posters especially, decorative elements and anything non-functional must be rigorously excluded. The naive

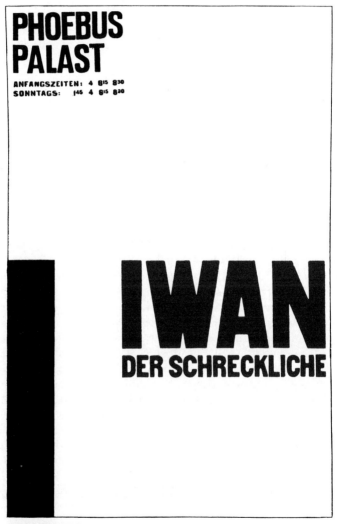

JAN TSCHICHOLD:
Typographic cinema poster, 1927. Black and red on white.

assumption that a circle by itself can be an "eye-catcher," must be discarded. (Why are circles so often placed in the least important position?) Even if a circle has once worked as an "eye-catcher," when continually repeated as decoration it is not eye-catching but repellent.

Effects must be reached with other means, for example a large letter, a figure, a special area of black or colour.

Posters can be effective with little or much text. While little text is always better than the book-length of certain posters, a long text can also be effective by means of contrasting type sizes and well-organized articulation. That is of course nearly hopeless when the client brings in a vast text and wants to have everything "big." Good poster designs are often prevented by unwise decisions. Variety and revue posters for example are lessons in ignorance about advertising in many of those who order them.

Colour in design has much to offer typographic expression. The colour of the paper itself is important. It is best to choose a paper that provides the greatest contrast in colour to other posters in use at the time. Of course this is often a matter of luck, since the colours on a hoarding can change completely overnight. Unusual colours, like pink, English green, light blue, grey, etc., and mixed shades that are not often used, can all be most effective. Admittedly papers in most of these uncommon colours are often more expensive, but their effect can be overwhelming, as they kill the monotony of the conventional yellows and violet-red.

Besides the usual black appearance of most posters, a poster in one or more colours can be very attractive. Printing a colour, say red, on a coloured, perhaps green, paper, can give a result rarely seen on hoardings, which will greatly strengthen the poster's power.

A poster can be distinguished from its neighbours by the printing of special colours and use of coloured papers. An additional and most effective means is in the use of white (unprinted) paper, a characteristic feature of the new typographic poster. This device is eye-catching, since there is almost no unprinted paper on hoardings or poster-pillars. The normal typo-poster on which every fraction of an inch is printed can look only chaotic and is therefore useless. Empty space however helps legibility and adds to the aesthetic effect.

The economy of its production gives the typo-poster today an advantage for the future, which will benefit the compositor — and most of all the printer — when it is in competition with some of the drawn posters. Such is its power.

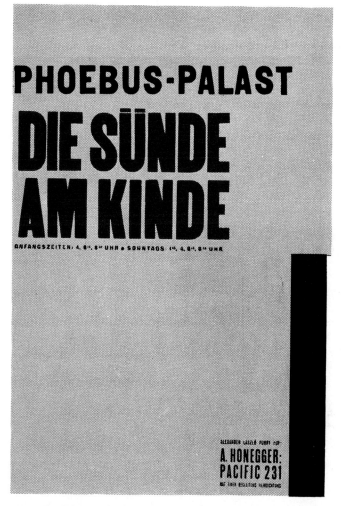

JAN TSCHICHOLD:
Typographic cinema poster. Black and blue on red-violet.

Vortrag Münchner Bund
mit Film STADTBAURAT
ERNST
MAY-Frankfurt
26. Okt. 8 Uhr Die zeitgemäße
Organisation
Garderobegebühr 70 Pfg.
des Wohnungsbaues
und der kurzfristigen
Wohnungsbeschaffung
Auditorium Maximum der Technischen
Hochschule, Eingang 2, Arcisstraße

How it should not be done!
What looks at first sight like a type-poster designed on modern lines, when looked at more closely is quite unreadable. Where does one begin reading? or continue? Ten sizes of type are used when certainly six at most were needed. The unnecessarily enlarged initials of several words introduce even more disturbance to the whole. Worst of all is the preconceived form-idea (here, the three columns) which forces the lines into fixed shapes and limits the line-lengths.

Even centred design would have been better!

180

THE PICTORIAL POSTER

Whenever advertising is required for an object which can be illustrated, the pictorial poster is essential, because it is incomparably more meaningful than any poster consisting only of words. The illustration itself must be as objective as possible: above all, free from the personal "touch" of the artist. Bernhard's "fact-posters" (for Stiller Boots, etc.) were already a step in this direction long before the war, and it must be freely admitted that they were not unsuccessful. But the individuality of the artist in those classic examples was a bit excessive and has perhaps now played itself out. The nervous hand of the painter was echoed in the "nibbled" lettering so characteristic of the pre-war period, and which degenerated into a mannerism. The theories of the pre-war artists still influence many contemporary designers, and result in posters which — apart from the few with the extreme linear skill of artists like Bernhard and Hohlwein — may interest a few for their aesthetic form but do not please the public who really matter. As no drawn posters of this kind existed at the beginning of the century, they could be effective. People had more time then than they have today, and the novel graphic forms led them to look at the posters. Today, conditions for posters are different. A poster, whether pictorial or lettered, must be absorbed at the moment of noticing or walking past; or, if a longer text is necessary, must strike and attract by means of its total effect. The poster today is still a "fact-poster" (as Lucien Bernhard preached), but the object being advertised must no longer be artistically simplified (=distorted), but must be shown in the most factual, unmistakable, and impersonal form. All trimmings which proclaim the hand of a particular artist contradict the poster's essence. From the mass of posters designed in the spirit of the earlier poster artists, hardly one stands out; the choice of colour and the painting or drawing of these individual-painterly posters have become formula-based and therefore uninteresting. The "hand" of the artist is simply superfluous, its purpose a pernicious waste of the public's time. When we realize that for the poster that must be read quickly on a hoarding, only the simplest and clearest forms can be right, we have to avoid strictly everything that is individual and unclear, because too strongly artistic. The need for the most objective, indeed the intensely factual, design is shown by the appalling quantity of inscriptions and posters in modern cities. If a poster or inscription is not crystal clear, it is useless.

For type, sanserif has in general the sharpest definition for use in posters. Pictures however are stronger and quicker in their effect than type, and here again only the most objective representation will communicate the poster's contents quickly and clearly to a passer-by. That is why so many

possibilities exist for the increased use of photography in poster design — although, when it is a question of larger poster sizes, restrictions are imposed because on the one hand the techniques of photo-reproduction have not yet advanced far enough (up till now, to my knowledge, only a few firms in Berlin can produce posters in 84 x 120 cm format by rotary print-ing) and on the other because the costs of screen exposures are still pretty high, admittedly significant only when runs are short.

More restrictive is the blind enmity, or at least hostile prejudice, of many artists against photography, which can only be explained by lack of imagi-nation. The public's taste is of course influenced by the poor quality of much advertising in more or less inferior papers, which it takes to be good but which leaves much to be desired. It is also a fundamental error of most artists to suppose that the use of photography makes artists unnecessary. By so thinking they must believe that they are seeing the end of their skills in the techniques of painting and drawing. Even a good photograph gives no guarantee of a good poster, and, equally, from only average pho-tographs good posters can be designed. It is always pictorial strength that provides the results.

The suggestive power that gives photo-posters the advantage over so many other kinds of poster lies in the extraordinary contrast of the richly nuanced "plastic" grey of photographs with areas of colour (or indeed pure white) which only the use of photography can give. Such a richly varied means of expression demands, contrary to usual opinion, at least as much imaginative ability as painting and drawing. In any case, a very highly developed feeling for harmony and proportion is needed, when posters or other printed advertising matter are being designed using these contempo-rary methods.

It is surprising how well a small part of a single photograph can sometimes work as a poster, as in the PKZ poster by Baumberger. It is a pillar-poster made from a colour photograph. Apart from the label sewn into the gar-ment, no lettering is used. Since laying down a colour photograph on stone is today virtually impossible, the colour separations for lithography had to be made by hand. Developments in reproduction technique in the near future will make mechanical reproduction possible.

JAN TSCHICHOLD: Film poster. 1927. Original in dark brown and grey.

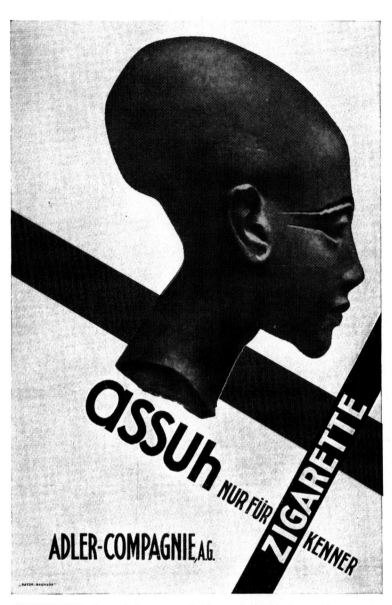

HERBERT BAYER: Shop-window poster in blue, red, and black on white.
Hand-drawn type. The line "Adler-Compagnie, AG" was added and does not belong to the
original composition.

184

OTTO BAUMBERGER:
PKZ pillar poster.
Original in full colour.

The cigarette poster by Herbert Bayer is also very effective, the design being developed from the oblique line of the neck. The line "Adler-Compagnie, AG" was added later, presumably at the request of the firm. It does not belong to the original design (as can easily be seen by covering it up) and disturbs the dynamic of the whole.

It is really astonishing that the film companies have up to now made so little use of photography for their posters. The few exceptions known to me are gravure posters with a single large photograph, in format 84 x 120 cm, but with absolutely no pretensions to any artistic form. But it is so obvious to use photography for film posters. For the posters which I was fortunate enough to design for the Phoebus-Palast in Munich in 1927, I was able owing to various circumstances to make use of only a few of the possibilities for composition and technique. The production costs of these posters, made unfortunately for only one cinema, had to be kept extremely low. As

185

a result I had to be economical with the size and number of photographs. The posters changed every week and as a rule had to be produced in from two to four days (= design and two- or three-colour printing!), so that the film title (following the usual film practice) could be published from four to two days before the first showing. Obviously in such circumstances it was rarely possible to exploit the full possibilities of design. Nevertheless I believe that the Phoebus posters are the first practical attempt to make true film posters. Moholy-Nagy has also made very interesting designs for film posters. Developments in photographic and printing techniques will certainly influence poster design.•

In spite of the many possibilities in photo-poster design, the drawn poster will probably not completely disappear. After the oil-painters of the pre-war period have played themselves out and today, insofar as they still have a name from earlier, go on repeating themselves with process blocks, like Hohlwein, nevertheless the movement today is for exactness and geometry, as opposed to the brush-painting of the earlier masters. We now have a feeling for pure mass and proportion. The work of the Frenchman A. M. Cassandre is typical of this new poster design. He has produced some out-standingly drawn posters, full of the spirit of our times and already worthy to be called classical achievements.

I end this section with statements about the new poster by two French painters, which I have taken from the monthly periodical *Querschnitt*. Both are founder members of the Cubist movement. Fernand Léger is, insofar as the expression "Cubism" still has validity, its foremost exponent.

• That from the point of view of the present it is an anachronism to cut posters in lino, like medieval woodcuts, I need hardly point out.

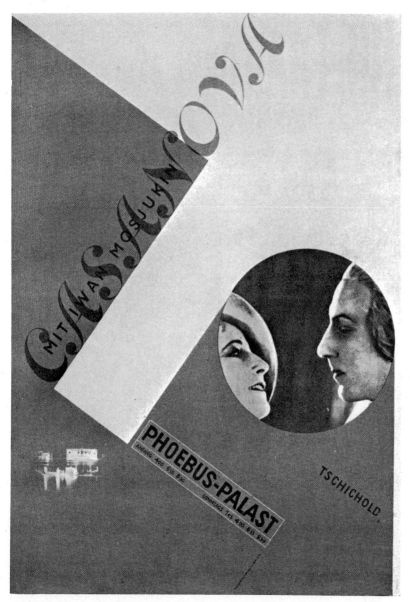

JAN TSCHICHOLD: Film poster 1927. The lower half light blue, "Casanova" red, partly overprinting the blue. The picture and the rest of the type brown-violet.

JAN TSCHICHOLD: Photo-plastic cinema poster. Photolithography and drawing on stone. Black and red on white.

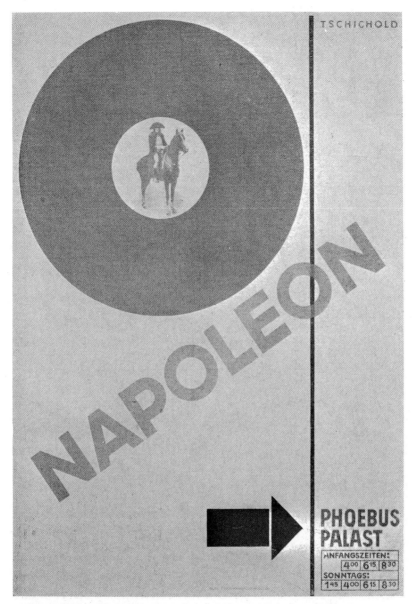

JAN TSCHICHOLD: Film poster 1927. Ring and Phoebus-Palast panel in red,
"Napoleon" and photograph in blue; the vertical rule and arrow in red and blue
overprinted.

189

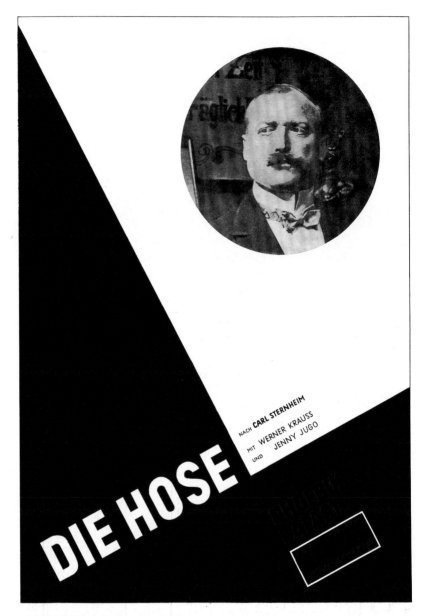

JAN TSCHICHOLD: Film poster 1927

FERNAND LÉGER:
The eye, the mistress organ with a thousand responsibilities, rules the individual more than ever. From morning to evening it registers without stopping. Speed rules in the modern world. On the other hand the strain of commercialism has grown so far that a mannequin parade by a tailor may compete with, if not surpass, the shows of a dozen small theatres. Accordingly, posters on the street must be better than an exhibition of paintings. Which makes it necessary to organize the street like a theatre. The street is altogether too dynamic, it is rapacious and wearing on the nerves. Our present life is so anxious and so frightening that we need quieter, better-ordered streets, where our nerves can be peaceful and not torn apart. The poster should therefore be thought of not as jazz but as orchestral music.

ROBERT DELAUNAY:
A poster is colour or nothing. Form is nothing but a dimension of colour. From a physical point of view, therefore, the best poster is that which we see most often and from farthest away, like a railway signal. How is the best result obtained? By each one of us, singly and alone, caring about the rhythm and interrelation of colours. Anything else can be forgotten. We must therefore stop using colours by chance or intuition, in order to make something "pretty" or "beautiful." We must be scientific and make them vibrate in harmony like music. And we must start from the beginning to make posters not a corruption of the eyes but an invitation or a source of information. Posters must be treated as such. No more trying to make them more or less seductive representations of objects, but have the aim of making them put us under their spell by their vibrating impressions of greater or lesser intensity.

Poster Formats
Standard sizes for posters are given on p.174.

LABELS, PLATES, AND FRAMES

Sizes of labels etc. in cardboard or other materials should be chosen first of all from the A-range. But it often happens in particular circumstances that these formats do not fit, so standards for long and square shapes must be found. These standards are shown in DIN 825, with directions for holes and margins.

The Standards Authority has also provided standards for plates and frames, needed for exhibitions and fairs. Because up till recently no such standards existed, nearly every plate and frame in exhibitions etc. was in a different size, which was unsatisfactory on both practical and aesthetic grounds. Directors of exhibitions, also businesses and schools, should in future make more use of these standards, for their economic as well as practical advantages. There is no longer a need to search always for new shapes and sizes. The A-range is naturally the only choice for plates and items to be framed. Items which do not fit in one frame must be placed in the next size up.

A noteworthy advantage of the standard is the fixing of punch-hole positions, made possible by the standard for rings.

Of course, the standards for frames and plates are only for practical purposes. It is not to be expected that artists should paint their pictures in standard sizes and put them in standard frames. Pictures in houses will, as before, be in their own special sizes and frames.

FOR STANDARD DIN 682 (PLATES AND FRAMES) SEE P. 194

Schildformate

Ohne Rand — Mit Rand

Bezeichnung eines Schildformates 52×105 mm:

Schildformat 52×105

Höhen a und Breiten b :

6,5 9 13 18 26 37 52 74 105 148 210 297 420 594 841 1189 mm

a und b sind DIN 476 Papierformate, Reihe A, entnommen

Richtlinien für Befestigungslöcher und Rand
mm

Seiten-verhält-nis	Schild-format a×b	An-zahl	Löcher Abstand c	e	f	Durchgang d f.Gew.	Rand g
1:1	☐						
	13× 13	2		8	2,5	1,8 M1,4	0,8
	18× 18	2		12	3	2,1 M1,7	1
	26× 26	2		20	3	2,4 M2	1
	37× 37	4	30	30	3,5	2,4 M2	1,2
	52× 52	4	42	42	5	3,1 M2,6	1,6
	74× 74	4	62	62	6	3,1 M2,6	2
	105×105	4	89	89	8	3,6 M3	3
	148×148	4	128	128	10	3,6 M3	4
	210×210	4	184	184	13	4,8 M4	5
1:√2 (1:1,41) nach DIN 476	☐						
	9× 13	2		8	2,5	1,8 M1,4	0,8
	13× 18	2		12	3	2,1 M1,7	1
	18× 26	2		20	3	2,1 M1,7	1
	26× 37	2		30	3,5	2,4 M2	1,2
	37× 52	4	29	44	4	2,4 M2	1,6
	52× 74	4	42	64	5	3,1 M2,6	2
	74×105	4	62	93	6	3,1 M2,6	3
	105×148	4	89	132	8	3,6 M3	4
	148×210	4	128	271	13	4,8 M4	6
	210×297	4	184	271	13	4,8 M4	6
	297×420	4	261	384	18	5,8 M5	8
	420×594	4	372	546	24	7 M6	10
1:2	☐						
	6,5× 13	2		8	2,5	1,8 M1,4	0,8
	9 × 18	2		12	3	2,1 M1,7	0,8
	13 × 26	2		20	3	2,1 M1,7	1
	18 × 37	2		30	3,5	2,4 M2	1,2
	26 × 52	2		44	4	2,4 M2	1,6
	37 × 74	4	27	64	5	3,1 M2,6	2
	52 ×105	4	40	93	6	3,1 M2,6	2,5
	74 ×148	4	58	132	8	3,6 M3	3
	105 ×210	4	85	190	10	3,6 M3	4
	148 ×297	4	122	271	13	4,8 M4	5
	210 ×420	4	174	384	18	5,8 M5	6
	297 ×594	4	249	546	24	7 M6	8
1:2√2 (1:2,82)							
	6,5×18	2		12	3	2,1 M1,7	0,8
	9 ×26	2		20	3	2,1 M1,7	1
	13 ×37	2		30	3,5	2,4 M2	1,2
	18 ×52	2		44	4	2,4 M2	1,6
	26 ×74	2		64	5	3,1 M2,6	2

Seiten-verhält-nis	Schild-format a×b	An-zahl	Löcher Abstand c	e	f	Durchgang d f.Gew.	Rand g
1:2√2 (1:2,82)	37×105	4	25	93	6	3,1 M2,6	2,5
	52×148	4	36	132	8	3,6 M3	3
	74×210	4	54	190	10	3,6 M3	4
	105×297	4	79	271	13	4,8 M4	5
	148×420	4	112	384	18	5,8 M5	6
	210×594	4	162	546	24	7 M6	8
1:4							
	6,5× 26	2		20	3	2,1 M1,7	0,8
	9 × 37	2		30	3,5	2,4 M2	1
	13 × 52	2		44	4	2,4 M2	1,2
	18 × 74	2		64	5	3,1 M2,6	1,6
	26 ×105	2		93	6	3,1 M2,6	2
	37 ×148	4	21	132	8	3,6 M3	2,5
	52 ×210	4	36	194	8	3,6 M3	3
	74 ×297	4	54	277	10	4,8 M4	4
	105 ×420	4	79	394	13	5,8 M5	5
	148 ×594	4	112	558	18	7 M6	6
1:4√2 (1:5,64)	6,5× 37	2		30	3,5	2,4 M2	1
	9 × 52	2		44	4	2,4 M2	1,2
	13 × 74	2		64	5	3,1 M2,6	1,6
	18 ×105	2		93	6	3,1 M2,6	2
	26 ×148	2		132	8	3,6 M3	2,5
	37 ×210	4	14	194	8	3,6 M3	3
	52 ×297	4	32	277	10	4,8 M4	4
	74 ×420	4	48	394	13	5,8 M5	5
	105 ×594	4	69	558	18	7 M6	6
1:8	9× 74	2		64	5	3,1 M2,6	1,2
	13×105	2		93	6	3,1 M2,6	1,6
	18×148	2		132	8	3,6 M3	2
	26×210	2		194	8	3,6 M3	2,5
	37×297	2		277	10	4,8 M4	4
	52×420	2		394	13	5,8 M5	4
	74×594	4	38	558	18	7 M6	5
1:8√2 (1:11,28)	9×105	2		93	6	3,1 M2,6	1,2
	13×148	2		132	8	3,6 M3	1,6
	18×210	2		194	8	3,6 M3	2
	26×297	2		277	10	4,8 M4	2,5
	37×420	2		394	13	5,8 M5	3
	52×594	2		558	18	7 M6	4

Die Schilder können mit scharfen oder abgerundeten Ecken, mit oder ohne Rand ausgeführt werden.
Die Rundungen der Ecken sind gleich oder kleiner als f zu wählen.
Die Schildformate können quer oder hoch angewandt werden.
Für Schilder in langen Formaten können mehr als 2 oder mehr als 4 Schrauben vorgesehen werden.
Befestigung durch Schrauben, Nägel, Niete, Klammern oder Einsteckrahmen.
Die Werte für Schilder in Kreis- und Ellipsenform sind sinngemäß der Zahlentafel zu entnehmen.
Ausführung, Werkstoff und Dicke sind frei.

Juli 1925

Tafeln und Rahmen
für Bilder und Muster

Maße in mm

ungerahmte Tafel

Rahmen

Leistenprofil

Bezeichnung einer Tafel im Format A 2 in Querlage
Tafel A 2 quer DIN 682¹)

Bezeichnung eines Rahmens für Einlage A 2 in Querlage
Rahmen A 2 quer DIN 682¹)

Rahmen	Format²) der Tafel und Einlage für Rahmen a × b	Rahmen			Leistenprofil					Ösen			
		lichteWelte c × d	Falz e × f	außen g × h	Richtmaße					Hochlage		Querlage	
					n	m	p	q		Abstand l	Anzahl	Abstand k	Anzahl
2 A 0	1189×1682	1163×1656	1193×1686	1243×1736	40	10	16	30		960	2	1440	2
A 0	841×1189	815×1163	845×1193	895×1243	40	10	16	30		720	2	960	2
A 1	594× 841	577× 824	597× 844	637× 884	30	10	10	20		480	2	720	2
A 2	420× 594	403× 577	423× 597	463× 637	30	10	10	20		240	2	480	2
A 3	297× 420	287× 410	299× 422	327× 450	20	8	6	12		240	2	240	2
A 4	210× 297	202× 289	212× 299	232× 319	16	6	5	10		0	1	240	2
A 5	148× 210	142× 204	150× 212	172× 234	16	5	4	10		0	1	0	1

¹) Werkstoff, Form und nicht angegebene Maße der Leisten sowie Ausführung und Farbe sind bei Bestellung anzugeben.

²) Die Formate der ungerahmten Tafeln und der Einlagen sind DIN 476 Papierformate Reihe A entnommen.

Bei Rahmen für Tafeln mit schweren Gegenständen sind die Ösen an der Einlage (Holztafel) zu befestigen.

Dicke der Einlagen sowie der ungerahmten Bilder und Tafeln gleich oder kleiner als q. Deckgläser haben die Größe der Einlage und sind besonders zu bestellen.

Beispiel für die Hakenanordnung

Januar 1926

ADVERTISEMENTS

What was said about the type-poster applies to advertisements: the major-
ity of today's advertisements are boring and ineffective because they have
not yet discarded the inflexible and unsuitable methods of out-of-date cen-
tred typography. This way of working has become unconsciously wearisome
to printers; and just as in unloved things something is expressed of their
makers, so ordinary advertisements betray the compositor's lack of joy.

A few years ago one of the reactionary Munich papers made an attempt to
produce good advertisement pages (in the old typography). They gave the
design and arrangement of these pages to a fairly well known book-artist.
The advertisements themselves were of course centrally designed, and the
arrangement of each whole page was symmetrical. Some parts of the
advertisements, important lines of type, were drawn by the artist.

The intention of the artist was actually pretty well realized, within the pos-
sibilities of the chosen form; but it must be said that such an attempt, apart
from being an interesting experiment, has no practical value.

Above all, the centred typography of earlier advertising is unsuitable for
our times because, being a preconceived external form, it tends to make
reading more difficult, or at least does not make it easier, as the New
Typography does. The speed at which advertisements normally have to be
made up makes it nearly always impossible to get good line setting on the

**EL LISSITZKY: Publisher's advertisement 1922. The "angle" on the left is the first
letter (G) of the publisher's name, Gelikon (= Helikon).**

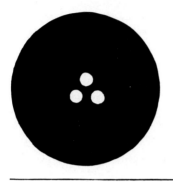

KABELS MET GEGARANDEERDE IONISATIESPANNING

NEDERLANDSCHE KABELFABRIEK DELFT

PIET ZWART: Advertisement (reduced)

old principles. Closely spaced lines, especially when followed by very short lines, always look ugly. (On the laborious block-setting method, which for long has been a favourite solution especially for cinema advertising, we need waste no further time.) The old typography always produces a very "gappy" pattern of lines, which with the pressure of small formats and the fixed copy-requirements of the customer make it either difficult or impossible to use large sizes of type. Now, the New Typography not only makes possible, but requires, strong contrasts of every kind (in type sizes etc.), and gives the compositor freedom to produce intelligent layouts.

The symmetry of the complete page, practised by the artists, is to be avoided not only on aesthetic grounds. In practice it is hardly ever possible to produce a whole page symmetrically. To achieve that, symmetry not only of format but of each adjacent advertisement would be necessary. It hardly needs saying that this will rarely happen. The opposite is the rule. The various different headings inevitably give an asymmetric effect, which however need not be inharmonious.

Even a single advertisement gains in effect when the centred arrangement is discarded. It will look more attractive, and the lines of type, as in the Baumeister example shown earlier (p. 67), can be more logically positioned. Besides discarding centred design, a more intensive use of black-and-white effects is required. There are endless possibilities, through enlarged

196

EUGEN RENTSCH VERLAG · ERLENBACH · ZÜRICH · MÜNCHEN UND LEIPZIG

hans

arp

DER PYRAMIDENROCK
DER PYRAMIDENROCK
DER PYRAMIDENROCK
DER PYRAMIDENROCK
DER PYRAMIDENROCK
DER PYRAMIDENROCK
DER PYRAMIDENROCK
DER PYRAMIDENROCK
DER PYRAMIDENROCK GEHEFTET GM 2.50
GEBUNDEN GM 3.50

IN DEN GROTESKEN STROPHEN VON HANS ARP STEHT DAS GESAMTE BILD DER WELT IM ZEICHEN EINER PHANTOMATISCHEN VERWANDLUNG. GLEICH EINEM GAUKLER MISCHT ER DIE SUBSTANZEN DER WORTE, DINGE, WERTE DURCHEINANDER, WORAUF ER DIESES SCHEINBAR SINNLOSE GEWIRR ZU EINEM MÄRCHENHAFTEN ORNAMENT VERDICHTET, IN WELCHEM SICH DIE WILLKÜRLICH GE-WÜRFELTEN ERSCHEINUNGSFORMEN IN SELTSAM HINTERGRÜNDIGEN BEZIEHUNGEN, IN SYMPATHE-TISCHEN ZUSAMMENKLÄNGEN UND IN OKKULTEN NACHBARSCHAFTEN ZUEINANDER FINDEN. DIESER METAMORPHOTISCHE HUMOR HANS ARPS, DER VON DER SPRACHE SELBST BESITZ ERGREIFT, IST MEHR ALS EINE SPIELENDE ARTISTENLAUNE, REICHEN DOCH SEINE WURZELN BIS ZUM TIEFEN GRUND DES MYTHISCHEN UND MAGISCHEN BEWUSSTSEINS, AUS DEM IN LÄNGST VERJÄHRTER ZEIT DAS RÄTSEL, MÄRCHEN UND DER ZAUBERSPRUCH ERWACHSEN SIND.

KUNST**ISM**EN 1924
EN 1923
EN 1922
EN 1921
EN 1920
EN 1919
EN 1918
EN 1917
EN 1916
EN 1915
KUNST**IST**EN 1914

HERAUSGEGEBEN VON EL LISSITZKY UND HANS ARP

DIE KUNST-ISMEN IST EIN BILDERBUCH (21:27 cm), DAS DIE PLASTISCHEN GESTALTUNGEN DES ALLER „ISTISCHEN" KUNSTDEZENNIUMS 1914–24 DARSTELLT. KEIN SCHREIBTISCHPRODUKT EINES KUNST-KRITIKERS. 15 ISMEN, 13 LÄNDER UND 60 KÜNSTLER SIND HIER MIT IHREM CHARAKTERISTISCHEN SCHAFFEN VERTRETEN. EINE REIHE WENIG BEKANNTER WERKE DER BEKANNTEN KÜNSTLER. DIE EINLEITUNG (IN DEUTSCHER, FRANZÖSISCHER UND ENGLISCHER SPRACHE) IST EIN ZWIEGESPRÄCH VON DEN HERREN + UND — .

GEHEFTET GM 4.50 · GEBUNDEN GM 5.50

EL LISSITZKY (1925): Page from a book publisher's catalogue

197

EL LISSITZKY: Publisher's advertisement on back cover of a journal.
The main line "Skify" (name of publisher) is drawn.
The axial arrangement of some of the paragraphs is due to the compositor. This example is shown only on account of the whole composition. The arrangement of the small paragraphs is poor.

letters, words, accompanying heavy rules, and so on, to heighten an advertisement's effect. The effect can be further enriched by flat tint-blocks, as in Baumeister's Tietz-advertisement (p. 205), or through photography and colour, as in Burchartz's advertisement for "Vierradbremse Poulet" (p. 206). Almost more important than these generalities is the question of how advertisements are placed in relation to each other. No one would agree that the universally used fine-rule separations are particularly beautiful, but they are often essential. They should however be avoided when neighbouring advertisements themselves use rules or similar devices which might lead to confusion.

In smaller advertisements in New Typography a rule (as in Baumeister) is often useful. But often, especially in horizontal half-page advertisements, a plain horizontal rule is enough — and is preferable. See Lissitzky's publisher's catalogue, p. 197. In larger advertisements, borders — which are in any case a characteristic expression of the earlier individualistic epoch — should be avoided. In newspapers with the usual half- and quarter-page arrangement, the use of fine rules for separation is nearly always unnecessary, since the advertisements are usually separated by white margins.

The great economic advantages that would result for the advertisement from a universal acceptance of standards for formats and type areas in newspapers is described in the following section.

There are a few newspapers that adopt a consistent style for the design of all their advertisements. That is of course the happier solution for this difficult problem. Many Dutch architectural magazines have for long used only sanserif, and the Prague journal *Stavba* uses only Sorbonne as typeface for advertisements. In both, except for bold rules, all ornament (and rule-combinations) are completely excluded. The advertising pages of these papers make a very good impression.

It seems, above all, to be exceptionally difficult to deal harmoniously with "small advertisements." The only practical way is to limit type sizes to one

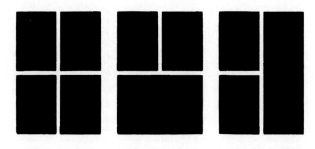

fixed size of an ordinary face (roman or sanserif) and at most three sizes of a fixed heading type (bold sans or bold roman). In order to get a good result, the often childish demands of advertisers may be ignored. These are the more unreasonable since small advertisements do not compete with each other but are read like a book. It is worth noticing that the small advertisements in *Gartenlaube* are up till now the best laid out, although in fraktur.

A justifiable complaint made against German newspapers and journals is that their advertising pages, with their great patches of black, are very ugly, and comparison is made with North America, whose newspapers by

**Newspaper advertisement
(*Münchener Neueste Nachrichten*)**
Bad, because:
unnecessary ornaments,
too many kinds of type and type sizes (7)
centred design,
which makes reading difficult and is
unsightly.

**The same advertisement, redesigned
(Jan Tschichold)**
Good, because:
no use of ornament,
clear type, few sizes,
(in all, only 5 different types)
good legibility,
good appearance.

**Kaufmännische
Ausbildung**
Private kaufmännische Kurse

Dr. Sabel Inh. Therese Sabel
München, Kaufingerstraße 14,2 Tel. 91064

Jahreskurse für schulentlassene Knaben
und Mädchen Beginn **16. April**
Halbjahreskurse Beginn **1. Mai**

Unterricht in Einzelfächern. Anmeld. täglich.
Angenehme Zahlungsbedingung. *[18767]2-2

200

WILLI BAUMEISTER: Store advertisement (1926)

avoiding strong black-and-white contrasts are better-looking. We Europeans however have good reason to defend our European culture against the invasion of American "cliché-culture," and must, if we wish to keep our end up, devise a good design style of our own. In general, it is not the heavy black-and-white contrasts in and among the advertisements themselves that create a bad impression, it is the low quality of advertising design in general, and above all how it is arranged on pages.

That advertisements differing greatly in size and form can be arranged together in a really pleasing way is shown here by two pages from a Japanese newspaper. Its design shows paradoxically that Japanese culture is closer to the European than is the North American pseudo-culture. In

201

any case, some of the Japanese advertisements are remarkable for their typographic design. The many-thousand-year-old collective mental attitude of the East reveals itself in the astonishing similarity of this typography to our own. The Japanese, for long masters in the use of space, have also in this area much to teach us. In a book *Japanische Reklame in der Tageszeitung* (Japanese advertising in daily papers) Dr Anna Berliner has written extremely well about this.

THE PERIODICAL

Whoever reads and has to work with many periodicals knows well their main failing: the lack of any unity in their formats. Since until recently no standard existed for them, they could be produced in any size. Everyone knows how inconvenient this is for their storing and arrangement.

The German Standards Committee has now provided standards for periodicals and published the relevant details in Standard 826 (reproduced on p. 204 overleaf).

The format is A4: it fits in with the format of business letters, advertising matter, illustrations, etc. From this come advantages for distribution, storing, and cataloguing.

In addition, type areas and block sizes are standardized. This makes it possible to move entire articles from one periodical to another. And special inserts have a unified appearance and can be collected together and put in order. Blocks in standard sizes can be moved to different positions without trouble. The exchange of illustrations is simplified.

There are advantages, in the standardization of column widths and type areas, for all the firms who advertise in several periodicals.

While in the past different block sizes were required for every periodical, now only one is needed, which will fit all standard periodical pages. This represents an often considerable economy in costs. The often-desired individuality of appearance in a particular periodical, seen from a higher point of view, is now undesirable. Standardization in periodicals is an important and necessary step on the way to a higher economy in intellectual work.

A large number of all technical periodicals have already gone over to standardization. All industrial booklets and technical literature should finally decide to follow.

The objection to be expected here, that the format will be too small, is not based on fact. The *Deutsche Drucker* and the *Typographische Jahrbücher* are both in approximate DIN sizes; similarly, the American *Printers Ink* and *Western Advertising,* and the English *Commercial Art* (London), are very nearly the same. All five have frequent supplements and large illustrations,

Two pages from the Japanese newspaper *The Tokio Asahi*. 1926.

203

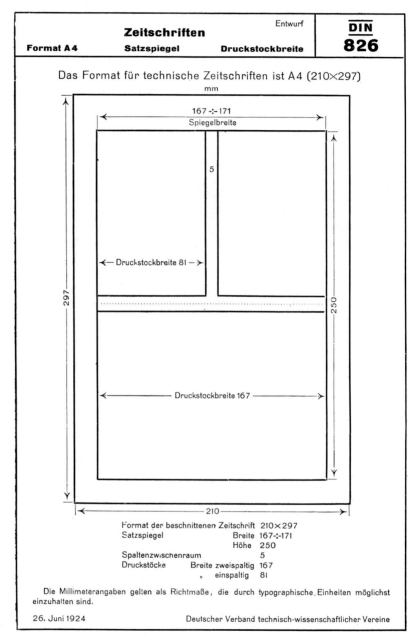

Das Format für technische Zeitschriften ist A4 (210×297)

mm

167 ÷ 171
Spiegelbreite

5

←— Druckstockbreite 81 —→

297

250

←——— Druckstockbreite 167 ———→

←——— 210 ———→

Format der beschnittenen Zeitschrift 210×297
Satzspiegel Breite 167÷171
 Höhe 250
Spaltenzwischenraum 5
Druckstöcke Breite zweispaltig 167
 „ einspaltig 81

Die Millimeterangaben gelten als Richtmaße, die durch typographische Einheiten möglichst einzuhalten sind.

26. Juni 1924 Deutscher Verband technisch-wissenschaftlicher Vereine

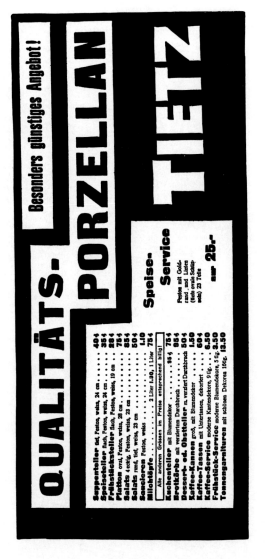

WILLI BAUMEISTER: Page-width advertisement in a daily paper

and give the impression that a smaller format brings no disadvantage for the clarity and design of supplements or illustrations. Very often a firm has to place a supplement in, for example, every single relevant periodical. This used to mean adapting to the sizes of the smallest and largest periodicals,

205

often widely different, from which followed compromises in design and unproductive additional costs in paper. This in now unnecessary.

There are also great advantages in standardized formats for art magazines.

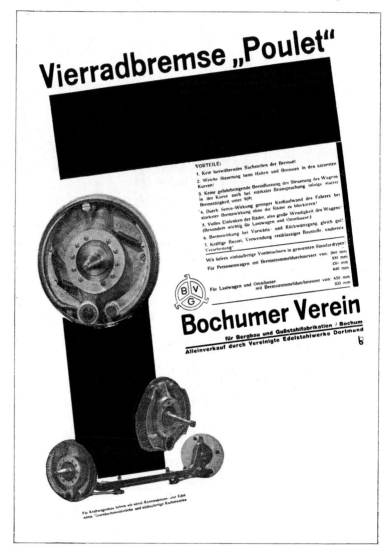

MAX BURCHARTZ and JOHANNES CANIS: Whole-page advertisement, black and red, with photomontage. 1925. Page width of original 30 cm.

Of the art and similar magazines that appear in standard formats, I know of *bauhaus* (Dessau), *i10* (Amsterdam), *Das Werk* (Zürich), and *Die Form* (Berlin). All four magazines (and there are certainly more) show that despite standardization typographic design can be faultless.

All new magazines and periodicals should certainly adopt standard sizes for type area and format. It is not least the duty of the print firms to acquaint themselves with the standard sizes: most publishers and authors know nothing about them.

It is much to be regretted that articles which are often of great importance have eventually no effect, because the finding of a particular article a year or so later is virtually impossible. The only remedy for this is to flag every issue, as for example the *Zeitschrift für Organisation* (Berlin, Spaeth & Linde) has done. Their individual articles, flagged with cards in DIN A6 size, provide a systematic index of subjects and authors, which makes it possible to find, years later, an article on a particular subject or by a particular author, without much difficulty. Here therefore is an important task for periodical publishers, for example the Börsenverein der Deutschen Buchhändler. With appropriate standardization a crying need would be met.

DEXEL JENA

SCHULENBURG & BESSLER

2. SEIDENWEBEREI
SEIDENE, HALBSEIDENE UND KUNSTSEIDENE STOFFE FÜR STRASSEN– U. GESELLSCHAFTS– KLEIDER • SCHWERE KOSTÜMSTOFFE

GERA-ZWÖTZEN

TELEGRAMMADRESSE: BESSLER GERAREUSS / FERNSPRECHER: 323 UND 400

1. WOLLENWEBEREI
MODERNE DAMENKOSTÜMSTOFFE IN REINEM KAMMGARN • MODERNE REGEN– MANTEL– UND STAUBMANTELSTOFFE HERREN– U. KNABENKONFEKTIONSSTOFFE

WALTER DEXEL: Advertisement (1925)

On the typographical design of periodicals

The prime requirement for the appearance of periodicals is a good type-face. Among those suitable are the good ordinary romans of the present day, for example Nordische Antiqua, Französische Antiqua, Sorbonne, but also the purely classical faces, for example Garamond, Baskerville, Didot, Bodoni, as well as good cuttings of ordinary Medieval and Antiqua.

Fraktur, now for long out of date, must be avoided, and also without exception the "artistic" types.

For *display faces,* for titles, page numbers, etc., bold or semi-bold sanserif is recommended, with its clear and plain appearance contrasting strongly with the text.

Article headings should no longer be centred, but set full out to the left. This also of course applies to figures like "1" and subtitles within an article. Asymmetry must never be disturbed by centred titles or forms.•

Page numbers should always (as is normal practice today) be placed on the outside of the page. The use of sanserif for emphasis is good. The very ugly use of rules separating columns must be avoided. An em gutter or more is all that is needed to separate columns clearly.

Just as unattractive are the stars, always in mysterious groups of three, at the ends of articles. Apart from usually being ugly, they are quite unnecessary. Just a small space between two articles is enough to separate them; every kind of decoration, especially one so questionable, is superfluous. If in special cases for any reason a strong separation is needed between short pieces of text, a single round six-point spot may be used.

Centred running heads above columns must be avoided: they will not go with asymmetric article titles. The best way is to place them on the outside — without any rules beneath! — set in sanserif. If a rule is used, do not use thick/thin or double rules. Simple fine rules, up to six-point, are the best.

Any intelligent person can only wonder at the impossible effects on block-making which result from the folly of centred typography. In the two examples shown here I have tried to show the difference between the old strait-jacket and a sensible arrangement of blocks. I have intentionally shown blocks of different and "accidental" widths, since that is what usually has to be contended with (although in the future, with standard block-sizes, it will

• Absolutely to be avoided are the *drawn* titles for articles, to be seen so often today. They are expensive and neither good-looking nor appropriate. A periodical that is type-set requires type-set headings. Although there is no standard for all headings, an infinite variety of typographic headings can be thought of.

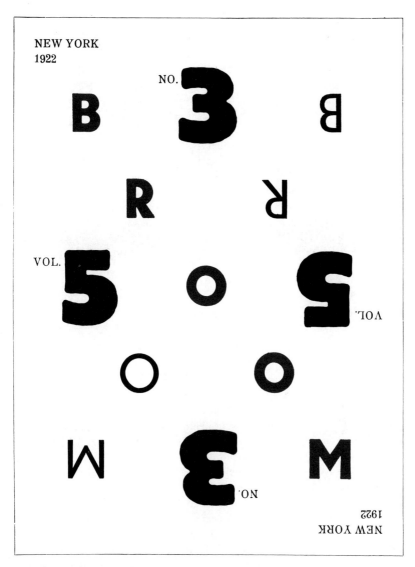

EL LISSITZKY 1922:
Cover of an American magazine (reduced)

How blocks used to be arranged in magazines.
Schematic, thoughtless centring of blocks. "Decorative," impractical, uneconomic **(= ugly).**

happen less often). Standard-size blocks will make the problem much simpler. The left-hand example shows clearly to what complicated lengths the old designer had to go. The centred illustrations are cramped and require costly and ugly narrowing of the measure. The redesign on the right speaks for itself: it is obvious how much simpler and so more beautiful the new form is. The mostly dark blocks contrast well with the grey type, and the blocks which do not fill the measure leave pleasant white spaces, whereas formerly the type round the blocks, often of only dictionary-column width, gave an impression of meanness.

Where possible, blocks should be placed close to their relevant text.

Like article headings, captions beneath illustrations (as in this book) must no longer be centred but must range left. To set them in bold or semi-bold sanserif will strengthen the general appearance of the page. That they can also often be set at the side of a block is in accordance with our modern practice.

As regards the blocks themselves, they must not be surrounded with unsightly rules. Blocks trimmed flush look better. The remarkable "clouds" (uneven dot patterns in halftone blocks) on which not only small items but

210

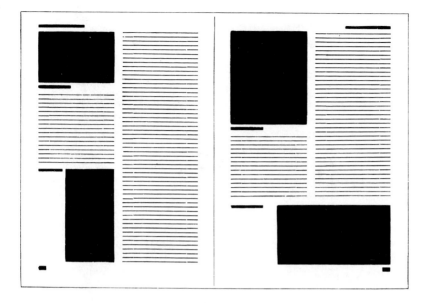

The same blocks, correctly arranged in the same type-area.
Constructive, meaningful, and economical **(= beautiful).**

even heavy machines try to float, are to be avoided both on aesthetic and practical printing grounds.

Magazine covers today are mostly drawn. That just as effective results can be obtained by purely typographic means is shown by the examples of *Broom* and *Proletarier.*

Broom is typical of the only kind of symmetrical design possible in the New Typography. We leave behind the two-sided symmetry of old title-pages as an expression of the past individualistic epoch. Only complete quadrilateral symmetry can express our aims for totality and universality.

The cover of the magazine *Proletarier* is an interesting example of the dynamic effect that comes from oblique typesetting. Both examples have achieved their strong effects without any use of trimmings such as rules or points.

The enormous importance of magazines today requires us to give them the most careful attention. Since today more magazines are read than books, and much important matter appears only in magazines, there are many new problems, of which the most important is how to find a contemporary style for their production. This chapter attempts to show the way.

THE NEWSPAPER

Although newspaper typography is, in general, characteristic of our time, and, at least in principle, shows how good typographic organization can be, there are also many examples where newspaper setting could be raised to a level really expressive of our times.

Apart from our now much heavier headlines, modern newspapers are not very different from those of, say, 1850. The first newspapers were like the flysheets and pamphlets of the 17th century, which themselves were set like book titles and pages. Newspapers remained even until today in their original dependence on book typography. But as the tempo of reading became faster, greater or lesser emphasis in parts of the text became necessary. This is done today by varied type sizes, letter-spacing, heavier weights of type, leading, and other uses of space. Many of these methods are much overused, but this is not our subject here. Such methods are based on sensible considerations with which we have no quarrel. They make it possible today for a newspaper, whose contents are about equal to a medium-sized book, to be "read" in a few minutes, i.e. to find and absorb what the individual reader himself wants. This is without doubt the way of our time.

But in the past, what all newspapers had in common was the typefaces they used. We find, when we look at old issues, the staple type of the political pages, the broadsheets, and advertisement pages was always fraktur. One has to look only once at the trade part of a paper (normally set in roman), for example the *Berliner Tageblatt,* and lay it beside the political pages of the same paper, and compare them, to see immediately how much pleasanter roman looks and reads. The supposed lesser legibility of roman in German, compared with fraktur, is a national old wives' tale. All progressive papers should take the first step and set the whole paper in roman. How splendid, for example, the Dutch newspapers look! They use sanserif for headlines and otherwise normal roman. Indeed the trade part of nearly all German newspapers is set in roman; and in other parts, chiefly the more modern parts, the technical, sport, film, and literature pages, fraktur is being more and more pushed out by the Latin type — greatly to the pages' advantage! It is to be hoped that soon all the remaining pages will be set in roman — sanserif will no doubt eventually follow as the normal reading face. For the time being we have no really suitable appropriate face. But for headings, sanserif is outstandingly suitable. Many sections of the *Frankfurter Zeitung* use it with excellent results. Headlines set in caps must be avoided, they are much too hard to read. For this purpose I find that

ANONYMOUS: Magazine cover

bold sans is more suitable than semi-bold: the latter is not different enough from the grey of the text.

In the fraktur pages of newspapers, Bernhard or similar fraktur types are most commonly used for important lines. The only objection to this is the basic one. It is completely incomprehensible, however, when the *Frankfurter Zeitung* uses the antiquated and hardly more legible gothic for its title masthead. It really is difficult to decipher these hieroglyphs! It is astonishing to see this in a paper that has tried hard, often with success, to present a really good typographic appearance.

I believe that it is not right for a newspaper set in type to have a drawn masthead. Our typography has enough variety to meet all exceptional requirements. That applies also to the newspaper's masthead. Its design, particularly in the case of old papers, should not be changed, even to roman, for it is the "trade mark" of the paper. Of course everything that is not the actual title can be set in roman or sanserif, but the main title or masthead, for example *Berliner Tageblatt,* should keep its original form unchanged. It does not follow that new newspapers must set their mastheads in some kind of fraktur — sanserif alone is right. On a newspaper stand it would hit the countless other mastheads in fraktur like a bomb!

It is time to give up the centred headings inherited from the 19th century (before that, there were hardly any), and introduce ranged left headings, which express the spirit of our time, as in this book. The white space following most ranged left headings has a good effect, and by its so to speak automatic allusion to neighbouring headings gives a better organization of the text. Today centred headings make a disturbing grey; the black type is mixed up with the surrounding white, instead of strengthening the page by pure separation.

Das Technische Blatt, a supplement of the *Frankfurter Zeitung,* has ranged left headings and has become a very handsome newspaper.

Vertical rules between columns should be abandoned; they are as unnecessary as they are ugly. A newspaper page looks really lighter without them. In place of the still much-used thick/thin rules beneath the title and above news and advertisements, simple bold rules (about four- or six-point) should be used. Thick/thin rules are obtrusive and a superfluous unbeautiful ornament.

Halftone blocks in newspapers look much better without the usually inevitable surrounding rule. Also pictures in gravure papers should be cut flush. All rules and especially borders should be discarded.

The design of advertising pages is dealt with in the section on advertising. It would be a great advantage for newspaper formats and type areas to be

214

standardized: many mistakes arising out of today's format chaos would be avoided.

The two pages from the Japanese paper *Osaka Asahi* (pp. 203, 204) show how beautiful a newspaper can look. Our newspapers naturally look different, but do not achieve the aesthetic effect of the Japanese paper. In any case, the beauty of the paper of the future will meet the needs of our time by striving towards better clarity and a far-sighted, consciously planned design.

THE ILLUSTRATED PAPER

In recent years the number of illustrated papers has increased enormously. This impresses on us the need of modern man for pictures, because lack of time makes reading the daily papers more troublesome. Besides satisfying genuine curiosity, illustrated papers often give real pleasure from their technically and visually excellent reporters' photographs. If the literary level of most papers of this kind is low, it is probably due to the similarity of the literary sources on which nearly all these papers depend. It is certainly true that the lack of difference between these sources is more and more evident. This problem however is not one for us to consider here.

It must be said that the optical appearance of these papers, although a phenomenon of our time, does not fully express its spirit. Illustrated papers are still comparatively young; as far as one can judge from their external appearance, they are very little dependent on "traditional" concepts. Such a dependence can be seen only in their actual typography; the arrangement and composition of their pictures is by and large contemporary.

Most of the article headings and all the picture captions are still in the old centred typography, while on the contrary the picture arrangement is completely asymmetric. Symmetry in the pictures nevertheless does sometimes occur, and may even be originally always intended, but the dimensions and sizes of the pictures make this hardly possible. The intrinsic asymmetric form of the pictures is very much disturbed by centred captions. If a harmonious design is wanted, the captions too must be asymmetric. They should be set flush left, but there are plenty of other possibilities.

For display faces (headings and captions), sanserif (bold or semi-bold) is the most suitable type. Its clarity and precision make it the contemporary type to be used above all in these documents of everyday use and activity. A clever and imaginative typographer can find delightful solutions for every kind of title by purely typographic means. The use of drawn headings must

be avoided, as out of date and untypographical. Headings do not have to express the nature of the contents, but say what they have to say as clearly and simply as possible, nothing more.

Unfortunately fraktur is still the almost universal text type in use. The *Illustrierte Blatt* (Frankfurt) has set a good example and gone over to roman. This has made a great improvement in the paper's appearance. For the need to use sanserif for display purposes, one can cite the further reason that it is the only face that truly matches photography, and has the same essential objectivity. The hooks and tendrils of fraktur, the type of 16th-century officials, do not belong to our time and cannot ever be suitable in such uncompromising expressions of the present as illustrated magazines and newspapers. Because at present a really good sanserif for everyday use does not yet exist, the next most simple face, roman, has to be used. The factual-impersonal roman faces, Garamond, Bodoni, Französische Antiqua, Nordische Antiqua, Sorbonne, and others, are better than all the art and jobbing faces; their outer form (unlike the latter faces) does not dominate their content.

Photographic blocks are improved when used without ugly border rules. The borders, often centimetres thick, to be seen in many newspapers, must absolutely be avoided. They are neither attractive to our eyes nor helpful to the effect of the pictures, but unsympathetic.

There are no laws for the placing of pictures on the page. Strong contrasts in size and form (large-small, tight-loose, dark-light, vertical-horizontal, deep-shallow, etc.) are easy to achieve and attractive. Photomontage can be used effectively in many ways. In view of all these rich possibilities, it is astonishing how poor is the design of most of our illustrated papers. The appearance of even the most important of them is really provincial. *Sportspiegel* and *Der Weltspiegel* have made good efforts to improve their arrangement of pictures.

As well as the above-mentioned items, the totally unnecessary framing of picture pages must take part of the blame. These frames should be discarded, making the pictures larger and more effective.

A further advantage for our time is the unified format, which was previously lacking. The DIN format A3 (297 x 420 mm) should be considered here, as most suitable for this purpose.

Finally we must mention the printing techniques of illustrated papers. We can certainly expect an ever-increasing use of rotary gravure. It is undoubtedly the most suitable process for illustrated papers. Offset-litho, because of the lack of depth in its printed images, cannot compare with it; in this connection it is in the same class as ordinary rotary letterpress, which also

can no longer compete with gravure. The rich depth and general effect of gravure are enticing to customers. Doubtless more and more illustrated papers will go over to it, unless, as is possible, a new, perhaps more beautiful and equally rational process is discovered.

TABULAR MATTER

In tabular matter, the usual thick/thin and fine double rules, and indeed all kinds of rule combinations, must at last be got rid of. With simple rules, from fine to twelve-point size, even the narrowest column-spacings can be made clear and better than with the old rule-combinations.

Table-headings, as long as they are outside the table itself, must not be centred but positioned left or right. Smaller headings inside tabular matter, on the other hand, should usually as an exception be centred, because otherwise they tend to look untidy.

To achieve the greatest clarity it is again sanserif that must be used in tabular matter for emphasis.

Old-style (non-ranging) figures must never be used. They are an unpractical and out-of-date historical form. En-body figures without ascenders or descenders are the only right ones for tabular matter — and elsewhere.

As guidelines for handwritten entries fine rules are more practical and better-looking than dotted rules. Since these entries are today usually typewritten, guidelines are often unnecessary and disturbing.

Tabular matter need no longer be a rather unpleasant job to design, if one can be free of rigid rules; on the contrary, it can become a really charming and artistic exercise, in no way less interesting than any other area of jobbing setting.

THE NEW BOOK

In the area of book design, in the last few years a revolution has taken place, until recently recognized by only a few, but which now begins to influence a much wider range of action.

It means placing much greater emphasis on the appearance of the book and a wholly contemporary use of typographic and photographic means.

Before the invention of printing, literature of that time was spread around by the mouth of the author himself or by professional bards. The books of the Middle Ages — like the "Mannessische Liederhandschrift" — had

merely the function of being a copy of the spoken word. Printing however had the immediate result of transferring the spread of literature from being spoken to being read.[•]

The man of the 15th century stood erect in front of the desk and read aloud. That was the reason for the large letters characteristic of most gothic books. It was not until later that the tempo of reading accelerated and made smaller type possible and necessary.

Reading aloud slowly, "feeling" each separate letter and word, has now given way to skimming the text. Modern reading technique owes its nature to the way newspapers are set, their large and small lines, their different weights of types, the spacing of single words and whole passages, the making passages prominent by wide spacing and leading, and so on. The optical appearance of newspapers is evidence of today's speed of life.

In literature itself, similar changes have taken place. The writer of today no longer describes at epic length, like the poet of the 19th century, the feelings of his heroes and the landscapes of his story. The speed and urgency of films has also influenced literature in the direction of second-by-second action. The novel has been replaced by the short story. In their search for new ways of expression some writers of today have turned to typography. They have tried to transfer the ways of expressing modern prose from acoustic to visual effects.

The Franco-Pole Guillaume Apollinaire wrote his "Calligrammes" in "concrete" form. His verse described the outlines of spectacles, clocks, birds, flowers, horses, men, etc. Its publication was dependent on photomechanically reproduced handwriting.

The Italian futurist F. T. Marinetti took a further step in the total typographic design of poetry in his book *Les mots en liberté futuristes* (1919). By using different weights of type and different types, by placing them in special positions, by repetition of consonants and vowels and a novel use of typographic signs, he tried to give a phonetic effect to the spoken word by the incisive optical effect of typographic forms. The printed word as the means of expression was enriched by the specifically optical effect of his typographic design. All earlier books count on reading aloud or leisurely reading well distanced from the world. The book of today's active man,

[•] The speaker did not disappear suddenly. Only in the last few years has the public's interest in him diminished.

For such works of literature, depending on acoustic effect — in which the spoken word is essential — the gramophone record is still a relatively perfect possibility: Kurt Schwitters and Joachim Ringelnatz have consequently spoken some of their "acoustic" creations on records.

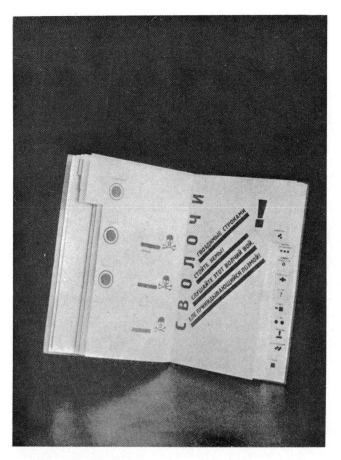

EL LISSITZKY (1922–1923):
The Mayakovsky book shown open (photo by Lissitzky)

whose eye is his most valued instrument of reception, has been designed for the first time by Marinetti.

Besides the pure "letter-book," a new book-form has arrived, the "picture-book," i.e. a combination of both forms. Modern man has found in illustrated newspapers and magazines a new source of delight. The impersonal clarity and precision of photographic reporting often communicates far better and faster than an article dealing with the same subject. In many papers photographs are already more important: text has taken a step back. The

former relationship has now been completely reversed: earlier, there was less illustration than text (100 lines of text = 1 picture): today there are more pictures than text (10 pictures = 10 lines). In a well-known new his-

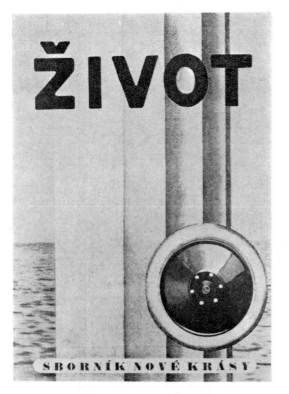

tory of art, the pictures are the major part of the book: in large picture-books about Germany and many other countries, illustrated with photographs (Orbis Terrarum), the only text is a short foreword.

After the Futurists, the Dadaists explored the possibilities of typographic technique in their magazines. Kurt Schwitters in his magazine *Merz* used typographic and varied photographic components which were unified by his typographic design. In Dadaistic designs the previous apparent incompatibility of reproductions in book design has disappeared and blocks, whether from photographs or drawings, have become an integrated part of the book.● The special (for example apparently plastic) form of a halftone

● The artists of the pre-war period denied the possibility of artistic unity in books using halftone blocks. This is in contradiction to the needs of our own time; and now also handmade paper and hand-coloured woodcuts belong to the past.

221

block is no hindrance to its use. On individual pages, and in the book as a whole, harmony in design comes from the use of larger and smaller "plastic" and flat elements, varied lines of movement (vertical, horizontal, slanting), and not least the positive value of unprinted space, which formerly meant nothing and now is as much a proper element as printed matter. These ideas coincide with the principles of "absolute" painting, whose initiators are contemporary with the originators of the New Typography.

The Russian El Lissitzky, one of the most important present-day artists in Russia, has also done varied and significant work in the field of typography: in 1922 in Berlin in the Russian/German/French magazine *Gegenstand*,

KAREL TEIGE:
Imprint of a
poetry book

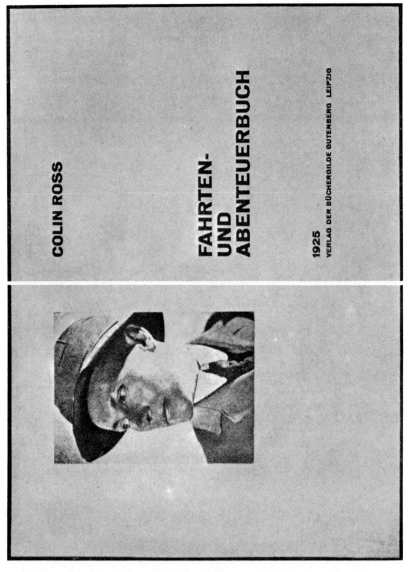

JAN TSCHICHOLD: Title-page of Colin Ross, *Fahrten- und Abenteuerbuch*
(Permission to reproduce the originally intended frontispiece shown here was refused by the owner of the photography — another publisher — and it had to be replaced by a much worse photograph)

in 1923 in an edition of poetry by Mayakovsky, the Russian Futurist, "For reading aloud" (*Dlya golossa*), from which we have already reproduced two double spreads (pp. 62, 63, and 219). The first pages of the poems are designed as pictorial paraphrases of their contents, as an optical expression of the spoken word. By means of a thumb index, as in a letter-file, a particular poem can be quickly found.

Another Russian, Rodchenko, in the book *Pro eto* by Mayakovsky, in 1923, was the first to illustrate the text by means of photography. With single photos in different sizes a new pictorial unity has been created (photomontage). The strength of design of the artist is here no longer expressed by the individual line of a drawing, but by the harmonious combination of various truly objective (photographic) related elements. The Dadaist photomontages were predecessors of these illustrations. The Malik publishing firm, founded in the Dada period, has made special use of these photomontages on their covers. With them, their creator John Heartfield has provided models for contemporary book-jackets. He is the inventor of photomontage bindings. His Malik-bindings are the first of their kind.

Similarly, some modern-thinking artists in Czechoslovakia, especially Karel Teige, have made a series of remarkable bindings for some Prague publishers and designed the books themselves.

In Germany, L. Moholy-Nagy has become known as a typographic designer through the Bauhaus books.

There is an important section of book production whose books, by nature of their text, like Marinetti's *Les mots en liberté futuristes* or Lissitzky's "For reading aloud," are not suitable for being designed. While there the typographic form is an independent (but inseparable) part of the whole work of art, typography in these books fills a purely subservient role.

To talk of "Neue Sachlichkeit" (New Objectivity) in their conception is here quite wrong, because objectivity in book design is by no means a new principle. With books of this kind (i.e. novels, and most scientific literature) it is not a question of making a really new kind of book (in a technical sense), because the old book-form is perfectly suitable for this kind of book, and will remain so until a better form is discovered. There is absolutely no need for change, which would only be justified when a really new form is found. In connection with typographic form, only modifications in traditional book design are possible. However little significance they may have for the actual content, they still seem to us to be important enough: just as the characteristic book-forms of the Gothic, Baroque, Rococo, and Wilhelmenian eras remained virtually unchanged technically, so our own time must create its own expression in the typography of the book.

224

EL LISSITZKY and KURT SCHWITTERS: Double-page spread from the "Nasci" issue of *Merz* 8/9. 1924.

Formate der gehefteten beschnittenen Bücher

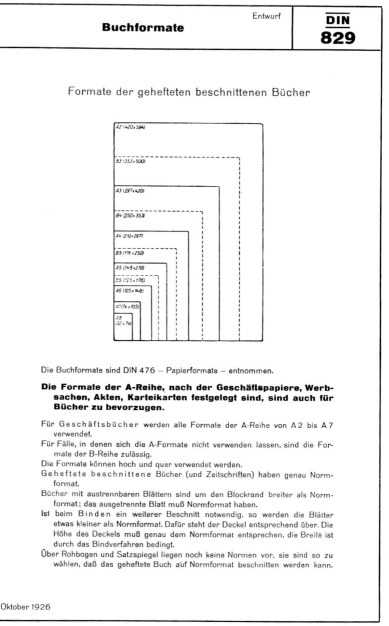

A2 (420×594)
B3 (353×500)
A3 (297×420)
B4 (250×353)
A4 (210×297)
B5 (176×250)
A5 (148×210)
B6 (125×176)
A6 (105×148)
A7 (74×105)
A8 (52×74)

Die Buchformate sind DIN 476 – Papierformate – entnommen.

Die Formate der A-Reihe, nach der Geschäftspapiere, Werbsachen, Akten, Karteikarten festgelegt sind, sind auch für Bücher zu bevorzugen.

Für Geschäftsbücher werden alle Formate der A-Reihe von A 2 bis A 7 verwendet.

Für Fälle, in denen sich die A-Formate nicht verwenden lassen, sind die Formate der B-Reihe zulässig.

Die Formate können hoch und quer verwendet werden.

Geheftete beschnittene Bücher (und Zeitschriften) haben genau Normformat.

Bücher mit austrennbaren Blättern sind um den Blockrand breiter als Normformat; das ausgetrennte Blatt muß Normformat haben.

Ist beim Binden ein weiterer Beschnitt notwendig, so werden die Blätter etwas kleiner als Normformat. Dafür steht der Deckel entsprechend über. Die Höhe des Deckels muß genau dem Normformat entsprechen, die Breite ist durch das Bindverfahren bedingt.

Über Rohbogen und Satzspiegel liegen noch keine Normen vor, sie sind so zu wählen, daß das geheftete Buch auf Normformat beschnitten werden kann.

Oktober 1926

Since to this form of a book its type is particularly significant, one change, namely the discarding of historical and historical-seeming typefaces, must be striven for. While in all other areas there are signs of movement towards modernization, our modern books on the contrary are still using the historical forms of fraktur and roman.

The present universal and exaggerated obedience to the pre-1914 watchword "material quality!" has meant, among other things, that German books are the most expensive in the world. So for someone of even average income, the German book has become an almost unattainable luxury object. It follows that we want today:

1. a contemporary (therefore not historical) typographic form;
2. inexpensive books for people, not luxury books for snobs.

Concerning the letterform of the text typeface, one can refer to the section in the present book that deals with this topic. But certainly one will be thinking of a roman designed not by any one person: a classic typeface — say Garamond — or a contemporary typeface such as Nordische Antiqua. This will be so as long as one cannot get hold of a sanserif in quantities that make its use as a text face possible. It is obviously not good to set a whole book in bold or semi-bold sanserif, since these types in quantity are not easily legible. For everyday use, light or ordinary sanserif should be used, and the present book shows that sanserif can be read as easily as any other typeface. For display, semi-bold and bold sanserif, Egyptians and bold roman are the most suitable. The text of travel books or novels can also be organized visually with larger and smaller bold sanserif for headings. The photographic block is being introduced into the book as a new element.

The Renaissance ideal — a book page of even grey — is finished; instead we have harmony from contrasting typographic and photographic elements using brightness, space, and direction. Contemporary bindings and bookjackets similarly show an increasing use of photography.

It is already clear today that a new form of book exists.

Book formats

The standard book formats on the facing page are not suitable for imaginative literature — for novels and similar books which are held in the hand for reading, they are too wide and therefore uncomfortable — but they certainly are for larger books, scientific works, catalogues in book form, handbooks (the present book is in A5), and are also suitable for smaller books (A6). The format A4 is very good for art books, monographs, etc.

It seems necessary to find a standard format also for novels, corresponding with the way they are used. The DIN-format page proportion is not suitable for these books. Perhaps we should standardize only their page depths, e.g. 176 mm depth for novels.

BIBLIOGRAPHY
In chronological order within the different language groups.

The bold letters following indicate:
b = wholly illustrated books
d = poetry
t = included only for their typography
Books marked with • are especially recommended for the reader.
Information on prices can be obtained from the publishers and booksellers.

Periodicals for modern design (in alphabetical order)
ABC. Beiträge zum Bauen. Basel, Augustinergasse 5.
DER ARARAT. Glossen, Skizzen und Notizen zur Neuen Kunst. Goltzverlag, München, 1919–1921.
DER STURM. Herausgeber Herwarth Walden. Berlin, Potsdamer Str. 136a.
DE STIJL. Zeitschrift für Neue Gestaltung. Herausgeber Theo van Doesburg. Kommissionsverlag für Deutschland: Ernst Wasmuth AG, Berlin.
•G□.Zeitschrift für elementare Gestaltung. Herausgeber Hans Richter, Berlin-Grunewald, Trabenerstraße 25.
•GEGENSTAND. Internationale Rundschau der Kunst der Gegenwart. Herausgeber El Lissitzky und Ilja Erenburg. Verlag Skythen, Berlin-Grunewald, Karlsbader Straße 16. Only nos. 1/2 and 3 (1922) appeared.
L'ESPRIT NOUVEAU. Revue Internationale illustrée de l'activité contemporaine. Directeurs: Ozenfant et Jeanneret. Paris, Jean Budry et Cie, 1921–1925.
MA. Zeitschrift für aktive Kunst. Herausgeber L. Kassák. Wien XIII, Amalien-straße 26.
•MERZ. Herausgeber Kurt Schwitters, Hannover, Waldhausenstraße 5, II.
PASMO. Herausgeber Artuš Černík, Brno-Juliánov, Husovo nabr. 10.

Special numbers (in chronological order)
•JUNGE MENSCHEN. Bauhausheft. November 1924. Typography: Joost Schmidt. Hamburg 13, Johnsallee 54.
DAS NEUE RUSSLAND. Sonderheft Russisches Theater. 1925, 3/4. Herausgeber Erich Baron, Berlin-Pankow, Kavalierstraße 10.
•DER BÜCHERKREIS. Sonderheft Neue Kunst. 1925, Heft 12. Verlag des Bücherkreises, Berlin SW68, Belle-Alliance-Platz 8.
LES CAHIERS DU MOIS. Nos. 16/17: Cinéma. Editions Emile-Paul Frères, 14, rue de l'Abbaye, Paris, 1925.
LES FEUILLES LIBRES. Sonderheft Man Ray, Mai-Juin 1925. Paris, Librairie Stock.

QUALITÄT. Sonderheft Das Bauhaus in Dessau. 1925, 5/6. Internationale Propaganda-Zeitschrift für Qualitätserzeugnisse, Berlin-Charlottenburg 9, Redaktion C. E. Hinkefuß.

•TYPOGRAPHISCHE MITTEILUNGEN. sonderheft elementare typographie. 1925. heft 10. redaktion jan tschichold. verlag des bildungsverbandes der deutschen buchdrucker, berlin.

•ABC. Serie 2, Nr. 2. Sonderheft Neue Kunst. Redaktion Hannes Meyer, Basel. Augustinergasse 5, 1926.

•DAS WERK. Sonderheft Die Neue Welt. Juli 1926. Redaktion Hannes Meyer. Verlag Gebr. Fretz AG, Zürich.

•OFFSET, BUCH- UND WERBEKUNST. Bauhausheft. 1926, Heft 7. Leipzig, Seeburgstraße 57.

Czech

ZIVOT II. Sborník nové krásy. Typography: Karel Teige. Photomontage on cover: Feuerstein — Krejcar — Sima-Teige. Vylvarny odbor umelecké besedy, Praha II, 1922.

\ITESLAV NEZVAL: Pantomima. Cover: Jindrich Styrsky. Typography: Karel Teige. Praha, 1924. **d**

KAREL TEIGE: Film. Cover and typography by the author. Václav Petr, Praha-Bubenec, 1925.

J. HONZL: Roztocené jeviste. Cover: Styrsky and Toyen. Typography: Karel Teige. Jan Fromek, Praha, 1925.

JAROSLAV SEIFERT: Na vinách TSF. Typography and cover: Karel Teige. Václav Petr, Praha-Bubenec, 1925. **d**

VITESLAV NEZVAL: Mensí ruzová zahrada. Cover: Styrsky and Toyen. Typography: Karel Teige. Odeon. Praha, 1926. **d**

Danish

HARALD LANDT MOMBERG: Aktiv Reklame. Nye principer i annonceringens kunst, Köbenhavn-Kristiania-Berlin, Det Ny Studentersamfunds Forlag, 1924.

Dutch

EL LISSITZKY: Suprematisch worden van twee quadraten. Verlag De Stijl, Clamart (Seine), Frankreich, 64 av. Schneider, 1922. **bd**

French

F. T. MARINETTI: Manifeste du futurisme (publié par le „Figaro" le 20 février 1909). Leaflet. Milano, n.d.

230

BALILLA PRATELLA: Manifeste des musiciens futuristes. Leaflet. Milano, 1911.

F. T. MARINETTI: Supplément au manifeste technique de la littérature futuriste. Leaflet. Milano, 1912.

UMBERTO BOCCIONI: Manifeste technique de la sculpture futuriste. Leaflet. Milano, 1912.

LUIGI RUSSOLO: L'art des bruits. Leaflet. Milano, 1913.

F. T. MARINETTI: Les mots en liberté futuristes. Edizioni futuriste di „Poesia". Milano, 1919.

TRISTAN TZARA: cinéma calendrier du coeur abstrait. maisons. bois par arp. collection dada. au sans pareil, 37 avenue kléber. paris, 1920. **db**

F. T. MARINETTI: Le tactilisme. Leaflet. Milano, 1920.

JEAN EPSTEIN: Cinéma. Paris, Editions de la Sirène, 1921.

MAX ERNST: Les malheurs des immortels, révélés par Paul Eluard et Max Ernst. Paris, Librairie Six, 1922. **db**

MAN RAY: Champs délicieux. Album de photographies avec un préface de Tristan Tzara. Paris, 1922. **b**

TRISTAN TZARA: sept manifestes dada. quelques dessins de francis picabia. éditions du diorama. jean budry & co, 3, rue du cherche-midi, paris, n.d. (1925).

ANDRÉ BRETON: Manifeste du surréalisme. Póisson soluble. Paris, Simon Kra (1925).

LE CORBUSIER: Vers une architecture. Paris, G. Crès & Cie, n.d. (1924).

LE CORBUSIER: Urbanisme. Paris, G. Crès & Cie, n.d. (1925).

LE CORBUSIER: L'art décoratif d'aujourd'hui. Paris, G. Crès & Cie, n.d. (1925).

LE CORBUSIER: La peinture moderne. Paris, G. Crès & Cie, n.d. (1925).

LE CORBUSIER: Almanach d'architecture moderne. Paris, G. Crès & Cie, n.d. (1925).

German

DIE SCHRIFTEN DER „BRÜCKE", Internationales Institut zur Organisierung der geistigen Arbeit. München 1911–1912.

MANIFEST DES FUTURISMUS. Katalog der Ausstellung „Der Sturm". Berlin. Der Sturm, 1912.

HANS ARP: die wolkenpumpe. paul steegemann. verlag. hannover, 1920. **d**

RICHARD HUELSENBECK: En avant dada. Eine Geschichte des Dadaismus. Paul Steegemann, Hannover, n.d. (1920).

•DR. W. PORSTMANN: sprache und schrift. Beuthverlag. Berlin, 1920.

GEORGE GROSZ: Mit Pinsel und Schere. 7 Materialisationen. Berlin, Malik-Verlag, 1922. **b**

MA-BUCH NEUER KÜNSTLER (100 pictures). Redigiert von L. Kassák und L. Moholy-Nagy. Ma-Verlag L. Kassák, Wien XIII, Amalienstr. 26, 1922.

KURT SCHWITTERS: Anna Blume, Paul Steegemann, Hannover, 1922. **d**

EL LISSITZKY: Figurinen. Die plastische Gestaltung der elektromechanis-chen Schau: Sieg über die Sonne. 10 original lithographs. Hannover, 1923. **b**

EL LISSITZKY: Proun. 6 original lithographs. 1. Kestnermappe. Hannover, Ludwig Ey, 1923. **b**

STAATLICHES BAUHAUS IN WEIMAR 1919–1923. Typography: L. Moholy-Nagy. Bauhausverlag. Weimar-München, 1923.

SAMMLUNG GABRIELSON-GÖTEBORG. Erwerbungen 1922/23 Berlin. Mit Beiträgen von Adolf Behne, Ludwig Hilberseimer, S. Friedländer-Mynona, N.p., n.d.

PRESSESTIMMEN (AUSZÜGE) FÜR DAS STAATLICHE BAUHAUS WEIMAR. Typography and jacket: L. Moholy-Nagy. Weimar, n.d. (1924).

PROF. DR. C. AUGUST EMGE: Die Idee des Bauhauses. Kunst und Wirk-lichkeit. Pan-Verlag Rolf Heise, Berlin, n.d. (1924).

•INTERNATIONALE AUSSTELLUNG NEUER THEATERTECHNIK WIEN 1924. Katalog, Programm, Almanach. Herausgegeben von Friedrich Kiesler. Typography: Friedrich Kiesler. Verlag Würthle & Sohn Nachf., Wien I, Weihburggasse 9, 1924.

LU MÄRTEN: Wesen und Veränderung der Formen — Künste. Taifun-Verlag, Frankfurt a.M., 1924.

BRUNO TAUT: Die neue Wohnung. Die Frau als Schöpferin. Cover: Jo-hannes Molzahn. Klinkhardt & Biermann, Leipzig, 1924.

L. TROTZKI: Literatur und Revolution. Verlag für Literatur und Politik. Wien, 1924.

WERBWART WEIDENMÜLLER: gesang vom werbewerk. stettin, willy puppe, 1924.

ALMANACH EUROPA 1925. Gustav Kiepenheuer, Potsdam, 1924.

HANS ARP: der pyramidenrock. eugen rentsch verlag, münchen, 1925. **d**

•ADOLF BEHNE: Von Kunst zur Gestaltung. Einführung in die moderne Malerei. Cover: Oskar Fischer. Arbeiter-Jugend-Verlag, Berlin, 1925.

DR. ANNA BERLINER: Japanische Reklame in der Tageszeitung. Stuttgart, C.E. Poeschel Verlag, 1925.

MAX BURCHARTZ: Folder with leaflets for the Bochum Association for Mining and Cast-Steel Production (typography with photomontage). Bochum, 1925. **t**

LUDWIG HILBERSEIMER: Großstadtbauten (Neue Architektur 1). Apoß-verlag, Hannover, 1925.

•EL LISSITZKY UND HANS ARP: Kunst-Ismen 1914–1924. Typography: El Lissitzky. Eugen Rentsch Verlag, München, 1925.

DIE SCHEUCHE. Märchen. Typographisch gestaltet von Kurt Schwitters, Käte Steinitz, Theo van Doesburg. Apoßverlag, Hannover, 1925. **d**

KURT SCHWITTERS UND KÄTE STEINITZ: Die Märchen vom Paradies. Typography: Kurt Schwitters. Apoßverlag, Hannover, 1925. **d**

COLIN ROSS: Fahrten- und Abenteuerbuch. Typography and cover: Jan Tschichold. Verlag der Büchergilde Gutenberg, Berlin, 1925. **t**

GUTENBERGFESTSCHRIFT 1925. Herausgegeben von A. Ruppel. Verlag der Gutenberg-Gesellschaft, Mainz, 1925.

ARTHUR SEGAL UND NIKOLAUS BRAUN: Lichtprobleme der bildenden, Kunst. Berlin, 1925.

DIE BAUHAUSBÜCHER:

 1 Walter Gropius: Internationale Architektur

 2 Paul Klee: Pädagogisches Skizzenbuch

 3 Ein Versuchshaus des Bauhauses

 4 Die Bühne im Bauhaus

 •5 Piet Mondrian: Neue Gestaltung

 •6 Theo van Doesburg: Grundbegriffe der neuen gestaltenden Kunst

 7 Neue Arbeiten der Bauhauswerkstätten

 •8 L. Moholy-Nagy: Malerei, Photographie, Film

 9 W. Kandinsky: Punkt und Linie zu Fläche

 10 Oud, Holländische Architektur

 11 Maléwitsch, Die gegenstandslose Welt

 Albert Langen, Verlag, München, 1925/28.

LE CORBUSIER: Kommende Baukunst (= Vers une architecture). Deutsche Verlagsanstalt, Stuttgart, 1926.

50JAHRESTADTTHEATER IN MAGDEBURG. Festschrift. Gesamtausstattung: Johannes Molzahn. Verlag: Mitteldeutsche Reklame-Gesellschaft m.b.H., Magdeburg, 1926. **t**

DIE FORM. Zeitschrift für gestaltende Arbeit. Verlag Hermann Reckendorf Berlin W 35, 1926.

RUDOLF KURTZ: Expressionismus und Film. Berlin, Verlag der Lichtbild-bühne, 1926.

KATALOG 1926/I der Richmod-Galerie Casimir Hagen, Köln, Richmodstr. 3. Typography: Anton Räderscheidt. Köln, 1926. **t**

SIEGFRIED EBELING: Der Raum als Membran. Dessau, 1926, C. Dünnhaupt Verlag.

KARL SCHEFFLER: Zeit und Stunde. Leipzig, Insel-Verlag.

(Normwesen:)

DR. PORSTMANN: Die Kartei. Beuthverlag, Berlin.

DR. PORSTMANN: Papierformate (DINbuch 1). Beuthverlag, Berlin, 1923.

•KIENCKE UND FRANK: Formate und Vordrucke. Beuthverlag, Berlin, 1926.

DEUTSCHE INDUSTRIE-NORMEN (Deutscher Normenausschuß):

DIN 198 Papierformate nach DIN 476, Anwendungen der A-Reihe

DIN 476 Papierformate

DIN 676 Geschäftsbrief

DIN 677 Halbbriefe

DIN 678 Briefhüllenformate

DIN 682 Tafeln und Rahmen für Bilder und Muster

DIN 827 Papier: Stoff, Festigkeit, Verwendung

Beuthverlag, Berlin SW 19.

MITTEILUNGEN DES DEUTSCHEN NORMENAUSSCHUSSES

22. August 1923: Scheckvordruck

26. Juni 1924: Zeitschriften

9. April 1925: Buchformate

17. September 1925: Fensterhüllen

Beuthverlag, Berlin SW19.

Italian

I NUOVI POETI FUTURISTI: (anthology, ed. F. T. Marinetti). Edizioni futuriste di „Poesia", Roma, 1925, **d**

Polish

ANATOL STERN — BRUNO JASIENSKI: Ziemia na lewo. Typography and cover: M. Szczuka. Warsaw, Verlag Ksiazka, 1924. **d**

Russian

ILJA ERENBURG: A wse-taki ona wertitsja! (But it does move!) Helikon-Verlag. L. Ladyshnikoff, Berlin, 1922.

ILJA ERENBURG: Schest powestej o legkich konzach. Cover and illustrations: El Lissitzky. Helikon-Verlag, Moscow and Berlin, 1922. **d**

EL LISSITZKY: Pro dwa kwadrata (Of two squares). Verlag Skythen, Berlin, 1922. **bd**

WLADIMIR MAYAKOWSKY: Dlja gólossa (For reading aloud). Typography: El Lissitzky. Russian State Publishing House, Moscow, 1923. **d**

WLADIMIR MAYAKOWSKY: Pro eto. Mit Photomontagen von Rodtschenko. Russian State Publishing House, Moscow, 1923. **d**

KTO, TSCHTO, KOGDA W KAMERNOM TEATRE. Typography and cover: G. Stenberg. Moscow, Chamber theater, n.d.

LIST OF ADDRESSES

Willi Baumeister	Frankfurt a.M., Neue Mainzer Str. 47
Herbert Bayer	Dessau, Bauhaus, Friedrichsallee 12
Max Burchartz	Bochum, Herner Str. 42
Dr. Walter Dexel	Jena, Fuchsturmweg 15
Theo van Doesburg	Clamart (Seine), Frankreich, 64, avenue Schneider
Lajos Kassák	Wien XIII, Amalienstr. 26
El Lissitzky	Moskau, Strominka 26, Quartier 50
László Moholy-Nagy	Dessau, Burgkühnauer Allee 2
Johannes Molzahn	Magdeburg, Sternstr. 24
Joost Schmidt	Dessau, Bauhaus, Friedrichsallee 12
Kurt Schwitters	Hannover, Waldhausenstr. 5, II
Franz W. Seiwert	Köln a. Rh., Eigelstein 147, III
Jan Tschichold	München, Pranckhstr. 2
Karel Teige	Praha, Tschechoslowakei, Černa 12 a
Tristan Tzara	Paris XIV, 15, rue Delambre
Piet Zwart	Wassenaar, Holland, Rijksstraatweg 290

For the use of some blocks in this book, the publisher thanks the generosity of other publishers and bodies. Permissions were given by

the Galerie Arnold, Dresden,
the Verlag Gebr. Fretz, A.-G., Zürich,
the periodical *Gebrauchsgraphik,* Berlin,
the periodical *Das Neue Frankfurt,* Frankfurt a.M.,
the Insel-Verlag, Leipzig,
the Verlag Gustav Kiepenheuer, Potsdam,
the Verlag Klinkhardt & Biermann, Leipzig,
the Verlag der Lichtbildbühne, Berlin,
the Deutscher Normenausschuss, Berlin,
the Photographische Gesellschaft, Berlin-Charlottenburg 9,
the Verlag Hermann Reckendorf, Berlin,
the periodical *Typographica,* Prague.

NOTE TO PAGE 210

During the production of this book, the *Berliner Tageblatt* was the first important daily paper to go over to roman type for its entire composition.

A NOTE ON THE BOOK AND ITS DESIGN

This first publication of an English-language version of Jan Tschichold's *Die neue Typografie* (1928) has attempted to follow the author's original page layouts and design precepts as closely as possible. Aurora Grotesk, shown in the Berthold Phototypes E1 catalog (1974), was identified as the typeface closest to that used in the original German edition; this typeface, however, had not been digitized at the time the California edition was produced. The text was set in 7.75 Imago Light Extended with 11.6 point leading. The typeface was revised by extending its overall set widths by 112 percent; character spacing was expanded to a Quark XPress tracking value of 16. Display fonts were set in Frutiger Ultra Black with a tracking value of 19. Illustrations were scanned from the reprint issued by Brinkmann & Bose (Berlin: 1987), and from *Leben und Werk des Typographen Jan Tschichold* (Munich: G. K. Saur, 1988). Paper and binding materials were selected to approximate those used in the Brinkmann & Bose edition. Sponsoring Editor: Edward Dimendberg, University of California Press, Los Angeles. Production Editor: Rebecca Frazier, University of California Press, Los Angeles. Production Coordinator: Danette Davis, University of California Press, Berkeley. Research and Design: Steve Renick, University of California Press, Berkeley. Research and Composition: Hassan Herz, TBH Typecast, Cotati, California. Image Scanning: ScanArt, Richmond, California. Printing and Binding: Edwards Brothers Inc., Ann Arbor, Michigan.